THE STORY OF VIRGINIA
Highlights from the Virginia Museum of History & Culture

THE STORY OF VIRGINIA
Highlights from the Virginia Museum of History & Culture

Jamie O. Bosket and William M.S. Rasmussen

VIRGINIA
HISTORICAL
SOCIETY

Virginia Historical Society, Richmond
in association with D Giles Limited, London

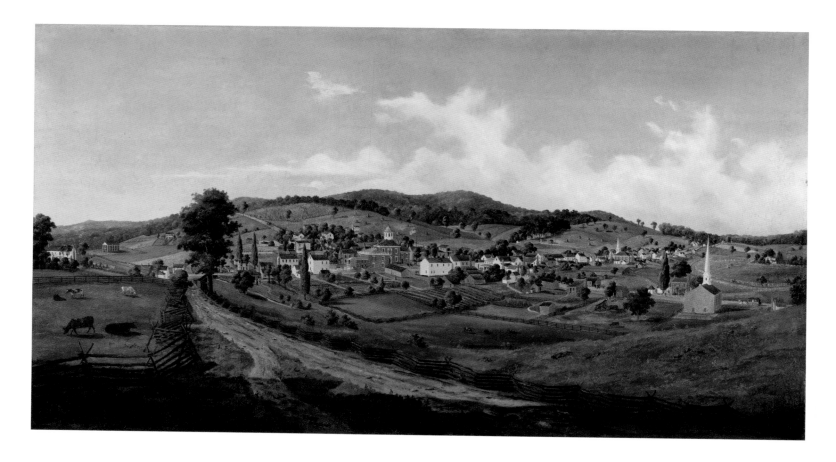

The Story of Virginia: Highlights from the Virginia Museum of History & Culture was made possible by a generous grant from the E. Rhodes and Leona B. Carpenter Foundation.

© 2018 Virginia Historical Society

First published jointly in 2018 with GILES
An imprint of D Giles Limited
4 Crescent Stables
London SW15 2TN, UK
www.gilesltd.com

ISBN: 978-1-911282-27-3

For D Giles Limited:
Copy-edited and proof-read by Sarah Kane
Designed by Caroline and Roger Hillier, The Old Chapel Graphic Design
Produced by GILES, an imprint of D Giles Limited, London
Printed and bound in Slovenia

All measurements are in inches and centimeters;
height precedes width precedes depth.

Front cover: Edward Beyer, *Christiansburg*, 1855 (detail); Gift of Lawrence Lewis, Jr. The full work is shown above.
Selected images from *The Story of Virginia*
Back cover: Charles Peale Polk, *Washington at the Battle of Princeton*, about 1789; Gift of Anthony M. Kelley; diary of George Washington, 1790–91 (see page 67); porcelain saucer marked MW belonging to Martha Washington, 1795 (see page 67)
Selected images from *The Story of Virginia*
Frontispiece: Virginia Museum of History & Culture

Contents

Foreword

At a young age, people rarely do enough to record their own history. They tend to focus instead on making history—bringing change and progress for the future. This may have been the case with Virginia's leaders in their first few formative decades as members of the newly established United States of America. Yet, an important transition was soon upon them in the early 1800s. While stepping soundly into a new century, Virginia soon lost the preeminence it clearly had in the founding era, as well as its stature as the largest and wealthiest state in the nation. The standout individuals, Virginia's Founding Fathers, who provided the voice and leadership needed to establish the country were slipping away. George Washington, Virginia's most famous son, was gone, as were Thomas Jefferson, George Mason, James Monroe, and others. As the nation celebrated its fiftieth anniversary, a commemoration of the centennial of Washington's birth was about to be a national occasion.

It was time. Time to do something before the stories and physical artifacts of the past—held dear by many—were lost forever.

With only a few examples to look to, a group of concerned Virginians came together to create a "society" to capture and preserve the history of the Commonwealth. Established in 1831, the Virginia Historical Society is now the oldest continually operating cultural organization in Virginia and one of the oldest and most distinguished history organizations in the country. Older than the Smithsonian Institution, or nearly any other likeminded organization, the historical society proceeded, just as George Washington had aptly described his presidential endeavor, on untrodden ground.

Selected to be its leader was Virginian John Marshall, the longest-serving chief justice of the United States Supreme Court and prominent Richmonder. As its honorary first member, the society welcomed Virginian James Madison, the fourth president of the United States, the sole remaining member of the early Virginia presidential dynasty.

Collecting was a goal from its earliest days. The society welcomed papers, books, and paintings—primarily focused on the Founding Fathers and the elite early families of the Commonwealth. Then, as now, most of what was cared for by the society was the result of generosity—objects were donated or funds were given for their acquisition.

Today, nearly two centuries later, a renowned history collection of some nine million items has been amassed to represent much of Virginia's storied

past. The society has one of the largest portrait collections in the American South, the largest privately held American Civil War research collection, and an astounding archive of the founding era, among other highlights.

A persistent challenge in the early years was finding a proper and safe home for these priceless reminders of the past. For decades, the society moved from one temporary home to the next. Fortunately, its transient situation likely saved the collection from being lost, burned, or looted during the destruction of the Civil War.

It wasn't until the twentieth century that a permanent home was found— in a structure created by a different organization for a different purpose. The "Battle Abbey of the South" was built decades after the Civil War by the Confederate Memorial Association as a temple for remembrance of Confederate history—a largely reinvented tale by that time. The society took possession of the building from the dissolving and dated organization, and quickly began an eight-decade-long transformation to grow and change it to provide the Commonwealth with a fitting history museum.

Now known as the Virginia Museum of History & Culture, the facility has grown to include nearly a quarter-million-square-feet of space to house the historical society's ever-growing collection, extensive research library, and exhibition and programming space.

This remarkable organization now evolves along with the unique, diverse, and history-rich state it represents. It fulfills its critical mission with purpose and through the lasting dedication of its members, supporters, Board of Trustees, staff and volunteers.

Jamie O. Bosket
President and CEO, Virginia Historical Society

Acknowledgments

This publication joins an impressive family of works created by the Virginia Historical Society or using its renowned collection. Chief among them is the *Virginia Magazine of History & Biography*, which has been continually published for more than 125 years. This is made possible—as is everything the society does—through the thoughtful support of more than 7,000 members worldwide and hundreds of major donors who believe in the power of Virginia history.

This book came to fruition thanks to the generous support of the E. Rhodes and Leona B. Carpenter Foundation. The foundation, which has a wonderful history of support for the Virginia Historical Society, was created by E. Rhodes Carpenter, founder of the Richmond-based company now known as Carpenter Co.

The driving force behind this work was Dr. William M.S. Rasmussen, Senior Curator of Exhibitions and Lora M. Robins Curator of Art. Bill is not only a talented historian, but is also one of the most passionate and dedicated members of the museum's staff. It was a privilege to partner with him on this project; even more, it was an advanced survey course in Virginia history. This book is a lovely reminder of his tremendously distinguished tenure, and the legacy he will leave here.

Sincere appreciation is also due to a number of individuals who gave generously of their time and expertise, and allowed Bill's and my vision to become reality. Included among them are our colleagues Troy Wilkinson, Photographer and Digital Asset Specialist; Rebecca Rose, Director of Museum Collections and Registration; Heather Beattie, Collections Manager; L. Eileen Parris, Sallie and William B. Thalhimer III Senior Archivist; Stacey Rusch, Chief of Conservation; Andy Talkov, Vice President for Exhibitions and Publications; John McClure, Director of Library and Research Services; Dr. Karen Sherry, Curator of Exhibitions; Graham Dozier, Managing Editor of Publications and Virginius Dabney Editor of the *Virginia Magazine of History & Biography*; Dale Kostelny, Director of Exhibition Production; Canan Boomer, Assistant to the President; Pam Seay, former Senior Vice President for Advancement; Elaine McFadden, Senior Officer for Corporate, Foundation, and Government Relations; and everyone who helps build, protect, and support our collections.

We also wish to recognize the support of expert reviewers and former staff, E. Lee Shepard, former Vice President for Collections, and Dr. Nelson D. Lankford, former Vice President for Programs.

As is the case at any longstanding institution, our work today benefits from the thoughtful contributions of those who came before us. There are too many to note here, but two must be singled out when it comes to this book: former head of Museum Programs, Dr. James C. Kelly, and one of the Virginia Historical Society's great visionaries and its President Emeritus, Dr. Charles F. Bryan, Jr.

While the items featured here are almost all part of the historical society's collection, some items are owned by partner institutions and on loan to the museum. These partner organizations include Virginia's Department of Historic Resources; National Park Service, Colonial National Historical Park; The Lyceum, City of Alexandria; the Mariners' Museum; NASA Langley Research Center; and Naval History and Heritage Command. We are deeply thankful for the great work they do, and for their trust in us to share their objects.

We also dearly appreciate loans from the following individuals: Frank B. Allen and George E. Allen on behalf of the descendants of Robert Henderson Allen, the family of Nancy Clawson Ansell, Mary Bradshaw, Catherine Churchill Taylor, Anne Byrd Keith, Mrs. Van Wyck W. Loomis, Gary Powers Jr., Charles Granville Scott, the A. C. Stewart Estate, the Honorable Helen Marie Taylor Collection, and Clayton R. Watkins, II.

Lastly, I want to offer my deep and sincere gratitude to the Virginia Historical Society's Board of Trustees. This remarkable state-wide group is one of the finest examples of benevolent leadership to be found in Virginia. Their generosity and steadfast commitment to our mission is inspiring. It is my pleasure to serve them, and to be a part of this worthy organization's continued progress.

Jamie O. Bosket
President and CEO, Virginia Historical Society

Introduction

I know of no way of judging of the future, but by the past.
—Patrick Henry, Richmond, Virginia, 1775

The story of Virginia is at the center of the American experience. The world-changing events of our nation have most often taken place in Virginia, or been meaningfully shaped by Virginians. As such, the Commonwealth is not merely a chapter of U.S. history, it is at the epicenter of its most pivotal moments. The ideas we cherish as Americans were oft inspired and contested here, and with lasting consequences.

Our history is long—it began much before 1607—and it is rich. Virginia's contribution to the American founding is unparalleled. It has been considered the "mother of states" because of the many American states formed from its early borders. It has similarly been called the "mother of presidents," as it was the birthplace of more presidents than any other, including six of the first ten.

Our history is also complex; complex in nearly every way a people's story can be. We have offered original ideas that would have lasting positive global impact; we have engaged in dynamic and tragic fights; and we have—at times—allowed, and even fostered, great inhumanity.

Yet, it is our story. We are the people and place we are today because of the trials, suffering, and advancements of days prior. It is complex, but it is ours. We must take ownership of it, share it, and—most importantly—learn from it.

Just a short distance from the iconic Virginia Capitol is a hilltop overlook that allows a scenic view over the city, and perspective on our journey.

Looking out from this popular overlook, you can see the waters of the majestic and historic James River. The water seems rather peaceful here as it makes its first significant bend below the dramatic rocks of the Richmond fall line. The waters of this wholly Virginia river make their way from the Appalachian Mountains to the Chesapeake Bay and ultimately the Atlantic Ocean.

For thousands of years this river was a hub of life for many of the native inhabitants who called this land home. They would do so until forced to near extinction by the first permanent European settlement in North America, despite its prolonged fragile state and near collapse. The English called this the "New World," but it was new only to them. Here there were already defined cultures with long histories, established languages, and community hierarchies. Many of

the Native Americans here would be pushed off their land or killed by conflict or disease. Their descendants who remained in Virginia struggled for recognition and support. It was not until 2018 that the United States government added to the lone recognized Virginia tribe by including six others that were part of the Powhatan Nation, allowing them access to federal support. These tribes were best known for Pocahontas, and were among those who first encountered the arriving English in 1607.

On the same hilltop with the river view stands a simple white church—the location where Patrick Henry so famously offered his cry for revolution, nearly two centuries after English occupation. Joined in spirit and opposition to the Crown, Henry and the other prominent Virginians of his time offered a promise—a promise of a new system of government and a society based on equity and freedom for all. Looking to their own past and hardships, they pledged to right the wrongs of their English leaders.

All the while, a system of racial slavery, which began in the early years of Jamestown, was growing to new levels in Virginia. Most of the Virginia Founding Fathers had no intention of truly fulfilling this promise for "all" at the time they pledged, yet they presented an idea our nation could rally around, evolve toward, and forever struggle to uphold; they secured Virginia's leading voice for independence.

Just a few decades later, the slave trade in Virginia grew to become the second largest human trafficking operation in the nation. Sadly ironic, its hub was at the base of the same hill along the James River, where Patrick Henry made his famous plea for liberty years before.

The road to ending slavery, the greatest challenge in fulfilling the promise of the Founders, would be complex. It would take an internal war of extraordinary scale. The decision of Virginia leaders to attempt secession to preserve slavery would be one of its worst. Nearly one out of every five white southern males would die during the war, many, of course, from Virginia. It touched every family, and its memory remains today.

After war ravaged the Commonwealth, and just days before Virginia general Robert E. Lee surrendered his army, President Abraham Lincoln travelled by boat up the James River to visit the Virginia capital. He stepped onto land within sight of that same graceful, storied bend in the river—setting the stage for a tumultuous period of reconstruction, followed by yet another century of dramatic change.

Our history is long, complex, and rich.

At times it has surely been hard to tell, but the inspired notion of Theodore Parker, and later made famous by Dr. Martin Luther King, Jr., relates here—the arc of our history bends toward justice. We have stepped backward too often, but we have progressed dramatically in sum.

And we must not stop our evolution, as it is far from complete. What we must do today is learn from the past, treasure its successes and improvement, and be resolved not to repeat its failures. Ultimately, this is how the promise of the Founders gains its real value; how we ensure sacrifice was not in vain; how we fulfill what others could not or chose not to do, and make a better Virginia.

The goal of this book is to add to the remembrance of our unique Virginia story through a sampling of artifacts. We aim to highlight the genius of our Founding Fathers, and also the realities of their actions and times. We strive to highlight innovation that changed lives, and to provide a reminder of crucial and inspiring figures and events.

We aim to do this with fairness and authenticity, as we are mindful of the many ways history, especially in Virginia, has been misappropriated or interpreted with bias.

While deep into this project, my co-author, Bill Rasmussen, walked into my office and set a children's book on my desk. It was published in the 1940s, with a similar title to our new work, and with his name neatly printed within. With a soft grin, he suggested I read it and study the illustrations.

It was a sign of the time. An interpretation with many of the same great moments we cover here, but lacking inclusion, and perpetuating a few one-sided narratives, most specifically the "Lost Cause" rhetoric of the early twentieth century, which diminishes slavery's role in the Civil War, and characterizes the federal government's actions as overreaching. This children's book, of course, was not alone in its approach; it is yet another sign of the complexity of our history.

Our book is not comprehensive, nor is it without fault of its own. But, it is an attempt to share real objects, tangible reminders of the past using the artifacts available to us. Our narrative is relatively brief, and we do not provide extensive

analysis or interpretation. We want these objects to speak for themselves. They are truth.

From a slave whipping post from Portsmouth, Virginia, to the bell that once adorned St. John's Church high atop that Richmond hill. From decorative buttons Pocahontas wore when presented to the English royals, to the buttons proudly worn by strong Virginia women campaigning for voting rights. From the annotated farming guide of George Washington, to beer taps representing one of today's burgeoning agricultural industries. From a Conestoga wagon, to one of the few remaining electric streetcars used on the nation's first city-wide system. A pen used to sign Virginia's secession declaration, to a treasured U.S. flag that flew over Richmond when it was reclaimed in 1865.

These objects each have a story to tell—one that adds greatly to the remarkable Virginia narrative, and the journey, or arc, on which we still tread.

Without doubt, Patrick Henry was right. It is through an understanding of what happened before us that we know how to act today. This is how we can look back at imperfection, and still have pride in our story and be rightfully proud of many of the people who made it.

The story of Virginia matters. It defines our national path, and the way in which our American contribution is world-reaching.

Jamie O. Bosket
President and CEO, Virginia Historical Society

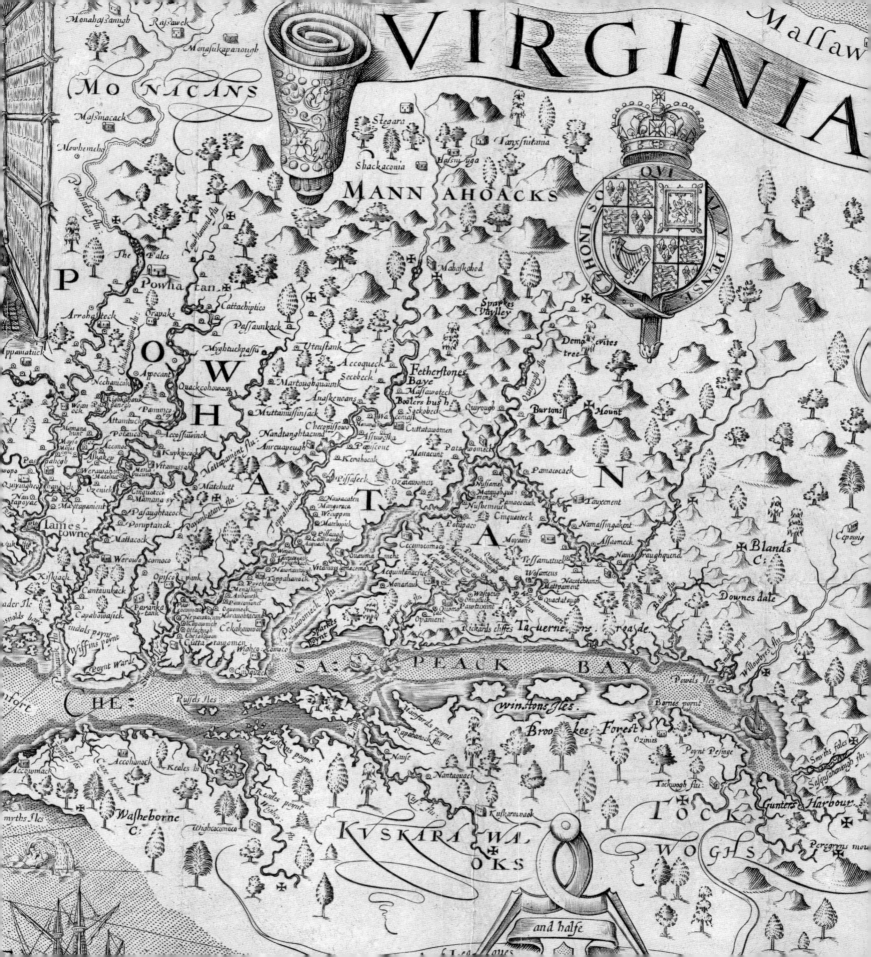

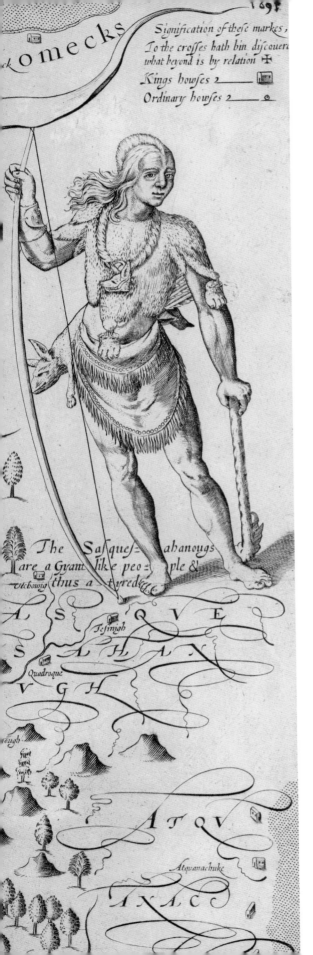

The following text appears within the map illustration:

omecks

Signification of these markes,
To the crosses hath bin discouer[ed]
what beyond is by relation ✠
Kings howses 2 [⌂]
Ordinary howses 2 ⊙

The Sasque=sahanougs
are a Gyant like peo=ple &
Vtchowig thus attyred

A S Q V E
Jesimah
S L H A N
Quadroque
V G H
ough
A T Q V
Atquanachuke
A X A C

16,000 BCE–1622 CE

LAND OF OPPORTUNITY —CREATING VIRGINIA

At the time of the great northern glaciers, American Indians followed the game they hunted to Virginia. Ten thousand years later, about 10,500 BCE, as the cold of the Ice Age gave way to a warmer, drier climate, they relied also on foraging and farming. After about 900 BCE they settled into villages that united into chiefdoms.

In 1607, in pursuit of opportunity in a new world, English settlers intruded into an eastern Virginia chiefdom of thirty tribes (15,000–20,000 people). Its leader then was Wahunsenacawh, whom the new settlers called by his title, Powhatan. In early written and drawn representations of Virginia, the English often emphasized what they perceived as the primitive, uncivilized state of this land. Yet the society that they had "discovered" was in fact long established with its own complex cultural, social, and economic patterns. Conflict between the two cultures over the land and its natural resources was probably inevitable.

LAND OF OPPORTUNITY

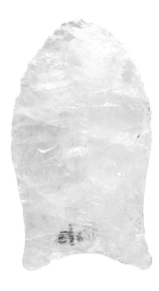

A Hunting Tip Used by Ancient Indians

Clovis point, about 9500 BCE, Paleo-Indian Period (15,000–8000 BCE).
On loan from the Virginia Department of Historic Resources

The first people in Virginia—known today as "Paleo" or "ancient" Indians—were nomads who arrived more than 16,000 years ago during the last Ice Age. They survived by hunting animals and gathering plants. They lived among conifers and grasslands, the ranges of which once extended onto Virginia's exposed continental shelf, an area now covered by ocean.

Clovis points (named after a New Mexico site where they were first found by modern archaeologists) were used as the tips of projectiles and as knife blades. Their flaked grooves ("flutes") allowed the point, made of various stones, to be attached or "hafted" to a wooden shaft. Clovis points were all-purpose blades that could cut plants but also could be attached to spears and knives and used to kill prey ranging from rabbits to mammoths. (Arrows were 8,000 years in the future.)

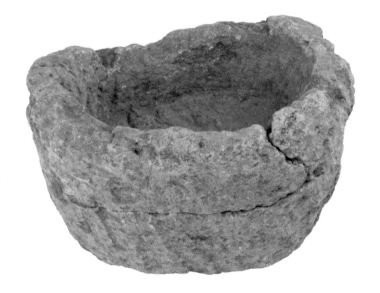

A Cooking Container Used by Archaic Indians

Bowl, about 2000 BCE, steatite, Archaic Period (8000–1200 BCE).
On loan from the Virginia Department of Historic Resources

Archaic Indians constantly searched for resources. They differed from their "ancient" predecessors by choosing to set up base camps from which to hunt and gather before moving to new locations. Their use of steatite suggests that they were somewhat settled, because the bowls were heavy and difficult to move. They were not too heavy, however, to trade. Fragments have been discovered hundreds of miles from where the stone was quarried—evidence of contact between peoples in the mountains and on the coast. Steatite, or soapstone, was a highly prized material because it absorbed, stored, and radiated heat. It could be easily carved to make cooking vessels.

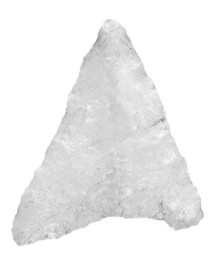

A Hunting Tip Used by Woodland Indians

Madison triangular point, Woodland Period (1200 BCE–1600 CE).
On loan from the Virginia Department of Historic Resources

As they developed an agricultural tradition and learned to make and use pottery, Virginia's Indians became more rooted in place. To grow corn, they settled near the fields they cultivated. Their clay pottery made cooking easier and allowed storage of food.

The people continued to hunt. Relatively small triangular points like the Madison type, made of various stones, are evidence of the use of arrows during this period. The Madison point was effective in hunting woodland game as large as deer. The point was inserted into the split end of an arrow and glued into place.

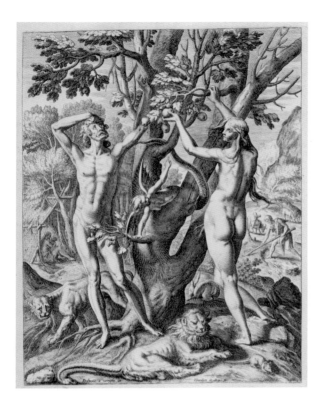

Virginia as a New Beginning

Theodor de Bry, "Adam and Eve," engraving, frontispiece to Thomas Hariot, *A Briefe and True Report of the New Found Land of Virginia*, Frankfurt, 1590. Bequest of Paul Mellon

This celebrated "Adam and Eve plate" is considered one of the finest copperplate engravings ever published and is emblematic of Europe's hope that the New World would prove a new Eden of peace and plenty. The imagery, however, suggests that the coming of Europeans can be equated to the arrival of Satan in the primordial "Garden"; a "Fall" will follow as all are cast out of Eden. Hariot was a mathematician and scientist dispatched as a surveyor to Roanoke Island by Sir Walter Ralegh.

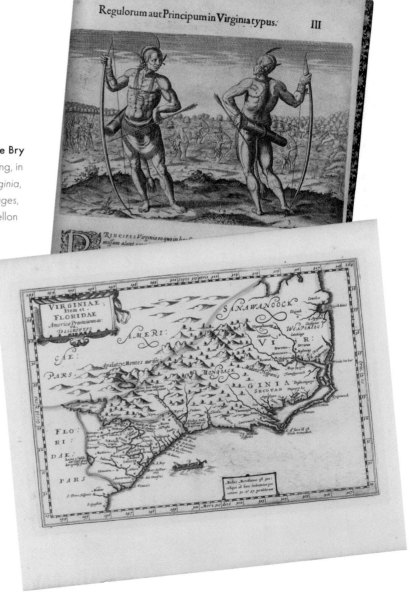

The Indians of White and de Bry

Theodor de Bry after John White, "Indian in Body Paint," etching, in Thomas Hariot's *A Briefe and True Report of the New Found Land of Virginia*, included in Theodor de Bry's six-volume *Great and Small Voyages*, Frankfurt, 1599, vol. 1 plate 3. Bequest of Paul Mellon

White's depiction of an Algonquian chief, made in 1585 in the Outer Banks region of present-day North Carolina, became for Europeans of this era an iconic image of the North American Indian. The original drawing carries the inscription, "The manner of their attire and painting themselves when they goe to their generall huntings, or at theire Solemne feasts."

An Early Vision of Virginia

Pieter van den Keere, *Virginiae Item et Floridae*, 1673, reproduction of the 1591 engraving by Theodor de Bry based on John White's 1586 watercolor. Gift of Summit Enterprises of Virginia, Inc. through the courtesy of Alan M. Voorhees

In the Elizabethan age, "Virginia" was the name given by English explorers to the entire region above Florida; they chose the name to honor the Virgin Queen, Elizabeth I (reigned 1558–1603). It stretched as far north and west as its settlers could imagine. John White was Sir Walter Ralegh's agent and artist for the Roanoke expedition. Roanoke Island is pictured to the right, in Pamlico Sound, which separates the mainland of today's North Carolina from its Outer Banks.

THE DREAM OF VIRGINIA

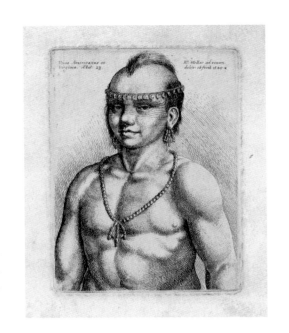

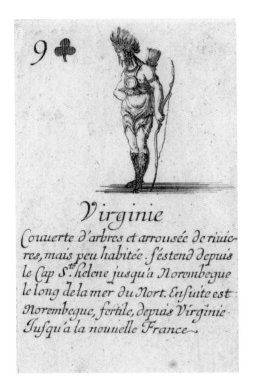

French Image of an Indian

Playing card depicting a Virginia Indian, Paris, 1644

This French playing card was printed in France in 1644 as part of "games devised for the instruction of Louis XIV as a child." The text explains that Virginia is "little habited" and extends "up to New France." Early French settlers had established "New France" beyond what is now Canada and into territory in what is now the eastern United States.

Czech Image of an Indian

Wenceslaus Hollar, *Indian from Virginia*, 1644, etching

A Munsee Delaware Indian named Jacques was taken in 1644 from New Amsterdam (now New York) to Amsterdam, where the Czech artist Wenceslaus Hollar made this sketch of him. In this period it was not unusual to refer to all of the East Coast American settlements—including New Netherland—as "Virginia."

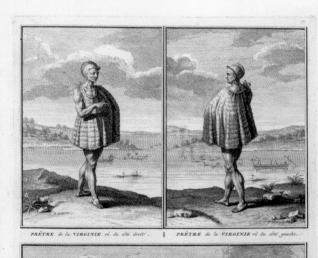

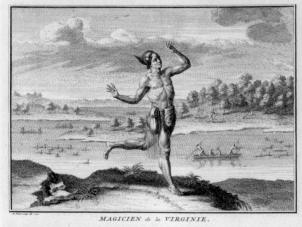

Dutch Image of Indians

Bernard Picart after Gysbert van Veen, "Priest and Magician of Virginia," 1721, from *Cérémonies et coutumes religieuses de tous les peuples du monde*, Amsterdam, 1723–43. Gift of William W. Cole in memory of his father, Robert Wallace Cole, Sr.

Theodor de Bry worked with an associate, Gysbert van Veen. For more than two centuries, the 1590 engravings of Virginia Indians by de Bry and van Veen were copied for other publications, such as Bernard Picart's illustrated survey of worldwide religious practices that appeared in 1721. On the page displayed, Picart combined John White's depiction of a priest (above) with White's depiction of "the flyer" (below). De Bry and Picart more helpfully called the bottom figure "the conjurer" and "magician of Virginia."

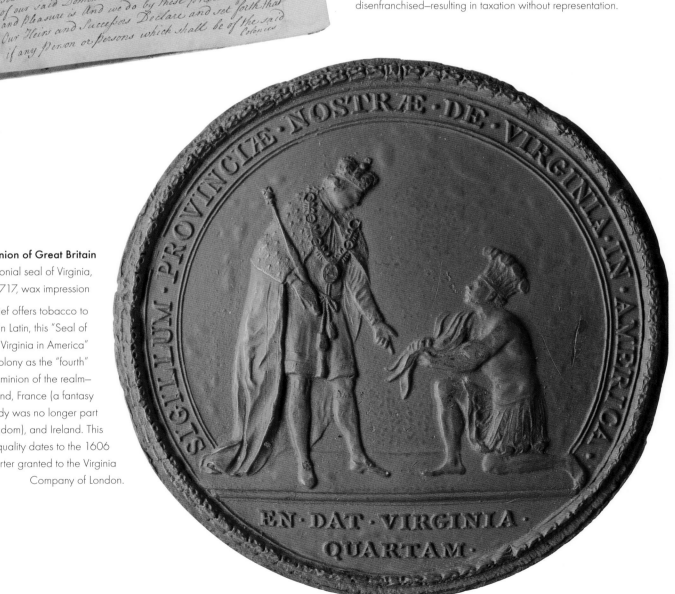

Charter of the Virginia Colony

"The Virginia Charter of 1606," a passage from the *Records of the Virginia Company of London, 1619 April 28 - 1624 June 7.* Eighteenth-century copy bears bookplate of John Randolph of Roanoke. Vol. 3, p. 76. Gift of William Leigh

Jamestown was established by the Virginia Company of London, a stock company that was granted a royal charter by James I. There the king made promises that Virginians would remember in 1776: all in Virginia "and Every of their Children... Shall have and enjoy all Liberties, Franchises, and Immunities... as if they had been Abiding and Born within this Our Realm of England." Virginians who launched the American Revolution would complain that they were disenfranchised—resulting in taxation without representation.

The Fourth Dominion of Great Britain

Colonial seal of Virginia, about 1717, wax impression

A kneeling chief offers tobacco to King James I. In Latin, this "Seal of our Dominion of Virginia in America" identifies the colony as the "fourth" ("quartam") dominion of the realm—equal to England, France (a fantasy since Normandy was no longer part of James's kingdom), and Ireland. This statement of equality dates to the 1606 charter granted to the Virginia Company of London.

JOHN SMITH AND POCAHONTAS

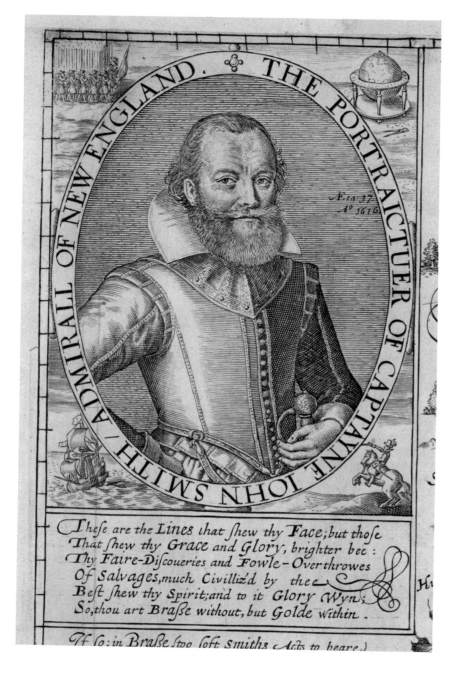

These are the Lines that shew thy Face; but those
That shew thy Grace and Glory, brighter bee:
Thy Faire-Discoveries and Fowle-Overthrowes
Of Salvages, much Civilliz'd by thee
Best shew thy Spirit; and to it Glory Wyn;
So, thou art Brasse without, but Golde within.

If so: in Brasse (two soft Smiths Acts to heare.)

Portrait of John Smith

Unidentified artist after Simon van de Passe, "Portraictuer of Captayne John Smith," engraving, detail from a map of New England contained in *The Generall Historie of Virginia, New-England, and the Summer Isles*, London, 1624

Soldier, explorer, and author, John Smith fought in the Netherlands and Hungary, toured France, Italy, the Mediterranean, Russia, Central Europe, and North Africa, and was enslaved in Turkey and Russia—all before landing at Jamestown in 1607. In Virginia he showed brashness and bravery that garnered both the highest respect of the Powhatan Indians and disdain from a number of English colleagues. Largely through his bold leadership in 1607–9 the Jamestown settlement survived.

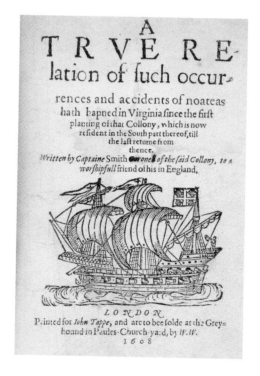

The First Book Written in America

John Smith, *A True Relation of Such Occurences ... as Hath Hapned in Virginia Since the First Planting of that Collony*, London, 1608. Bequest of Paul Mellon

Written in America, this volume is in fact the first American book. It is also the first accurate account of America's first permanent English colony. The accomplished collector Paul Mellon bequeathed to the collection a dozen extremely rare early seventeenth-century books that are period accounts of the Virginia settlement.

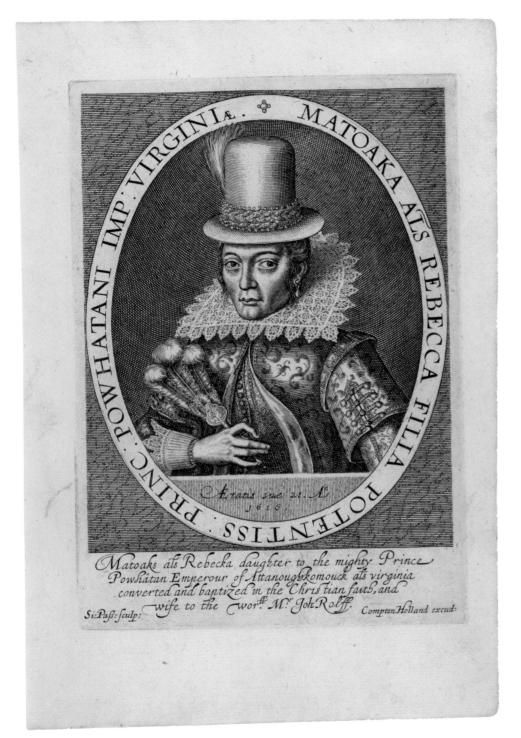

The Real Pocahontas?

Simon van de Passe, *Pocahontas*, 1616, engraving

This is the only portrait of Pocahontas taken from life and thereby the most credible image of her. In rigid, Jacobean attire, twenty-one-year-old Pocahontas seems uncomfortable, but the costume probably hid tattooing and certainly provided the chaste image wanted by the Virginia Company. That organization sponsored the Virginia settlement and Pocahontas's trip to England, and it probably commissioned this print for publicity, as a means to celebrate the conversion of an "Indian princess" to English and Christian ways.

Buttons Fit for Royalty

Button worn by Pocahontas, maker and date unknown, gold. Gift of Mrs. Hugh Blair Grigsby Galt and Margaret Purviance Hastings

Members of the Rolfe family preserved several small buttons (¼ in. in diameter) as relics of their famous ancestor who had married the Jamestown settler John Rolfe. The buttons entered the Virginia Historical Society with virtually no documentation. They were reputed to have been worn by Pocahontas while in England, where no doubt they were made.

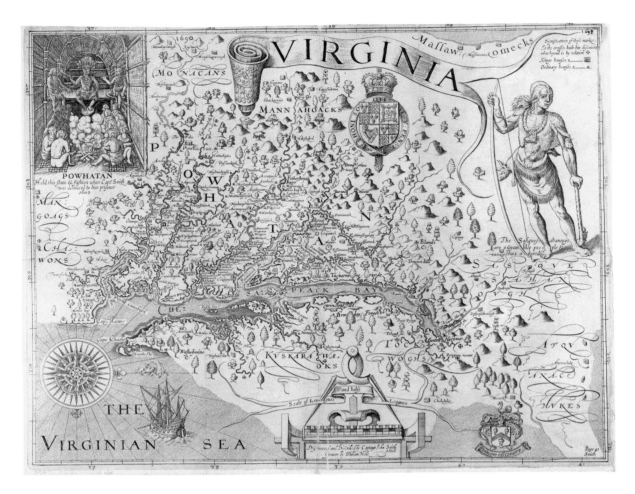

John Smith's Map

Virginia / Discovered and Discribed by Captayn John Smith, 1624 edition. Bequest of Paul Mellon

The Jamestown colonists explored the land around their settlement in search of minerals and metals, a water passage across the continent, and survivors from Roanoke Island. John Smith gathered their observations to create this map that is remarkable not only for its accuracy but also, and more particularly, for its identification of seemingly innumerable Indian settlements. It is one of the most important and often copied maps from colonial America.

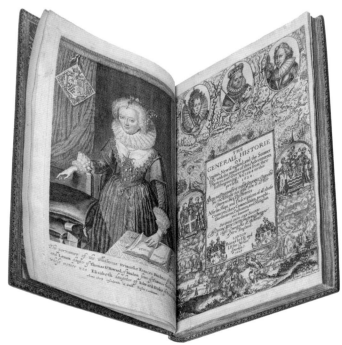

John Smith's Most Famous Book

John Smith, *The Generall Historie of Virginia, New-England and the Summer Isles*, London, 1624

Much of what is known about the Jamestown settlement comes from the pen of John Smith. His *Generall Historie* is the best known and most detailed of several books that he wrote. Smith's narratives and his maps played an important role in promoting English colonization.

THE INDIAN UPRISING

Record of the Virginia Company

"Instructions to Governor Wyatt, 1 August 1622," a passage from the *Records of the Virginia Company of London, 1619 April 28-1624 June 7.* Eighteenth-century copy bears bookplate of John Randolph of Roanoke. Vol. 3, p. 170. Gift of William Leigh

In 1622, in part to retaliate for stolen land and crops, Indians executed a well-coordinated assault on English plantations along the James River. About 350 people were killed, a quarter of the English population. This "massacre" did not deter settlement. The governor was instructed to commence a "War of Extermination." "As for the Indians we condemn their Bodies the Saving of whose Souls we have so zealously affected[,] root them out from being any longer a people So cursed, a nation ungrateful to all benefits and uncapablle of all goodness...." How many Indians were killed in retaliation is not known. The settlers were more motivated to take land than take lives.

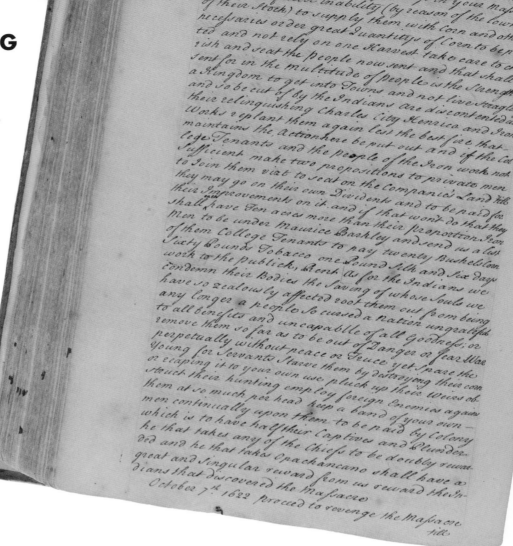

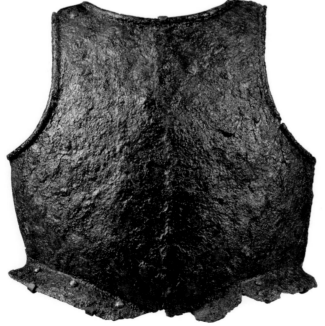

English Armor

Iron breastplate from the armory of the Tower of London; excavated at Jordan's Journey, Prince George County, Virginia, about 1623-35. On loan from the Virginia Department of Historic Resources

Following the 1622 Indian attack on the English settlers, King James I provided weaponry from the Tower of London and sent new settlers to help the colony "reclaim" lost ground. "His Majestie ... hath ... bestowed upon us div[e]rs[e] arms ... such as against the Indians may be very useful ... and ... 400 young men ... to repaire... the number that is lost," reported the Virginia Company.

1622–1763

A DISTANT DOMINION

The Indian uprising of 1622 was prompted by the strategy of the Virginia Company of London to abandon the search for gold and a passage to India, and to instead lure settlers with land ownership. Increasingly, the English settlement encroached upon tribal lands. To further increase the colony's settlement rate, the Company encouraged women to venture there. In 1619, when the cargo of a Portuguese slave ship was stolen by English vessels, Africans were carried to Virginia for the first time. In that same year, the first popularly elected legislative body in the New World was convened. Tobacco—grown initially by white indentured servants, then later in the century primarily by enslaved Africans—brought prosperity to Virginia.

Settlement spread beyond Jamestown. Beginning in 1642, Governor William Berkeley granted vast tracts of land to a small, elite group of dynastic families that would in effect rule Virginia throughout the colonial period. In the 1700s, this gentry built impressive mansion houses on their plantations, in an effort to project the colony as no longer a backwater outpost but rather a remote part of England.

In 1676, economic distress and Indian attacks prompted Nathaniel Bacon to lead landless, impoverished whites and some free blacks in the first American rebellion. They burned Jamestown before their effort failed. In the next decades the white gentry and black slavery became entrenched. By 1750, the gentry looked to expand westward. They viewed the Ohio Valley as part of the colony's grant from James I. The explorer Robert de La Salle, however, had laid claim to the same region in 1669–70 for the king of France. The two nations were on a collision course that would precipitate the French and Indian War. The distant dominion of Virginia had become increasingly difficult to govern from London. The American Revolution was but a decade away.

RECORDS OF ENGLISH SETTLEMENT

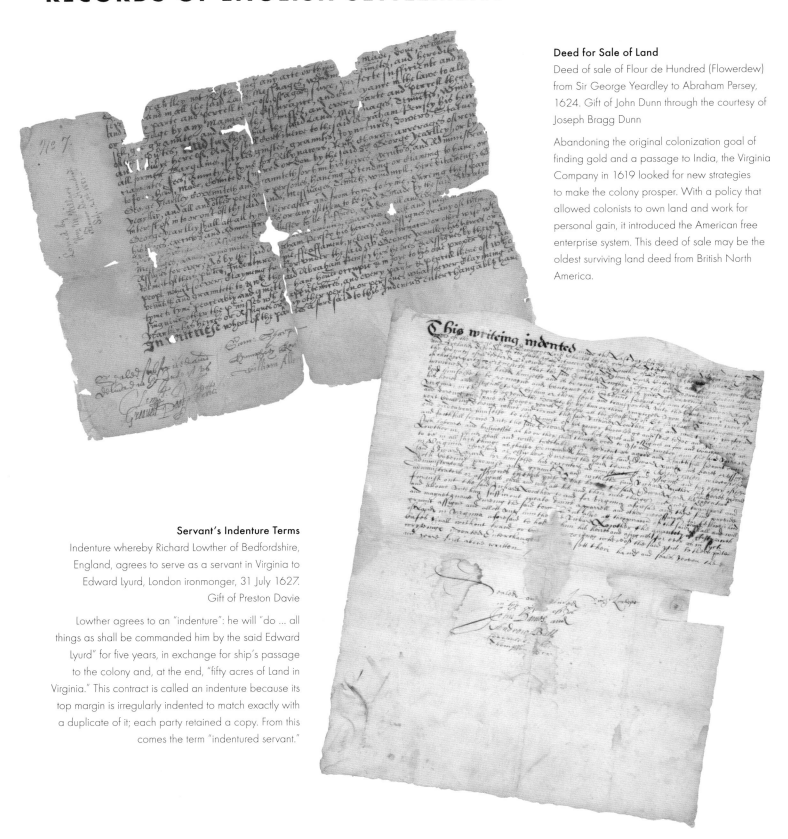

Deed for Sale of Land

Deed of sale of Flour de Hundred (Flowerdew) from Sir George Yeardley to Abraham Persey, 1624. Gift of John Dunn through the courtesy of Joseph Bragg Dunn

Abandoning the original colonization goal of finding gold and a passage to India, the Virginia Company in 1619 looked for new strategies to make the colony prosper. With a policy that allowed colonists to own land and work for personal gain, it introduced the American free enterprise system. This deed of sale may be the oldest surviving land deed from British North America.

Servant's Indenture Terms

Indenture whereby Richard Lowther of Bedfordshire, England, agrees to serve as a servant in Virginia to Edward Lyurd, London ironmonger, 31 July 1627. Gift of Preston Davie

Lowther agrees to an "indenture": he will "do ... all things as shall be commanded him by the said Edward Lyurd" for five years, in exchange for ship's passage to the colony and, at the end, "fifty acres of Land in Virginia." This contract is called an indenture because its top margin is irregularly indented to match exactly with a duplicate of it; each party retained a copy. From this comes the term "indentured servant."

Order Banishing Rogues

King of England and Wales James I, *The Order [Banishing Rogues to the New Found Lands]*, London, 1603. Bequest of Paul Mellon

Printed in London, this broadside—the earliest printed proclamation relating to Virginia—initiated a policy of transporting criminals to the colony that ended only with the American Revolution. The king sought to oust "incorrigible or dangerous Rogues" from the homeland to "places ... beyond the Seas." Virginia's reputation suffered accordingly, so that in 1697 the colony could be described in *The Present State of Virginia* as both the "best" and the "worst" country in the world.

Receipt for Importing a Felon

Customs collector (Upper James River District of Virginia), import certificate for female convicted felon Ann Reed, 6 September 1756

This certificate was issued to Christopher Stephenson of the ship the *Duke of Cumberland* as a receipt for paying the import duty for Ann Reed. She was considered "incorrigible or dangerous," but—whatever her crime—not so dangerous as to be awarded the death penalty that was given frequently in seventeenth- and eighteenth-century England. Women formed a minority of the convict immigrants who were sent to Virginia.

Record of a Trial for Witchcraft

Notice of Grace Sherwood's trial for witchcraft, 3–10 January 1706. Copied in 1832 by J. J. Burroughs from the now lost Princess Anne County records. Gift of Archibald Taylor (one of the first documents given to the Virginia Historical Society)

Grace Sherwood of Princess Anne County, Virginia, was accused by Luke Hill of bewitching his wife, Elizabeth, and causing her to miscarry. The court had her dunked—she floated as they thought a witch would. It had her "serched by ffive antient weamen who ... [found] two things like titts on her private parts of a Black coller [color]" that served to suckle demons. That was proof enough—Grace was clapped in irons and put in the "common Gaol." Virginia records of perceived witchcraft are scarce.

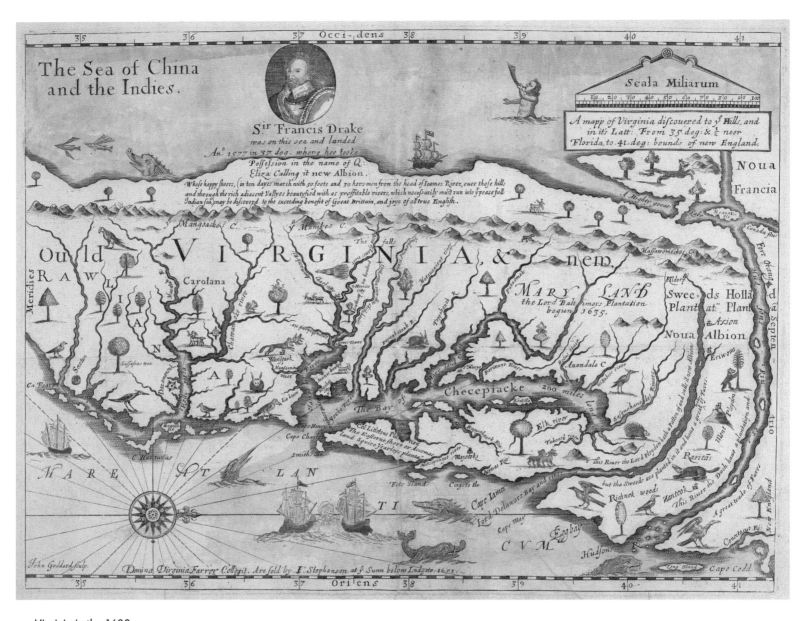

Virginia in the 1600s

Virginia Farrer, after a map by her father John Farrer, *A Mapp of Virginia Discouered to Ye Hills...*, [London], 1651. Gift of Henry C. Taylor

In the mid-seventeenth century, "Virginia"—labeled "Ould Virginia" to differentiate it from Maryland and "Noua Francia"—still encompassed nearly the entire American continent of the New World. Throughout the 1600s the extent of the continent remained unknown to explorers. Here (at the top), the Pacific Ocean appears just beyond the Appalachian Mountains, and a Northwest Passage (the waterway at the right) connects to "The Sea of China and the Indies." Pictured on the map is Sir Francis Drake, an English privateer who circumnavigated the globe and claimed for England what is now California.

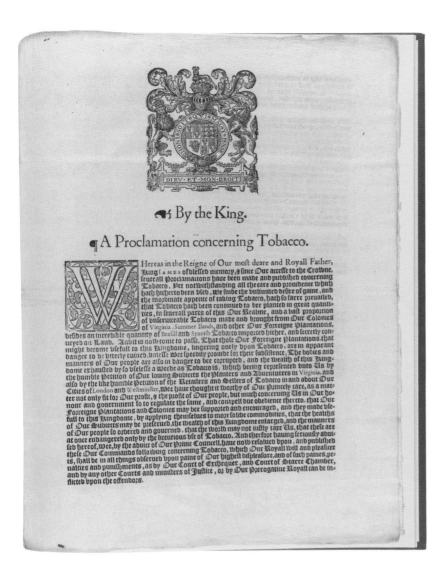

A Trade Monopoly

Charles I, *By the King: A Proclamation Concerning Tobacco*, London, 1630. Bequest of Paul Mellon

Charles I exercised the monarch's right to grant a trade monopoly in return for fees paid to the Crown. Virginians generally opposed such fees (taxes), but the benefits could outweigh that burden. Here, Charles forbids the growing of tobacco in the British Isles and restricts the importation of all tobacco except that grown in Virginia and certain Caribbean islands.

Marketing Tobacco

Tobacco label ("R. Mascall's Best Virginia"), late 17th or 18th century, woodcut

The high quality of tobacco that was grown in Virginia led English merchants to identify it, using labels that pictured black men, women, or children growing and harvesting tobacco, or packing it in barrels and smoking it. The figures tend to have African features yet Native American dress—hybridized characteristics that symbolize both the enslaved people who grew the tobacco and the American origin of the plant. This marketing imagery joined two stereotypes to form a figure that became a symbol of Virginia.

THE SLAVE TRADE

The CASE of the *Separate Traders to Africa.*

[The full-page reproduction of the 1709 document text is shown at left.]

Companies in the Slave Trade

The Case of the Separate Traders to Africa..., London, 1709. Bequest of Paul Mellon

Beginning in 1672, by patent from King Charles II (reigned 1660-85), the Royal African Company enjoyed a monopoly on English slave trading out of Guinea. Following complaints from the American colonies that the company did not supply "a sufficient Number of Negroes," the trade was opened to other companies in 1698. The "separate traders" argue in this document that since then the demand for an increased number of slaves has been met.

Tile from a Distant Land

Tile fragment, with depiction of a North African camel, after 1600. On loan from the Virginia Department of Historic Resources

Portuguese and English ships carried goods to the west coast of Africa where they were traded for captured people. On the second, or "middle," part of the journey, these ships crossed the Atlantic Ocean laden with their human cargo. This tile, excavated at Jordan's Journey in Prince George County, Virginia, is believed to have been manufactured in England or the Low Countries. It is evidence of the commerce between Europe, Africa, and America.

Pipe Decorated with an African Gazelle

Pipe fragment, 17th-18th century. On loan from the National Park Service, Colonial National Historical Park

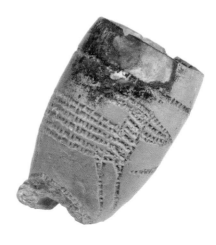

The depiction here of an animal never seen in America—the African gazelle—suggests that this pipe was made by a person of African origin, likely a slave. Until the 1670s, white indentured servants emigrated in abundance and formed 80 percent of the colony's workforce. By the 1690s, fewer whites were available, Bacon's Rebellion had frightened the gentry, and 80 percent of the laborers were enslaved Africans.

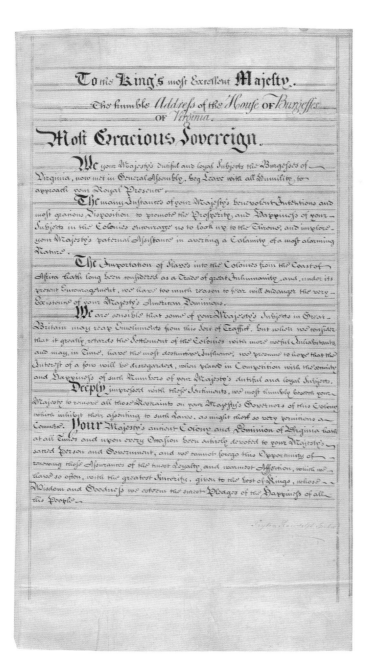

Petition to the King

Virginia House of Burgesses, petition to King George III, April 1772. Bequest of Paul Mellon

Economic motives underlie this seemingly altruistic request to curtail "a Trade of great Inhumanity." The burgesses feared that the king's imposition of high duties on slave imports was both reducing the Atlantic slave trade and driving up the price of tobacco. Ending the slave trade might be better: it would encourage the immigration of artisans and craftsmen and decrease the potential for slave insurrections. George III rejected the proposal—for which Thomas Jefferson criticized him in his draft of the Declaration of Independence.

Slavery in Virginia

Slave wrist shackles, 17th–18th century

The first enslaved people in British North America arrived at Point Comfort, Virginia, in 1619, shaping the subsequent history of the nation. Gradually, race-based slavery became entrenched in Virginia and throughout the American South, and would dramatically shape history for the next four centuries. Between 1619 and 1807, twelve-and-a-half million Africans were enslaved and transported from Africa to North and South America and the Caribbean, against their will and in chains—128,000 were brought to the Chesapeake Bay region.

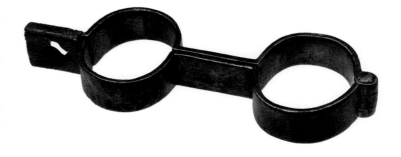

WARS AND REBELLION

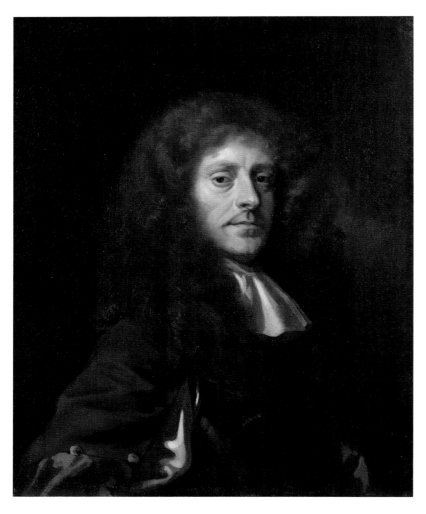

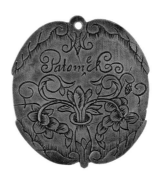

Passport Badges for Indians

Indian badges, about 1662, silver, engraved to chiefs of "Patomeck" and "Machotick". Gift of John Pratt; gift of Richard T. Pratt

Virginia's colonial government issued passport badges to control Indian entry into English territory. A 1662 act of the General Assembly ordered "that badges, silver [for chiefs] and copper, with the name of the [Indian] towne graved upon them, be given to all the adjacent tribes" and warned that "if any damage or injury be done" to the settlers by an Indian, his chief would "be answerable for it."

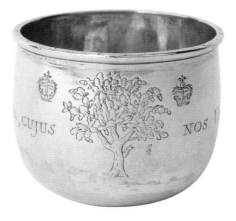

Unrest Brings a New Lieutenant Governor

Unidentified English artist, *Colonel Herbert Jeffreys*, before 1676, oil on canvas. Partial gift of J. Bradley Jeffreys; Purchased in part through the Paul Mellon Acquisition Fund

Jeffreys was sent to Virginia in 1676 with 1,000 royal troops to quell Bacon's Rebellion, which had been sparked by Indian unrest, economic decline, and conflict between Governor William Berkeley and Nathaniel Bacon, the self-appointed leader of campaigns against Indians whom the settlers considered hostile. By the time the troops arrived, Bacon was dead and the rebellion ended. When the governor returned to London to defend his conduct, Jeffreys assumed Berkeley's vacant post, as lieutenant governor, in which position he served until his death in 1678.

Support for the English Monarchy

Unidentified English maker, cup owned by the Temple family of King William County, about 1680–85, silver. Gift of Frances Roberdeau Wolfe

Following the beheading of King Charles I in 1649 during the English Civil War, the future Charles II at one time escaped Oliver Cromwell's men by hiding in an oak tree. Thus the meaning of the crown and tree depicted on this royalist's cup and the Latin inscription that translates, "Honored is the tree whose shade shelters us." When many of Virginia's elite opposed the revolution led by the Puritan Cromwell, the colony became a stronghold of royalists (called "Cavaliers") who championed the return of the English monarchy.

EMERGENCE OF THE GENTRY

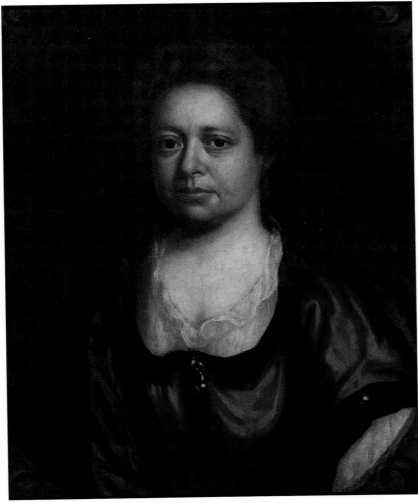

Portrait of a Lady

Unidentified artist, *Rebecca Eskridge,* about 1715, oil on canvas. Bequest of Peter C. Rust

The sober, concerned face of this sitter from Westmoreland County, Virginia, suggests that around 1700 Virginia's gentry class had yet to assume its later self-confidence, exuberance, even ostentation. Rebecca Eskridge and her husband, George, were newly wealthy and mindful of economic uncertainties. They had matured in a harsh world marked by civil unrest and sudden and often early death. The portraits of both Eskridges are evidence that a competent artist was active in Virginia's Northern Neck at an early date.

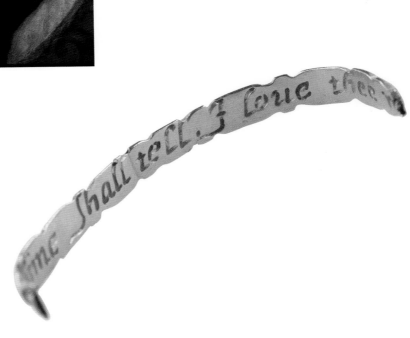

A Wedding Band's Message

Wedding band fragment, about 1650-75, gold, found in Poquoson, York County, probably made in England. On loan from the Virginia Department of Historic Resources

Women could easily find husbands in seventeenth-century Virginia because men outnumbered them three or four to one. The phenomenon of the "mail-order" bride quickly emerged, as English women were encouraged to venture to the colony. The inscription engraved here, "Time shall tell, I love thee w[ell]," is particularly poignant because of the high mortality rate in the early years of the colony; many couples never had "the time to tell" the truth about their marital commitment.

VIRGINIA FAMILIES

Randolph Family Portraits

No family in colonial Virginia was more prominent or more powerful than the Randolphs. The dynasty was founded by William Randolph I, who in 1680 established a plantation below the falls of the James River. During the next hundred years, generations of his heirs established eleven additional plantations of size and prominence, as they expanded the family's holdings to encompass tens of thousands of acres of land worked by hundreds of slaves. As major landowners, as well as merchants and shipowners, the Randolphs—unified like a business conglomerate of today—impacted economic affairs of the colony. They also influenced the administration of government. William Randolph III of Wilton (Charles City County, Virginia) commissioned ten paintings; his widow added three to the group. The Virginia Historical Society collection contains fifteen Randolph family portraits.

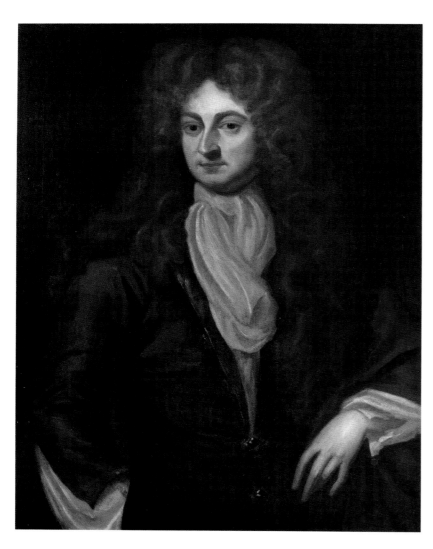

Unidentified artist, possibly in Virginia, *William Randolph I of Turkey Island*, about 1695, oil on canvas. Bequest of Kate Harris Williams

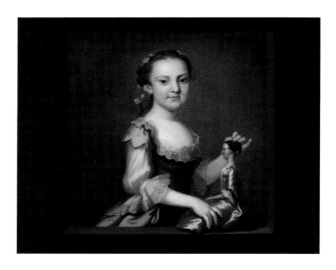

John Wollaston, *Elizabeth Randolph (later Mrs. Philip Ludwell Grymes)*, about 1755, oil on canvas. Bequest of Kate Harris Williams

Matthew Pratt, *Lucy Randolph Burwell*, 1773, oil on canvas. Bequest of Kate Harris Williams

Fitzhugh Family Portraits

The large and powerful Fitzhugh family emerged in Virginia's Stafford and King George counties at the end of the seventeenth century. The portrait and letterbook of dynasty founder William Fitzhugh project his conviction that a man's manner and dress must suggest aristocratic status in order for his extensive plantation operations to run with economic stability. In his famous letterbook (also in the Virginia Historical Society collection), he complains about the scarcity in the colony of "good ingenious company." The Fitzhugh portraits span five generations, beginning with colonial copies of an English forebear and of William Fitzhugh, and continuing with images from life taken from three eighteenth-century generations. All were painted by the American artist John Hesselius, who became virtually "court painter" to this Virginia family.

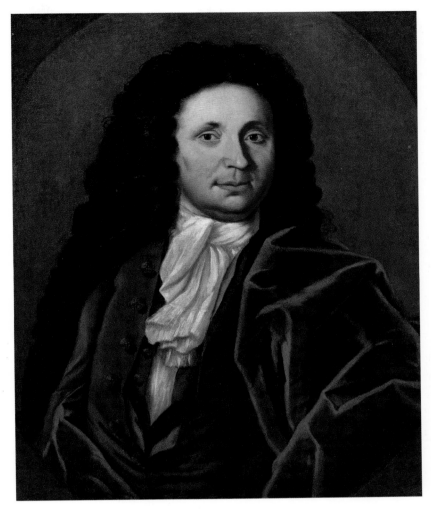

John Hesselius, after an unknown English artist, *William Fitzhugh*, 1751 (1698), oil on canvas. Bequest of Alice-Lee Thomas Stevenson

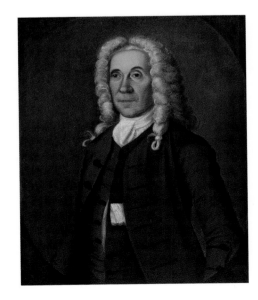

John Hesselius, *Captain Henry Fitzhugh*, 1751, oil on canvas. Bequest of Alice-Lee Thomas Stevenson

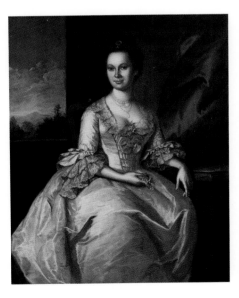

John Hesselius, *Elizabeth Fitzhugh of Fitzhughburg*, 1771, oil on canvas. On loan from Catherine Churchill Taylor

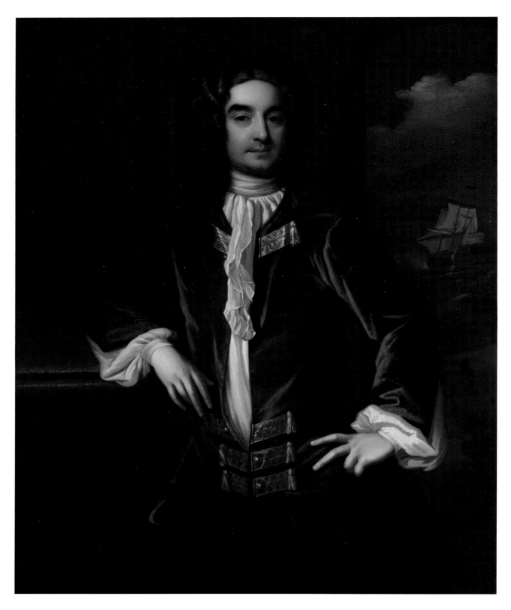

Attributed to Hans Hysing, *William Byrd II*, 1724, oil on canvas.
Gift of William Byrd of Princeton, New Jersey

The Westover Portrait Collection

The art collection of William Byrd II was unmatched in colonial America in quality and quantity. It included canvases by accomplished English masters and grew to total thirty portraits, eight of which are reunited in the Virginia Historical Society collection. Educated in England, Byrd developed refined tastes there and on the Continent. He became a member of London's elite social circles and the prestigious Royal Society. He collected eight treatises on painting and thirty on architecture, part of his sizable library of 4,000 volumes that he kept at Westover, his Charles City County, Virginia, estate, along with the portraits. The majority of these paintings were commissioned when he lived in London, between 1714 and 1726. Many of the sitters are London figures he either knew or wished to know.

Diary of William Byrd II, 1717–21.
Gift of Susan L. Taliaferro

Byrd kept his now-famous diary in a secret shorthand code, hiding routine matters as well as the most intimate details of his personal life. It was decoded in the twentieth century.

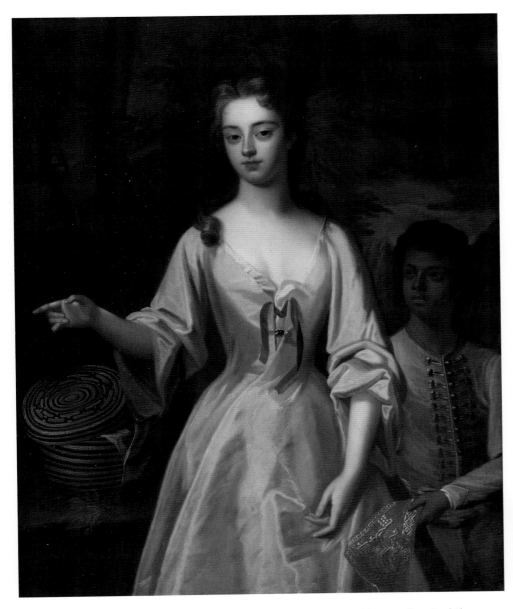

John Closterman, *Daniel Parke II*, about 1705, oil on canvas. Gift of Mr. and Mrs. D. Tennant Bryan

This portrait was one of the most spectacular paintings to hang in an American collection at an early date, probably 1706, the year Byrd married Daniel Parke's daughter Lucy. Parke had served in the Duke of Marlborough's forces at the Battle of Blenheim in the War of the Spanish Succession against the armies of Louis XIV of France, as remembered in the background here. His reward was the governorship of the Leeward Islands, where his misrule caused settlers there to brutally murder him.

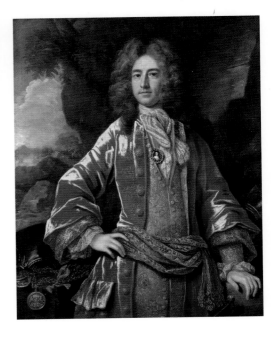

Unidentified London artist, in the style of Sir Godfrey Kneller, *Lucy Parke Byrd (Mrs. William Byrd II)*, about 1716, oil on canvas. Gift of Joan Bryan Gates

Accompanied by a slave who is exotically dressed and who awaits her commands, Lucy Byrd is presented as a young woman whose husband's wealth gave her whatever she wanted. The depiction of a slave reminds us of the source of Byrd's wealth, and the depiction of a basket reminds us of the goods she ordered from England. In his secret diary, Byrd mentioned her cruelty to their slaves; he also recorded the tempestuous yet loving relationship that he had with his first wife. She died of smallpox at the age of twenty-nine.

Art from the Westover Collection

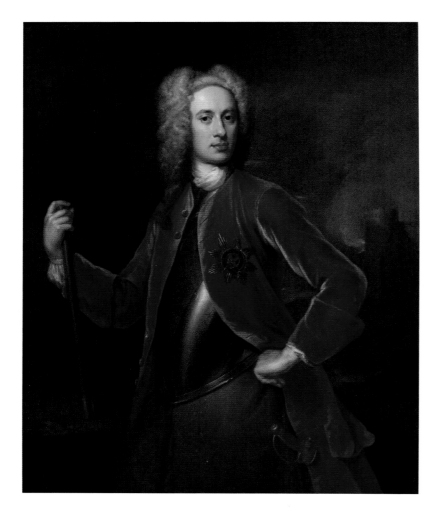

William Aikman, *John Campbell, 2nd Duke of Argyll and Duke of Greenwich*, about 1718–25, oil on canvas. Gift of the Battle Abbey Council

This striking portrait of a prominent military leader from Scotland, one of the most powerful figures at the court of George I, illustrates the high quality of the best of the Westover works and the elevated social standing that Byrd achieved in London. A member of Britain's most elite order of knighthood, Argyll here wears the star of the Garter. He was also a duke, a holder of the highest title in peerage. Argyll valued Byrd's friendship for three decades.

Unidentified London jewelry maker, watch owned by Wilhelmina Byrd, about 1720, gold and enamel. Gift of the heirs of Ellen M. Bagby

William Byrd II presented this exquisite object to his daughter Wilhelmina at the time of her marriage to Thomas Chamberlayne. Its image of courtship was appropriate for a wedding gift.

Unidentified London artist, fan owned by Evelyn Byrd, about 1720, ivory. On loan from Anne Byrd Keith

This fine object was William Byrd II's gift to his daughter Evelyn. A gardener, maiden, and gentleman in a formal garden with classical temple are depicted on one side, while the reverse pictures a woman and child approaching a family shrine in a rural setting. This imagery fits the pastoral ideal that Virginians of the gentry associated with the society that they were building.

The Page Family

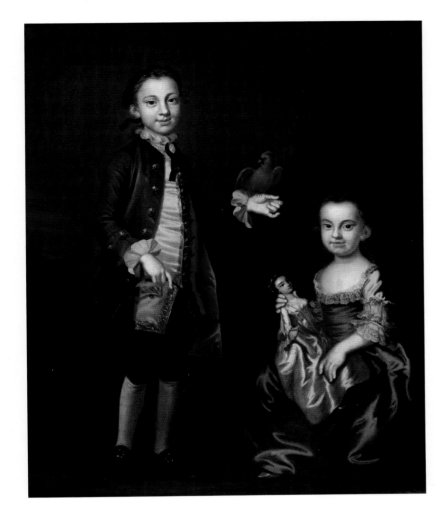

John Wollaston, *Mann and Elizabeth Page*, about 1755, oil on canvas. Bequest of Louise Anderson Patten

Beyond the formal attire and deportment of the sitters—appropriate for residents of the grandiose estate of Rosewell (near Williamsburg)—the artist is able to suggest the vulnerability of childhood. He delights the viewer with improbable props. Six-year-old Mann Page holds a wild cardinal, the exotic "Virginia red bird" that already was a symbol of the region. Four-year-old Elizabeth Page holds as a toy a fashion doll used by adults to transmit clothing styles.

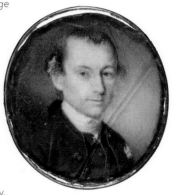

Charles Willson Peale, *John Page* (1743–1808), about 1725, miniature, watercolor on ivory. Gift of Mrs. William Maury Hill

Colonel John Page of Rosewell was a congressman and governor of Virginia, a Democrat who championed the political policies of Thomas Jefferson. Like the painter Charles Willson Peale, Page was the devoted father of a large family.

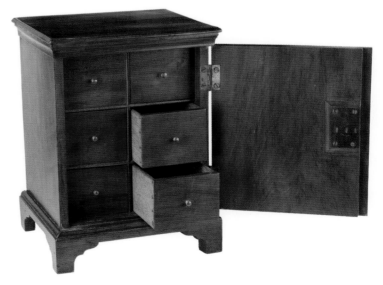

Unidentified maker of the Williamsburg school, spice cabinet, about 1760, cherry (top) with chestnut or mahogany, and white oak and yellow pine secondary. Bequest of Louise Anderson Patten

This carefully crafted small cabinet was a luxury item owned by the Page family, first at Rosewell and later at Mannsfield. Few families of this era owned such furniture or could own the exotic spices to put in it.

Grymes Family Portraits

The Grymes family was established in Middlesex County, Virginia, by the late 1600s. John Grymes II (b. 1691) served on the Governor's Council and married Lucy Ludwell whose prominent family put three generations on the council. The couple commissioned family portraits from Charles Bridges. Their son Philip continued the tradition with either Gustavus Hesselius or his son John. The Grymes portraits are evidence that children in Virginia were made to assume the genteel behavior of refined adults, and that portraiture proved to be a helpful device in that exercise, providing models of adult decorum to be copied. The seventeenth-century European perception of children as dangerous, evil animals (a viewpoint perpetuated in Puritan New England) had given way to a new appreciation of childhood as an enjoyable and important stage of development.

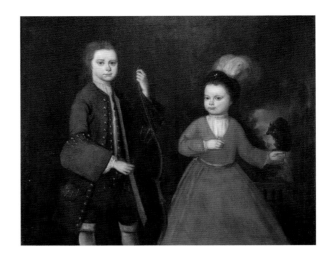

Attributed to Charles Bridges, *Benjamin and Ludwell Grymes (Sons of John and Lucy Grymes)*, about 1736, oil on canvas. Bequest of Charlotte B. Picot

Bridges, an English artist in Virginia, adapted the English tradition of placing figures before a backdrop of architecture and landscape. Here he added a hunting motif of bow and arrow from that tradition, as well as a regional element, the Virginia squirrel. More inventive was his decision to turn the canvas on its side—shifting the traditional vertical portrait format to a horizontal one. He manages to suggest a warm relationship between ten-year-old Benjamin and his younger brother Ludwell, still in skirts, and to give them mannerisms characteristic of their ages.

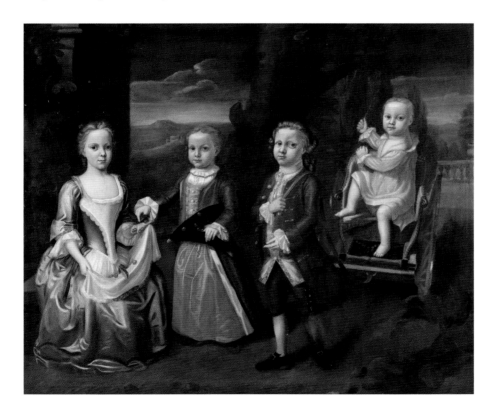

Gustavus Hesselius (or possibly John Hesselius), *The Grymes Children*, about 1751, oil on canvas. Bequest of Nora Crena Braxton Macon

This is one of the most appealing images to survive from colonial America. To group together children aged eight, four, five, and three (left to right), the artist turned his canvas on its side and devised an imaginary landscape. Some portraits done in England at this time are remarkably similar in the clothing and accessories given to children, including the extraordinary toy wagon that is pictured—a product of the new, permissive attitudes about childrearing. This painting suggests that high society in England and Virginia in fact shared similarities.

The Carter Family

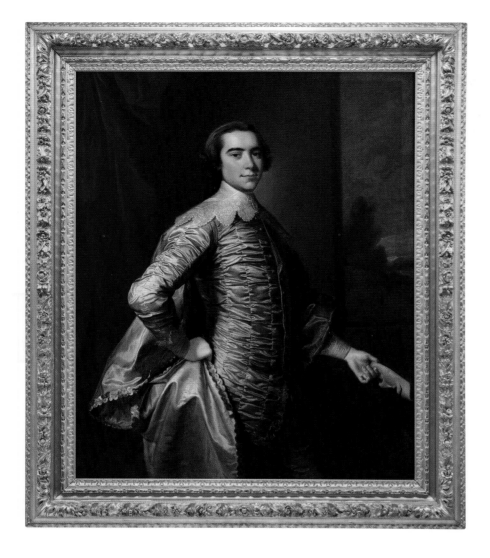

Thomas Hudson, *Robert Carter III*, 1753, oil on canvas. Bequest of Louise Anderson Patten

This grandson and namesake of powerful Robert "King" Carter was sent to the College of William and Mary for schooling and then to London to observe the ways of high society. The grandson commissioned this painting from London's best portraitist at mid-century. He is presented as a young dandy dressed for a masquerade ball in a van Dyck costume of a century earlier, the grand era of Charles I. Carter's facial expression is another mask, if we can believe his cousin John Page who said that London left Carter "illiterate ... corrupted and vicious." In the end, however, Carter matured from his youthful debauchery. He rejected Virginia's high society, turned to alternative religious sects, and freed the nearly 500 slaves he had inherited. This proved to be the largest emancipation in North America prior to the Civil War.

Robert "King" Carter, patent issued to Catesby Cocke for 142 acres in Prince William County, 8 September 1731. Bequest of Louise Anderson Patten

The Northern Neck proprietary was a five-million-acre tract of land between the Rappahannock and Potomac Rivers that had been granted by the future Charles II to a group of Loyalists and was inherited by Thomas, 6th Lord Fairfax. Robert "King" Carter became Virginia agent for Lord Fairfax, and, through sales and commissions of land, acquired thousands of acres that made him the richest man in the colony. Twenty years later, Lord Fairfax's cousin, William Fairfax, hired the young George Washington to survey proprietary lands in the Valley.

FURNITURE AND EVERYDAY OBJECTS

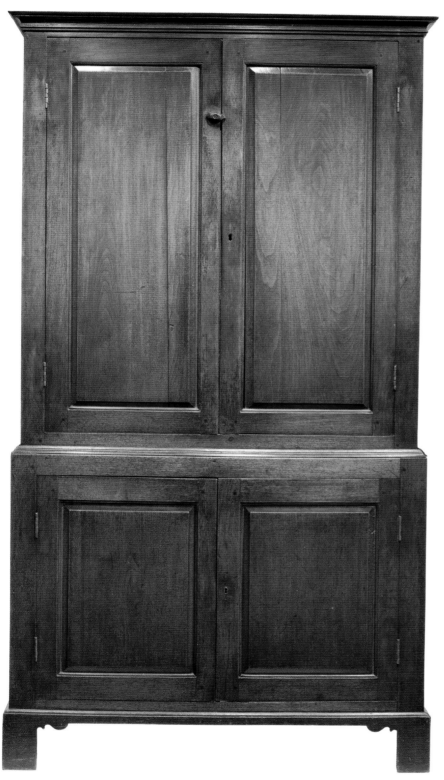

Unidentified maker in Tidewater Virginia (possibly Gloucester County), press or cupboard, after 1750, walnut primary. Bequest of Charlotte B. Coles

Panels of rich Caribbean walnut—arranged in a geometric array of rectangles placed in symmetry and carefully proportioned in relation to the whole—give beauty to this piece. The use of a single board to produce both the feet and base molding, and the addition of unnecessary pegs on the doors, are features generally not found in imported or cosmopolitan examples, suggesting a rural origin for this cupboard.

Alexander Johnston, London, sugar basket, about 1750, silver. Gift of Mrs. Marion Whiting Nelson

This luxury item—which few in the colony could afford—was owned by John Robinson (1705–1766), speaker of the House of Burgesses and treasurer of Virginia, one of the most powerful political figures in the colony.

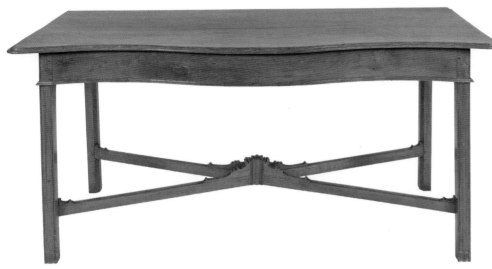

Unidentified maker in Fredericksburg or Alexandria, sideboard table, 1770-90, cherry primary with poplar secondary. Bequest of Charlotte B. Coles

Sideboard tables functioned as the principal serving furniture used in early Virginia. This monumental example is one of the most ambitious for the late colonial period. Related examples were owned by families living along the fall line between Fredericksburg and Alexandria.

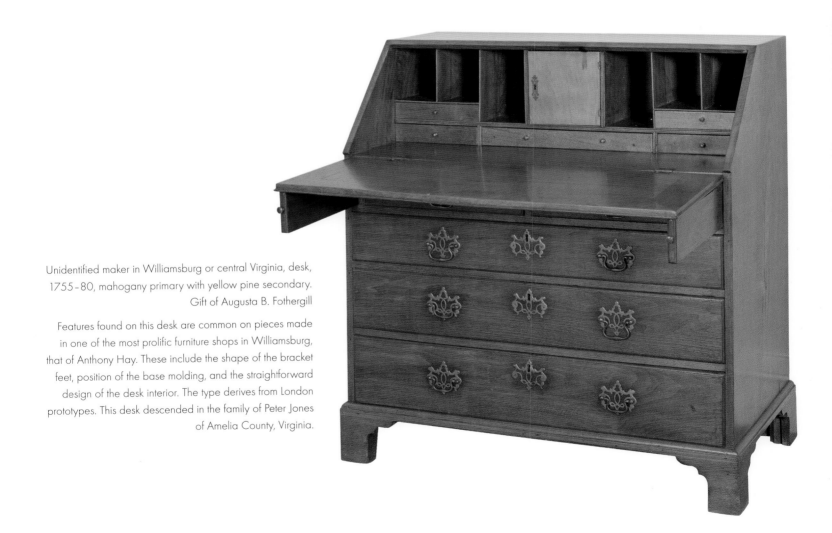

Unidentified maker in Williamsburg or central Virginia, desk, 1755-80, mahogany primary with yellow pine secondary. Gift of Augusta B. Fothergill

Features found on this desk are common on pieces made in one of the most prolific furniture shops in Williamsburg, that of Anthony Hay. These include the shape of the bracket feet, position of the base molding, and the straightforward design of the desk interior. The type derives from London prototypes. This desk descended in the family of Peter Jones of Amelia County, Virginia.

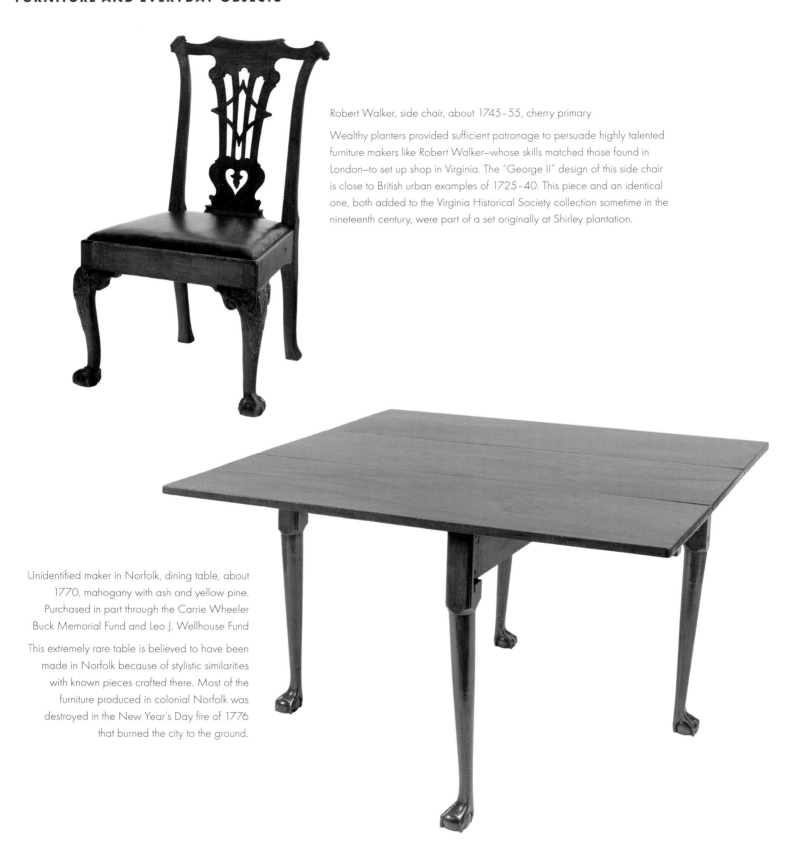

Robert Walker, side chair, about 1745–55, cherry primary

Wealthy planters provided sufficient patronage to persuade highly talented furniture makers like Robert Walker—whose skills matched those found in London—to set up shop in Virginia. The "George II" design of this side chair is close to British urban examples of 1725–40. This piece and an identical one, both added to the Virginia Historical Society collection sometime in the nineteenth century, were part of a set originally at Shirley plantation.

Unidentified maker in Norfolk, dining table, about 1770, mahogany with ash and yellow pine. Purchased in part through the Carrie Wheeler Buck Memorial Fund and Leo J. Wellhouse Fund

This extremely rare table is believed to have been made in Norfolk because of stylistic similarities with known pieces crafted there. Most of the furniture produced in colonial Norfolk was destroyed in the New Year's Day fire of 1776 that burned the city to the ground.

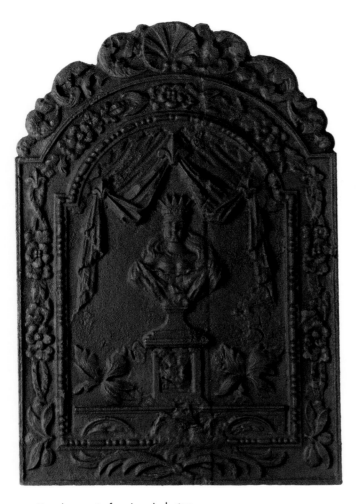

An Accurate Measure

Bushel measure, about 1734–35, cast brass, made in London and used in King William County, inscribed "King William County Bushell". Gift of William Aylett Hoge

In 1734 the General Assembly enacted uniform standards of measure to be followed throughout the colony, explaining that "the buying and selling by false weights and measures, is of late much practiced." Each county was ordered to procure from London accurate weights and measures that would serve as standards. They were inscribed "Winchester" in reference to the cathedral in which the official English dry and liquid measures were first stored.

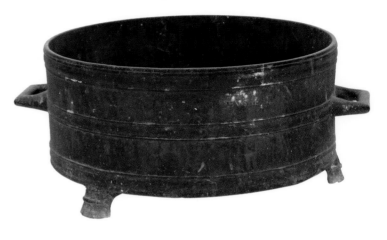

Development of an Iron Industry

Fireback, about 1730, cast iron, Orange County. Purchased with funds provided by Bruce Gottwald, E. Claiborne Robins, Jr., Paul Mellon, D. Tennant Bryan, Henry Stern, Thomas Towers, and Mrs. E. Schneider

Excavated from the site of Alexander Spotswood's estate, this fireback was almost certainly the product of Spotswood's own ironworks at Germanna. He staffed the operation with Germans imported for their mining and manufacturing skills. Around 1730, when this object was made, Germanna was by far the most westerly settlement in Virginia. The crowned Indian princess depicted on the fireback derived from one of Virginia's colonial seals—imagery well known to the former governor.

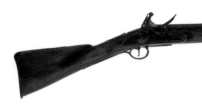

Arming the Colony

Long fowler, about 1750. On loan from Charles Granville Scott and conserved with gifts from Woodson descendants

According to family tradition, this gun—remembered as the "Woodson musket"— was used by Sara Woodson to defend her Prince George County, Virginia, home in 1644 from Indian attack. However, only the barrel dates to the seventeenth century—its hardware dates to about 1750. It is a fowling piece for shooting birds.

THE FRENCH AND INDIAN WAR

The French Claim to the Ohio Valley

Céloron plate, 1749, lead. Gift of James M. Laidley

This remarkable object is one of the first added to the Virginia Historical Society collection. During the early colonial period, both France and Britain claimed ownership of the Ohio Valley. In 1749, Captain Pierre Joseph Céloron de Blainville asserted France's claim to the region by placing this lead plaque and as many as six others along tributaries of the Ohio River. This was a traditional manner of marking territory. Only this plate survived intact. Its inscription is in French.

George Washington Confronts the French

"Map of the Western parts of the Colony of Virginia as far as the Mississippi," from The Journal of Major George Washington, London, 1754

Fearful of losing the Ohio Valley to the king of France, Governor Robert Dinwiddie sent twenty-one-year-old George Washington to deliver a demand to the French to retreat. Washington kept a journal during this mission that was widely published.

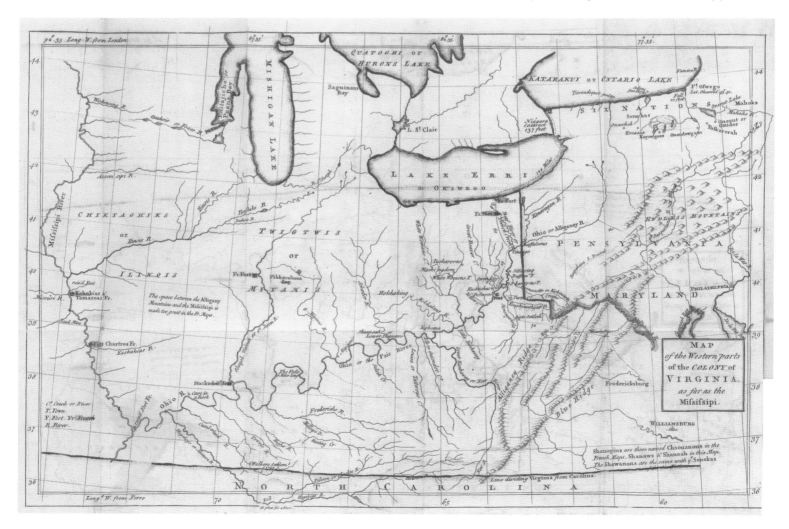

George Washington Starts a War

George Washington to Robert Dinwiddie, letter, 29 May 1754.
Gift of William Wilson Corcoran

Anticipating an imminent French incursion into the Ohio Valley, Dinwiddie sent a force to the region and directed its commander, George Washington, to "kill & destroy" any who interrupted "our settlements." The Virginia unit attacked a French party and killed its commanding officer, Monsieur de Jumonville. On the fifth page of this letter Washington acknowledges the "engagement." He had inadvertently, perhaps recklessly, initiated the Seven Years' War between France and Britain.

The Governor Approves George Washington's Decision to Attack

Letterbooks of Lieutenant Governor Robert Dinwiddie, Vols. 2 & 3, 15 March 1754–12 September 1757. Vol. 2, p. 11. Gift of William Wilson Corcoran

Governor Robert Dinwiddie's letterbooks retain copies of his correspondence. He wrote to George Washington approving the actions that killed Jumonville, concluding, "I heartily congratulate You." Following the defeat at Monongahela, Dinwiddie recognized Washington's "Loyalty Courage & good Conduct" there and awarded him a commission (12 August 1755) as commander-in-chief of Virginia forces that suddenly faced a desperate situation.

SURVEYING THE BACKCOUNTRY

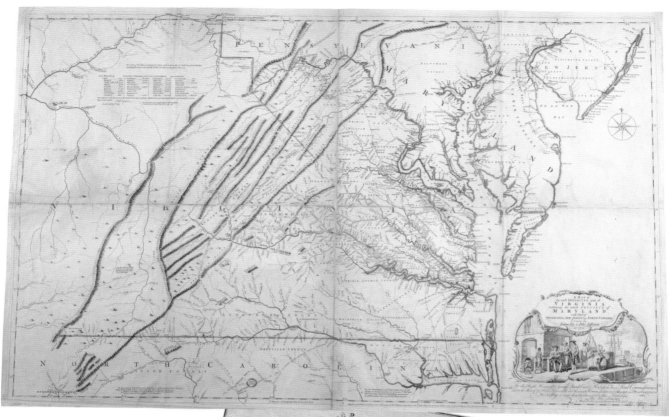

Virginia Settlements and the Lands Beyond

Joshua Fry and Peter Jefferson, *A Map of the Most Inhabited Part of Virginia ... 1751*, London, 1755. Bequest of Paul Mellon

In 1750—a century after the Farrer map (p. 28)—Virginians still knew little about the west. The Tidewater was densely settled, the near backcountry was under development, and Virginia land companies were pushing beyond the Allegheny Mountains to a region claimed by both the English and the French. To facilitate the British claim, Governor Dinwiddie sent George Washington to reconnoiter the Ohio Valley, and the Board of Trade and Plantations in London requested this map of all of Virginia. Peter Jefferson, one of its makers, was the talented father of Thomas Jefferson.

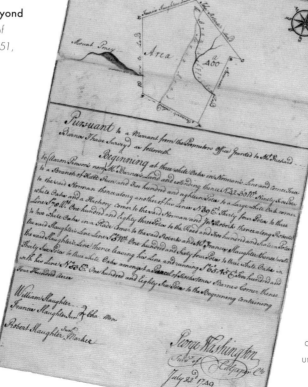

George Washington in the Shenandoah Valley

George Washington, land survey, taken in Culpeper County, 22 July 1749. Gift of Alice Hanauer Strauss in memory of Admiral Lewis Lichtenstein Strauss

Washington, the soldier and president, was first a surveyor who recorded tracts of land claimed as the backcountry was settled. The work provided him income and an opportunity to explore lands available at bargain prices. He would become a landowner in the Shenandoah Valley, and initially be elected to the House of Burgesses from there. As a soldier, Washington would draw upon his surveyor's understanding of maps to inform military strategy.

END OF THE COLONIAL PERIOD

George Washington Turns to Farming

M. Duhamel du Monceau, *A Practical Treatise of Husbandry*, London, 1762

Although George Washington had served with distinction during the French and Indian War, he decided at its end to retire from the military and pursue the life of a planter. This volume provides convincing evidence of how seriously he studied farming. He made marginal notes on pages that record the Frenchman Monceau's methods of planting wheat. This was a key grain crop that Washington would have to cultivate successfully if he was to be liberated from the production of tobacco, which was his objective. The price of tobacco—controlled by the market in England and by actions of the Crown—fluctuated unpredictably.

Virginia Planters Sink into Debt

Perkins, Buchanan & Brown, letter to Thomas Jefferson, 2 October 1769. Gift of Thomas James Massie

Initially, planters sold tobacco to English merchants and received payment immediately. But when tobacco prices fell in the 1680s, planters evaded an unstable market by consigning their tobacco with commission agents. Here, a century later, a London mercantile firm asks Thomas Jefferson to ship his tobacco to them, they will sell it for a price "at least equal" to that of any tobacco sent from Virginia, and they promise "utmost concern in the purchase of any Goods." If prices did not rise, Jefferson would sink deeper into debt.

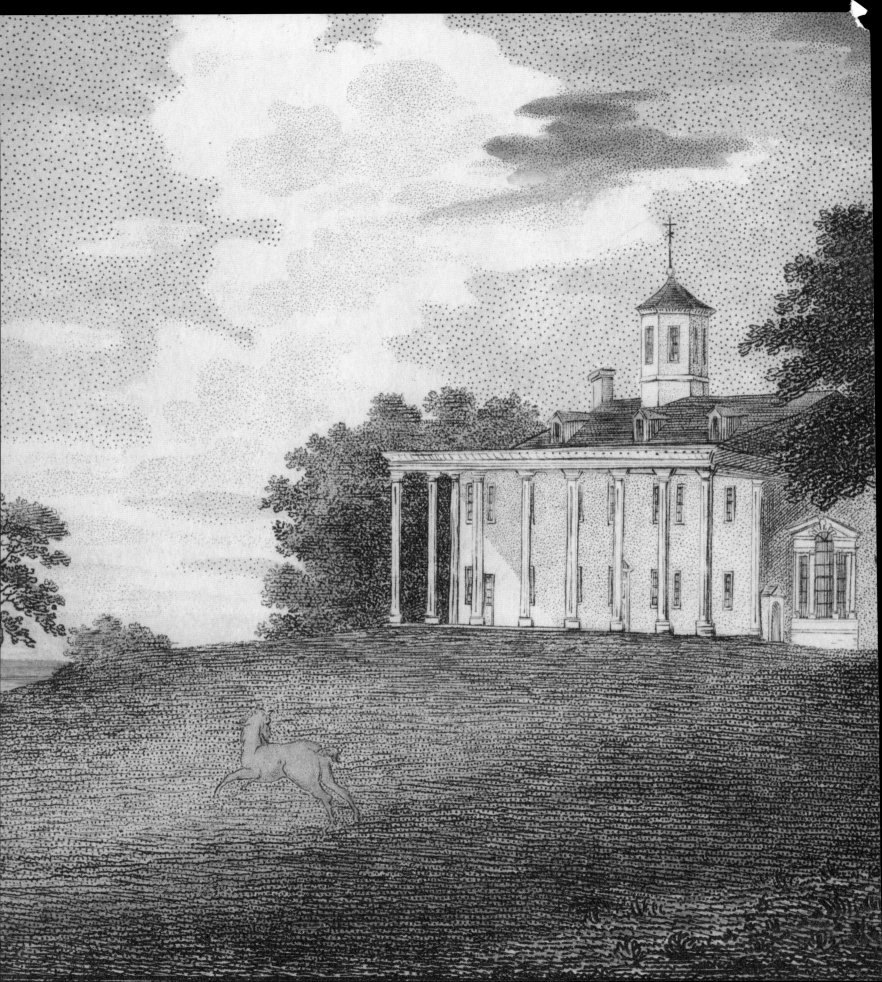

1763–1825

FROM BRITISH COLONY TO AMERICAN STATE

British taxation—introduced at the close of the French and Indian War to pay for war debts and a British military presence in America—was unexpected by the Virginia gentry and resented. Those Americans began to view British policy as an affront to their liberty. Their leaders included Peyton Randolph, George Washington, Patrick Henry, George Mason, Thomas Jefferson, James Madison, John Marshall, and James Monroe. They played leading roles in the Continental Congresses that debated independence, in the fighting of the American Revolution, and in the conception and implementation of a new government. They introduced principles of human rights that underlie the government of the United States and that to this day define America—government serves the people; the powers of government must be separate, as must church and state; all men are created equal with unalienable rights that include the rights to vote, to enjoy freedom of speech, to bear arms, and to be awarded trial by jury. Virginia provided four of the new nation's first five presidents and a chief justice who defined the power of the Supreme Court. Although Virginia's early leaders advocated equality, did not extend it to women, Native Americans, and African Americans. Not listening to those neglected, they concluded that their generation had in fact accomplished a great deal—but could not correct every injustice. Jefferson and Madison wrote of their anguish over slavery (Madison used the word "despair"); they conceded that the dilemma would have to be resolved by a later generation. Washington was alone in freeing some of his slaves after his death.

51

CHOOSING SIDES

Loyalist

Robert Edge Pine, *Ralph Wormeley V*, 1763, oil on canvas. Gift of the estate of John Chauncey Williams

Some planters—like Ralph Wormeley—remained firmly Loyalist. Also called at the time Tories or Royalists, Loyalists were those who opposed revolution and remained loyal to the British crown. They numbered at least 20 percent of the population of the American colonies.

Ralph Wormeley V was sent to England for his education. He entered Eton at age twelve and at eighteen completed his studies at Trinity Hall, Cambridge, depicted in the background of this graduation portrait. He became a prominent Virginia politician. In the 1770s he said he bore "the accursed tyranny of rebellion with impatient mortification." Consequently, revolutionary authorities arrested him and confined him to family land in faraway Berkeley County (now West Virginia).

Support for the American Cause

Matthew Pratt, *Mary Jemima Balfour*, about 1772, oil on canvas. Matthew Pratt, *James Balfour and his Son George*, about 1772, oil on canvas. Bequest of Emma Collier Akin

Born in England, James Balfour had served in Virginia since 1741 as a merchant for a London mercantile house while also engaged as a planter. As early as 1770 Balfour openly supported the American cause. Thus it was fitting that both he and his wife were depicted here as proud of their accomplishment in America, active yet sensitive, different from the entitled and idle landed gentry in England who were rarely depicted in portraiture as active at their desk, engaged with their children, or even reading.

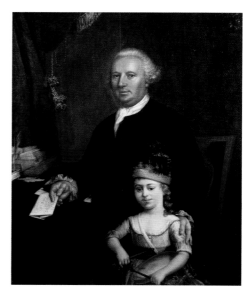

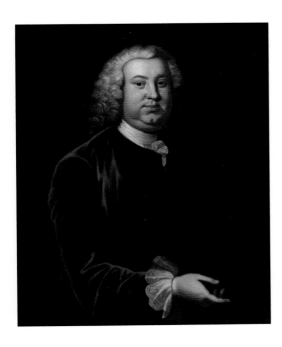

"Father of the Country"

John Wollaston, *Peyton Randolph* (about 1721–1775), about 1755, oil on canvas

Randolph served as a very popular attorney general and speaker of the Virginia House of Burgesses before he was elected president of the Continental Congress. There he "preside[d] with [such] dignity" (wrote Connecticut delegate Silas Deane) that he seemed "designed by nature for the business." He won the support of America's founding fathers and (prior to George Washington's ascendancy) was lauded in Williamsburg as "the Father of [the] Country."

The Most Popular Patriot

Charles Willson Peale, *Henry Tazewell* (1753–1799), 1775, oil on canvas. Gift of Virginia Stuart Waller Davis

Tazewell was never defeated in an election, and historians say he may have been the most popular Virginian of his era. Born in Brunswick County, Virginia, he served as a burgess, then as a delegate to the Virginia constitutional conventions of 1775 and 1776, and was a cavalry captain during the Revolution. He then was elected to the Virginia General Assembly, became chief justice of the state's General Court, and president pro tempore of the United States Senate.

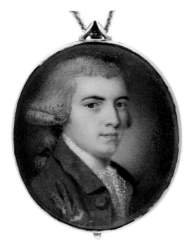

Serving in Government

Unidentified artist, *Benjamin Harrison of Berkeley* (1726–1791), 1750s?, miniature, watercolor on ivory. Gift of Merritt Harrison Taylor, Jr.

Throughout the revolutionary years, Harrison was among the most active political figures in Virginia, serving on a half-dozen committees and signing the Declaration of Independence. He helped establish the State, War, and Navy departments. After the war, he was elected to the Virginia House of Delegates and to serve as governor. At the Virginia constitutional convention of 1788 he opposed approving the Constitution if it did not have a Bill of Rights.

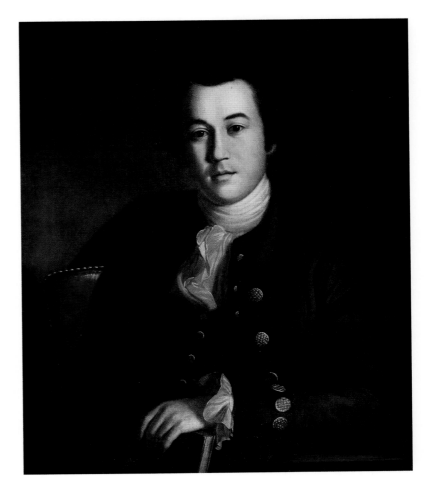

REJECTION OF TAXATION

The Infamous Tax on Paper
"Stamp Act" stamp, 1765. Gift of the Historical Society of Pennsylvania

To help defray the cost of defending the American frontier, the English Parliament in 1765 required that all official documents, newspapers, almanacs, and pamphlets in America be taxed. These papers were "stamped" when payment was made. The impressed stamp displayed here has been cut out of a vellum land deed into which it was embossed.

Celebration of the Repeal
Unidentified London silversmith, "Stamp Act" spoon, 1766, commissioned by Landon Carter of Richmond County. Gift of Elizabeth Carter Hollerith and John Wellford Guest in memory of their mother, Carol Randolph Wellford Guest

In response to the Stamp Act, some colonists chose to boycott British goods, because without representation in Parliament they had no voice in the decision. Landon Carter directed his London merchant to send him tablespoons. If the Stamp Act was repealed, send them in silver, if not, lowly horn or bone. The spoons are each inscribed "1766 Repeal of the American Stamp Act."

George Washington Joins the Protestors
George Washington to Bryan Fairfax, letter, 20 July 1774. Gift of William Wilson Corcoran

Like his neighbor Landon Carter, George Washington was unwilling to submit to what he considered unfair taxation. In letters to the Fairfax family he became a spokesman against British usurpation of colonial rights. Here he writes, "Parliament of Great Britain hath no more Right to put their hands into my Pocket than I have to put my hands into yours, for money."

REJECTION OF TAXATION

"Sentinel for the People"

Thomas Sully, *Patrick Henry*, 1851, oil on canvas. Gift of Thomas Sully

Self-described as "a sentinel" for the people, Patrick Henry propelled the movement toward American independence. The outrage of Virginia planters—whose standard of living was impacted by taxes and the price of tobacco—found expression in his speeches. In his "Virginia Resolves to the Stamp Act," he argued before the burgesses that the colony had legislative independence and "the exclusive Right & Power to lay Taxes." Henry's radical measures passed because of what Thomas Jefferson called their author's "sublime eloquence."

Patrick Henry's Theatrics

Eyeglasses owned by Patrick Henry, about 1760-99. Gift of John A. Lancaster

After interviewing contemporaries who had heard Patrick Henry speak and had watched him entrance his audiences, one historian noted that, "If his remarks were to be brief, his spectacles remained on his nose. But if he ever was seen to give his spectacles a cant to the top of his wig, it was a declaration of war, and his adversaries must stand clear." These spectacles—included in this portrait—played a role in Patrick Henry's oratorical theatrics.

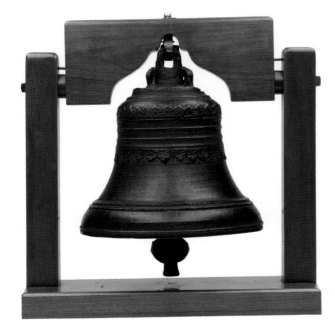

A Second Liberty Bell

Bell from St. John's Church, Richmond. Gift of Mrs. Charles Benjamin Bryant

St. John's was the site of Patrick Henry's 1775 "liberty or death" speech. He argued that only colonial assemblies can make laws for the colonies and urged Virginians to prepare for war with England rather than endure "chains and slavery." His rallying cry, "Give me liberty or give me death!," has been repeated for centuries by oppressed people around the world. Ironically, despite Henry's revolutionary calls for liberty from tyranny and his subsequent advocacy of abolition, he never freed his own slaves.

TOWARDS INDEPENDENCE

Champion of Human Rights

Louis Mathieu Didier Guillaume, *George Mason,* 1858, oil on canvas (copy of a lost 1750 portrait by John Hesselius). Gift of Thomas T. Giles

Mason is remembered as a champion of human rights. After serving as a burgess, he withdrew behind the scenes to draft such important documents as the Nonimportation Resolutions, the Fairfax Resolves, Virginia's first constitution and the Virginia Declaration of Rights. The Declaration of Independence and the Bill of Rights of the Constitution are rooted in Mason's Virginia Declaration. Mason eloquently denounced slavery, but—like many of his contemporaries—he remained a slaveholder himself.

Foundation of the American Dream

George Mason, *A Declaration of Rights made by the representatives of the good people of Virginia, assembled in full and free Convention...* [Williamsburg, Va., 1776]

This extremely rare printed copy of the Virginia Declaration apparently dates to 1776. The Declaration proclaims that human rights must be the "foundation of government," that government must serve the people, and that legislative and executive powers must be separate from the judiciary. It is filled with ideas and phrases that later became well known through Thomas Jefferson's Declaration of Independence and James Madison's Bill of Rights added to the Constitution.

Philadelphia June 19ᵗʰ 1775

Dear Jack,

I have been called upon by the unanimous voice of the Colonies to take the command of the Continental army — It is an honour I neither sought after, or was by any means fond of accepting, from a consciousness of my own inexperience, and inability to discharge the duties of so important a Trust — However, as the partiality of the Congress have placed me in this distinguished point of view, I can make them no other return but what will flow from close attention, and an upright Intention. — for the rest I can say nothing — my great concern upon this occasion, is, the thoughts of leaving your mother under the uneasiness which I know this affair will throw her into; I therefore hope, expect, & indeed have no doubt, of your using every means in your power to keep up her spirits, by doing every thing in your power, to promote

Mss1L5114e2

George Washington Accepts Command

George Washington to John Parke Custis, letter, 19 June 1775. Gift of Mrs. A. Smith Bowman, Jr., and Robert E. Lee IV

This letter to George Washington's stepson announces his decision to accept command of the American forces. Washington claims that he did not seek the position, yet he wore a military uniform to the Second Constitutional Convention to assure that he would be chosen. He asks his stepson to look after his mother and "promote her quiet." A day earlier he had mailed his wife his newly written will.

REVOLUTIONARY TIMES

George Washington, Commander-in-Chief

A Satisfactory Image
James Peale,
after or with Charles
Willson Peale,
George Washington,
after 1787,
oil on canvas.
Gift of R. B. Kennon

Charles Willson Peale
wrote Washington
in 1787 that the
general's friends
wanted a satisfactory
image of him. James
Peale worked at
his brother's side
during the sitting that
resulted, a sitting
which likely served
as the basis for this
portrait. It emphasizes
Washington's rock-
solid endurance. He
is still strong despite
eight tiring years
of war, his concern
about the future of
the former colonies,
and his ambivalence
about returning to
public life.

Mount Vernon, *Virginia, the Seat of the late* Gen.¹ G. Washington.

Drawn Engraved & Published by W.Birch Springland near Bristol Pennsylv.ᵃ

Sustained by Mount Vernon

William Russell Birch, "Mount Vernon," from *The Country Seats of the United States of North America* ..., Springland near Bristol, Pennsylvania, 1808 [i.e. 1809], copperplate engraving with hand coloring. Bequest of Paul Mellon

George Washington's hands-on supervision of the renovations to Mount Vernon began in 1773 and continued during the Revolutionary War, while he was in the field. He stated that the improvement of Mount Vernon was what sustained him during the war years. He was fighting to protect his home and the life that he had built there, as well as to secure the political freedom of the colonies.

Letters Home

George Washington to John Parke Custis, letters, 1776–80. Gift of Mrs. A. Smith Bowman, Jr., and Robert E. Lee IV

This collection of sixteen of General Washington's letters to his stepson from the field provide first-hand accounts of the condition of the army and the dangers that he faced. He writes such comments as, "We have a powerful Fleet in full view of Us—at the Watering place of Staten Island—general Howe and his Army are Landed thereon.... [When he attacks the city of New York] there will be some pretty warm Work."

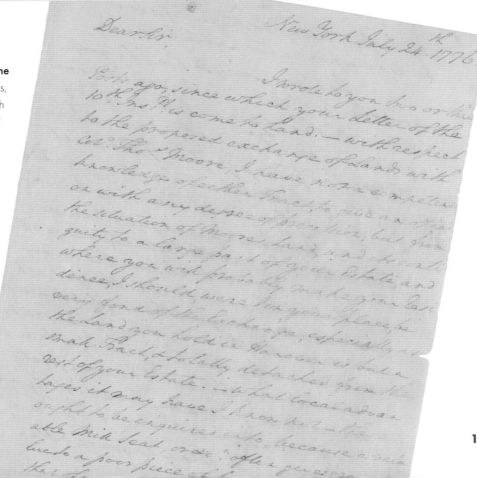

Soldiers and Statesmen

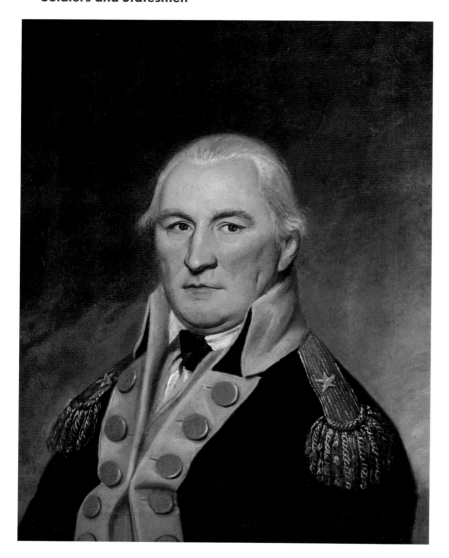

The "Virginia Giant"

Unidentified artist, *Peter Francisco*, about 1800, miniature, watercolor on ivory. Gift of Martha Dunlop Spotswood

Known as the "Virginia Giant," fifteen-year-old Francisco stood 6½ feet tall and weighed 260 pounds when he enlisted in the 10th Virginia Infantry. He fought in the New York and New Jersey campaigns of 1777–79 and was twice wounded. After reenlisting, he was wounded at Camden, South Carolina. After returning home, his clash with as many as eleven British cavalry raiders in Buckingham County, Virginia, became legendary because he reputedly escaped the encounter with their horses.

Brilliant Tactician

Charles Willson Peale, *Daniel Morgan*, 1780s or 1790s, oil on canvas. Gift of Percy Robert Blythe

Captain of a Virginia rifle company, Morgan was a gifted battlefield tactician who employed guerrilla tactics learned from Indians. During the Revolutionary War, his efficient marksmen saw action throughout the northern campaigns, and in the South they won one of the most decisive victories of the war at Cowpens, South Carolina, where Morgan tricked and captured most of a British army of light infantry.

"Largest Man in the State"

Charles Willson Peale, *Colonel James Innes*, about 1790, miniature, watercolor on ivory. Gift of Innes Harris Moulton in honor of her granddaughter, Kathryn Innes Moulton Ericson

Innes was described as possibly "the largest man in the State. He could not ride an ordinary horse, or sit in a common chair.... The vastness of his stature is said to have imparted dignity to his manner." Innes fought in several campaigns of the Revolution, then served in the Virginia House of Delegates. In 1786 he defeated John Marshall to become the state's attorney general.

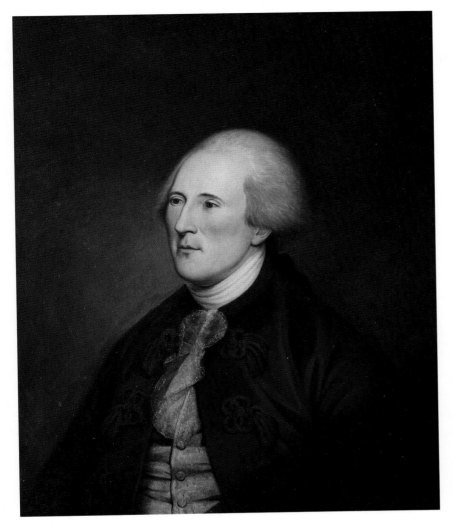

The Lee Family

Charles Willson Peale, *Arthur Lee*, about 1780–90, oil on canvas. Gift of Charles Carter Lee

Four Lee brothers born in Westmoreland County, Virginia, at Stratford Hall—Richard Henry, Francis Lightfoot, William, and Arthur—played prominent roles as patriots during the Revolutionary era. Arthur Lee served in 1775 as the London correspondent of the Continental Congress and in 1776 as a commissioner to negotiate a treaty with France. In the end, the Lee brothers offended many of their fellow patriots by becoming too prominent, powerful, and arrogant.

Paying for the War

Twenty shilling plate, 6 May 1776, brass and copper. Gift of Dr. Daniel Norborne Norton

Virginia's Revolutionary War money in twenty shilling denominations (one pound) was printed from this plate. The war was financed through loans from European nations, but the difficulties of determining how much money to print and how to address the resulting debt became a problem that the new American nation would have to address.

Patrick Henry the Soldier

Dragoon sword, one of 2,000 ordered from France in 1777 by Governor Patrick Henry

Patrick Henry was one of Virginia's wartime leaders. In April 1775, he led the militia of Hanover County, Virginia, to Williamsburg to demand from the royal governor the return of stolen gunpowder that had been stored for the public defense. He briefly commanded all of the colony's forces. He served as Virginia's first post-colonial governor, from 1776 to 1779. This sword's blade is engraved "Dragoon of Virginia" and "Victory or Death."

The French Connection

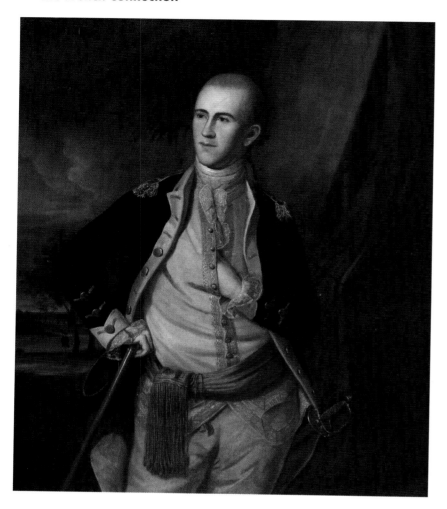

Lafayette at the Start of His Career

Charles Willson Peale, *Lafayette*, 1777,
oil on canvas. Gift of Thomas Harding Ellis

This first portrait to enter the collection depicts the young French nobleman the Marquis de Lafayette at age twenty, newly arrived in Philadelphia, where the Continental Congress awarded him the rank of major-general. He had inherited wealth and title, but he admired the republican ideals of the colonists. Lafayette befriended George Washington, fought in Pennsylvania, helped persuade the French king to support the American cause, and conducted the first stages of the campaign in Virginia that brought victory at Yorktown.

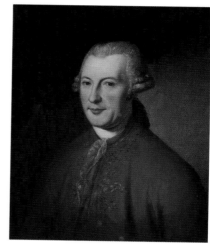

A Diplomatic Ally

Charles Willson Peale, *Conrad-Alexandre Gérard*, about 1779, oil on canvas. Gift of Mrs. John A. Chevallie

In 1778 Gérard was named France's minister plenipotentiary to the United States. Invested with the power to take independent action, the diplomat assessed the character and capabilities of George Washington to determine whether the American cause was worthy of French support. He then involved himself in the financing and provisioning of the American forces, in maintaining peace with Spain, the Province of Quebec (now Canada), and the Indians, and in promoting Franco-American harmony.

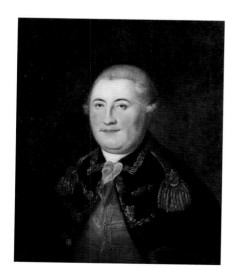

Honored Member of America's Society of the Cincinnati

Charles Willson Peale, *Anne César, Chevalier de la Luzerne*, about 1780, oil on canvas. Gift of Mrs. John A. Chevallie

After a career in the military, la Luzerne became a diplomat. He was appointed minister to the United States in 1779 to replace an ailing Conrad-Alexandre Gérard. Like his predecessor, he devoted himself to financing and provisioning the American army, and he left, in 1783, an honored and respected figure. He was made a member of the Society of the Cincinnati, the social order founded to preserve the ideals and fellowship of officers of the Continental Army who had served in the Revolutionary War.

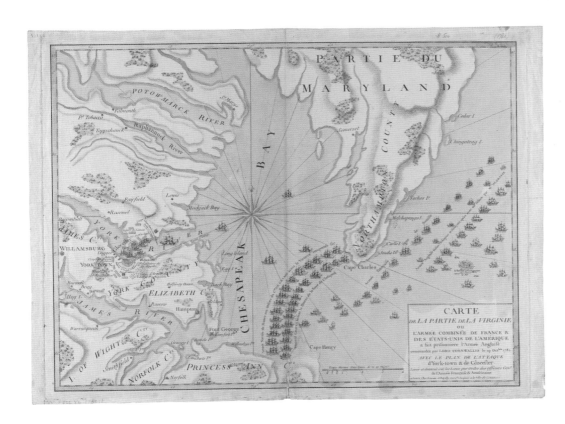

Logistics of Yorktown

Esnauts et Rapilly, *Carte de la partie de la Virginie ou l'armée combinée de France & des États-Unis de l'Amérique a fait prisonniere l'Armée Anglaise commandée par Lord Cornwallis le 19 Oct'bre 1781...*, Paris, 1782. Bequest of Paul Mellon

Virginia played a critical role in the winning of independence when a British force under the command of Lord Charles Cornwallis was trapped and defeated at Yorktown by a combined French and American army under George Washington. Two years later the war would end. The transformation of the British colonies into American states would be complete. Nation building could begin.

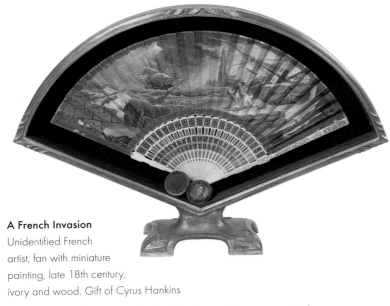

The Yorktown Victory

Glorious News. Provide[n]ce, October 25, 1781, Newport, 1781. Bequest of Paul Mellon

The news that Lord Cornwallis and his army had surrendered at Yorktown was carried to New England via a schooner that had left the York River five days

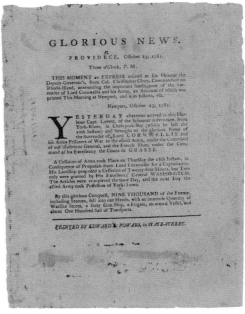

A French Invasion

Unidentified French artist, fan with miniature painting, late 18th century, ivory and wood. Gift of Cyrus Hankins

This decorative object is enriched with both a marine scene, copied from a painting by Claude Joseph Vernet, and a miniature portrait (at the base) of an unidentified French officer. By family tradition, the Frenchman pictured was a medical officer quartered in the household of William and Mary Reynolds of Yorktown during the siege of the city in 1781.

earlier. This broadside was produced in Providence, Rhode Island, to disseminate that news. This is the only known copy of the broadside to survive. With the surrender of Cornwallis, the British lost their resolve to continue the war.

SETTLERS IN THE BACKCOUNTRY

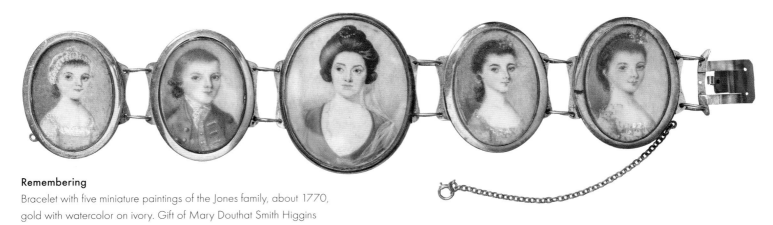

Remembering

Bracelet with five miniature paintings of the Jones family, about 1770, gold with watercolor on ivory. Gift of Mary Douthat Smith Higgins

West of the Blue Ridge Mountains, Margaret Strother Morton married Gabriel Jones, a lawyer in the Shenandoah Valley. By means of this bracelet, she kept images of their four surviving children close to her. Margaret Jones is depicted in the center miniature, flanked by children Anne, William, Elizabeth, and Margaret. In an era that witnessed high infant and maternal mortality rates, such objects were treasured family heirlooms.

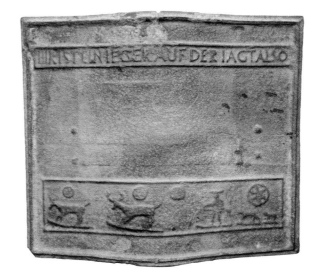

Utilitarian and Artistic

Deric Pennybacker's Redwell Furnace, side plate for a six-plate stove, 1787, cast iron, Page (formerly Shenandoah) County

The Shenandoah Valley was populated in part by Germans migrating from Pennsylvania. Many became industrious at farming and at making utilitarian and artistic ironwork and pottery. This panel pictures a hunter, hunting dogs, and deer, and is identified by an inscription in German ("HIR IST EIN JEGER AUF DER JAGT ALSO") that translates, "Here is a hunter on the hunt."

The German Population

Ambrose Henkel, *ABC- und Bilder-Buch* (ABC- and Picture-Book), New Market, Va., 1817

Since many of the German settlers in the Shenandoah Valley spoke and wrote only German, a printing industry emerged to serve this community's needs. Brothers Ambrose and Solomon Henkel established a German-language press in New Market that was used to help preserve culture, language, and religious beliefs.

"Much Displeased with Kentucky"

Anne (Henry) Christian, Beargrass, Kentucky, to Anne (Christian) Fleming, letter, 15 December 1785. Gift of William S. Morton, Mr. and Mrs. Hugh Blair Grigsby Galt, and gift/purchase of Mrs. William S. Morton

After the American Revolution, Colonel William Christian brought his family from the Shenandoah Valley to Kentucky County, Virginia (now Kentucky). Life there was hard. His wife, Anne (a sister of Patrick Henry), wrote to her sister-in-law, "Your Brother seems to be much displeased with Kentucky," and in another letter advised "never to think of coming thru the wilderness to this country." Two years later, William was killed by Indians and Anne returned to the Shenandoah Valley.

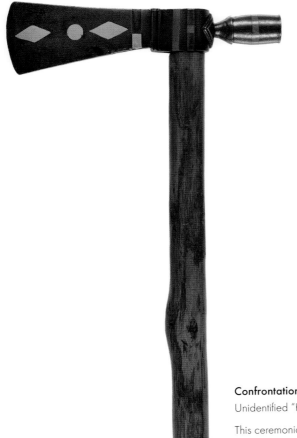

Confrontations with the Indians

Unidentified "Kentucky rifle" maker, pipe tomahawk, about 1780–1800

This ceremonial piece is evidence of cultural interaction between settlers and natives. The English took the Indian idea of the tomahawk, but, by inlaying it with German silver, brass, and copper, they made it a fashion accessory for the English gentlemen pioneers who played a large role in westward exploration. This tomahawk was found in Clarksburg (now West Virginia), but probably was made in the Shenandoah Valley.

GEORGE WASHINGTON

The Nation's First President

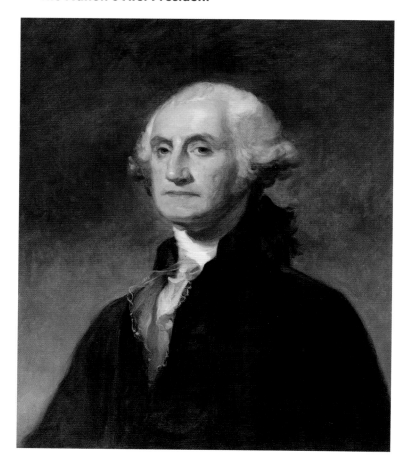

"The Father of His Country"
Thomas Sully after Gilbert Stuart, *George Washington*,
1856, copy of 1796 original, oil on canvas. Gift of
Jaquelin Plummer Taylor

The tribulations of the presidency aged Washington—as this
image reveals. He was still, however, an impressive figure. This
portrait depicts him not as general or president, but as a virtuous
citizen, the serene "Father of His Country" who had placed the
nation above himself and was a revered figure. This image was
the one that appealed the most to Washington's later admirers.

"Not the Tincture of Hauteur about Her"
Charles Willson Peale, *Martha Washington*, 1795,
oil on canvas. Gift of Mrs. John A. Chevallie

Martha Washington sought a life centered on family, but her
husband's celebrity thrust her into the public eye. She adjusted,
writing, "I am still determined to be cheerful and happy." Thus
this pleasant and down-to-earth woman became an effective First
Lady. Her fortitude was already well known, for she had spent
more than half of the war years with the military. Abigail Adams
observed, "Her manners are modest and unassuming, dignified
and femenine, not the Tincture of ha'ture [hauteur] about her."

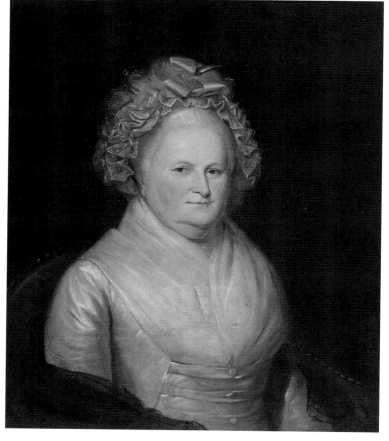

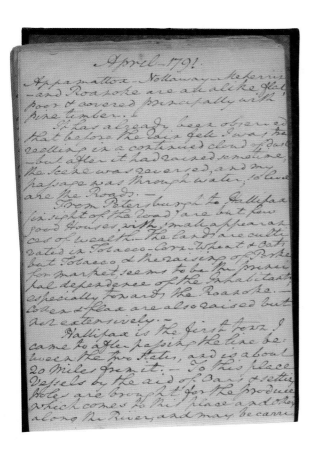

The President's Diary

Diary of George Washington, 1790–91. Gift of
James K. Marshall through the courtesy of John C. Hamilton

George Washington kept this diary in New York and Philadelphia during his first presidential administration, when the newly designed government of the United States was put into operation and the first chief executive determined how his role should be performed. It provides insight into decisions he faced—such as how he should receive foreign and domestic visitors—and indicates how he spent his leisure time and where he traveled.

Martha Washington's Porcelain

Unidentified Chinese maker, saucer, 1795, export porcelain, marked "MW" for Martha Washington

Out of admiration for the president, Andreas van Braam, an agent for the Dutch East India Company, gave a set of porcelain to Martha Washington that borrows its design from American paper currency. The motif of a sunburst and chain symbolizes the eminence and strength of the new American union. The motto, "a glory and a defense from it," is taken from Virgil's *Aeneid*.

Thomas Jefferson's Opinion of George Washington

Thomas Jefferson to Walter Jones, letter, 2 January 1814. Gift of William Wilson Corcoran

Here Jefferson praises George Washington, his late political opponent, but tempers his remarks. "His mind was great and powerful, without being of the first order; his penetration strong, though not as acute as that of a Newton, Bacon, or Locke, and no judgment was ever sounder. It was slow in operation, but sure in conclusion.... He was indeed, in every sense of the words, a wise, a good, & a great man."

THOMAS JEFFERSON

Author of the Declaration of Independence

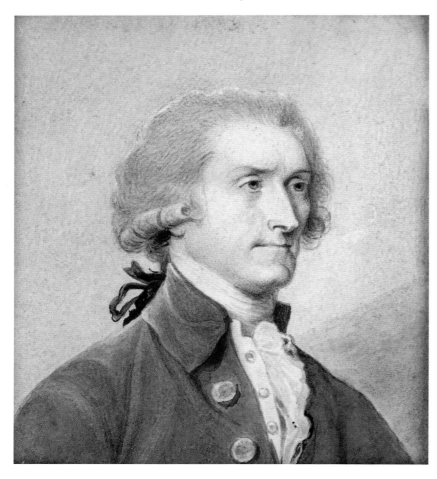

Dignified and Determined

Attributed to John Trumbull, *Thomas Jefferson*, about 1786–1820, watercolor on paper. Gift of Dr. Frederick D. Gillespie

This small portrait of Jefferson is related to Trumbull's famous and monumental painting of the presentation to Congress of the Declaration of Independence by its five-man draft committee. (That painting hangs in the U.S. Capitol.) This watercolor is either a study, perhaps taken from life and done by Trumbull himself, or it is a copy of Trumbull's image by a very competent contemporary.

A Love of French Culture

Bowl owned by Thomas Jefferson, 1789, Sèvres porcelain. Gift of Martha Jefferson Randolph

Marks on the bottom of this bowl stand for Louis XVI, the king of France who was the patron for whom it was made. The Sèvres factory was under his royal patronage. How Jefferson acquired the bowl is unknown, but it was undoubtedly linked to his service as U.S. minister to France, 1784–89. He returned to America with eighty-six crates of belongings. This bowl was given by Jefferson's daughter soon after the Virginia Historical Society was founded in 1831, possibly as a tribute to her father's dearest friend, James Madison, its first honorary member.

The Most Important American Book of Its Time

Thomas Jefferson, *Notes on the State of Virginia, Written in the Year 1781...*, London, 1787

Notes is a compilation of data about natural resources, economy, and society, and is arguably the most important American book published before 1800. To its later editions, Jefferson appended his *Virginia Statute for Religious Freedom*—his most enduring legacy. That law separated church and state by ending the financial support given to the Anglican Church by state taxes, and by freeing the individual to worship or not worship.

Jefferson's Letters

Thomas Jefferson to Thomas Adams, London, letter, 1 June 1771. Gift of Thomas James Massie

Serving in the House of Burgesses, Jefferson supported non-importation agreements in opposition to parliamentary taxation—except when he wanted a "charm[ing]" piano and sashed windows for Monticello. Here he states, the piano is "worthy the acceptance of a lady"—Martha (Patty) Skelton, whom he would marry at the year's end. They sang together, she played the piano and he the violin. The Virginia Historical Society holds close to one hundred of Jefferson's letters.

The "Pen" of American Independence

Thomas Jefferson, *A Summary View of the Rights of British America*, Williamsburg, 1774 (printed by Clementina Rind). Gift of Alan M. Voorhees

Jefferson's authorship of this bold pamphlet earned him the assignment to draft the Declaration of Independence. He dares to criticize the British king for "unwarrantable encroachments and usurpations" upon the rights of British Americans. He complains of taxes and trade restrictions. He offers the logical conclusion to the colonial protests that had begun in 1765: "the British parliament has no right to exercise authority over us." Such sentiments made him a traitor in the eyes of the British authorities.

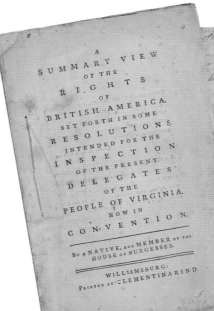

Call for the End to Slavery

Thomas Jefferson, draft of a constitution for the state of Virginia, 1783 or 1784. Gift of George Moffett Cochran

Jefferson's proposed constitution never became law. He shared it with his friend Judge Archibald Stuart who made this copy. Jefferson's ideas about the separation of powers and the guarantee of rights were not unusual. Extraordinary—given his reluctance to free his own slaves at Monticello—was his proposal to eventually end slavery: the General Assembly is not "to permit ... the continuance of slavery beyond the generation which shall be living on the thirty-first day of December 1800 ... all persons born after that day being hereby declared free."

THOMAS JEFFERSON

Third U.S. President, a Time of Expansion

Cliffhanger of an Election

Thomas Jefferson to Archibald Stuart, letter, 12 February 1801. Gift of Alexander Hugh Holmes Stuart

The presidential election of 1800 that ousted the Federalist Party from the presidency in favor of Jefferson's Democratic-Republicans was a cliffhanger decided by balloting in the House of Representatives. Here, Jefferson reports to his friend and supporter in Staunton that twenty-five ballots had been taken without a resolution of the near tie between Jefferson and John Adams, with more votes to come.

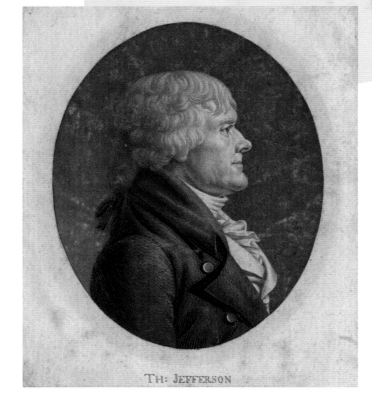

TH: JEFFERSON

Midway through His Presidency

Charles Balthazar Julien Févret de Saint-Mémin, *Thomas Jefferson*, 1804–5, engraving

Jefferson was sixty-one and nearing the end of his first term as president when he sat for this realistic image by Saint-Mémin. The artist produced a copperplate from which he was able to print forty-eight engravings that Jefferson purchased from him to give to family, friends, and members of his cabinet.

THE
ADDRESS
OF
THOMAS JEFFERSON,
To the SENATE, the MEMBERS of the *House of Representatives*, the PUBLIC OFFICERS, and a large Concourse of CITIZENS.
DELIVERED
In the SENATE CHAMBER,
ON THE
4th day of *March*, 1801,
On his taking the OATH of OFFICE,
AS
PRESIDENT
OF THE
United States of America.
————
BALTIMORE:
Printed for KEATINGE's Book-Store,
1801.

A Voice of Conciliation

The Address of Thomas Jefferson, to the Senate, the Members of the House of Representatives ... on the 4th Day of March 1801, on his Taking the Oath of Office as President of the United States of America, Baltimore, 1801

The author of the Declaration of Independence produced here a second political masterpiece, one that offered a conciliatory message to a divided nation: "All ... will bear in mind this sacred principle, that though the will of the majority is in all cases to prevail, that will to be rightful must be reasonable, that the minority possess their equal rights, which equal law must protect, and to violate would be oppression."

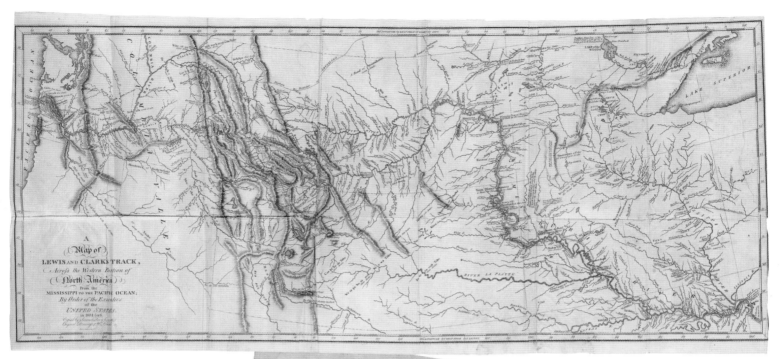

The Lewis and Clark Expedition

Travels in the Interior Parts of America ... by Captains Lewis and Clark, London, 1807

Jefferson's purchase of the Louisiana Territory (half a continent for $15 million dollars) doubled the size of the republic and was one of the most consequential executive actions in American history. Virginians Meriwether Lewis and William Clark were dispatched to lead an expeditionary force to explore the territory from St. Louis to the Pacific Northwest and establish an American presence there. The journey, 1804–6, brought them into contact with numerous native tribes. Jefferson had been thinking and worrying about the West since the Revolution.

The Embargo of 1809

Thomas Jefferson to Charles L. Bankhead, letter, 19 January 1809. Gift of Margaret Cabell Brown Loughborough

Jefferson's presidencies (1801–9) were challenged when both England and France imposed naval blockades and seized American ships, and his retaliatory Embargo of 1807 had little effect on the warring countries while it wrecked the American economy. Here, Jefferson admits that "disquietude in the North is extreme" and hopes "that England will repeal her decrees" and war might be averted.

JAMES MADISON

From Virginia Planter to Fourth President

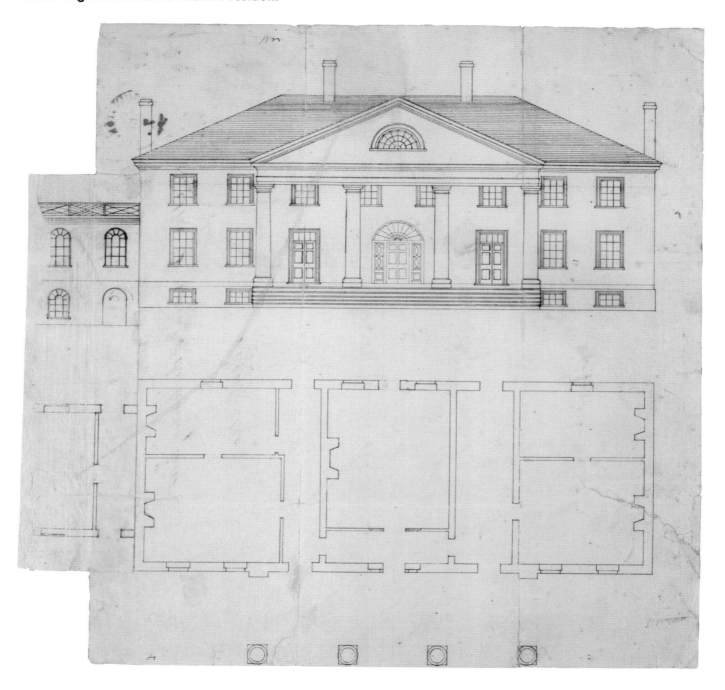

Help from a Friend

Attributed to James Dinsmore and possibly others, *Elevation and Plan of Montpelier*, 1808. Purchased through the Lettie Pate Whitehead Evans Fund

Dinsmore, an Irish craftsman, worked at Montpelier, James Madison's plantation house. This drawing was mailed to "The President of the United States, Monticello," for comment. Jefferson began advising his good friend Madison in 1797 on renovations to his father's house. The distinctive Tuscan portico that was added was a Jeffersonian feature. This drawing, found in the sketchbooks of architect Thomas R. Blackburn, informed restorations made to Madison's house in 2003–8.

A Lifetime of Invaluable Service

Joseph Wood, *James Madison*, 1817, oil on wood panel. Gift of Katherine Weeks Davidge

It was Madison who called for a Constitutional Convention, led the debates, and was the principal author of the resulting Constitution and its later Bill of Rights. Following four decades of public service, he was weary when he sat for this portrait. His presidency, like that of his predecessor Jefferson, had become entangled in the centuries-old conflict between England and France. He and Jefferson had been virtually powerless in limiting the attacks on American shipping by the forces of the French emperor Napoleon and an English nation struggling to survive. Madison's decision to declare war with England in 1812 proved to be ill-advised.

A Savvy First Lady

Joseph Wood, *Dolley Madison*, 1817, oil on wood panel. Gift of Katherine Weeks Davidge

Skillful as First Lady—serving both the widower Thomas Jefferson and her own husband—Dolley Madison not only led Washington society during four presidential terms, but also proved to be a politically savvy hostess who influenced political events from 1801 to 1817. Before British troops burned the White House in 1814, she organized slaves and staff to save portraits and silver.

"Father of the Constitution"

The Fight for Religious Freedom

James Madison, *A Memorial and Remonstrance, on the Religious Rights of Man; written in 1784–5, at the Request of the Religious Society of Baptists in Virginia,* Washington City, 1828

A "memorial" is a statement of facts; a "remonstrance" is an objection. The bill under protest was Governor Patrick Henry's proposal to continue taxation to support religion—but with a change: the taxpayer would designate the church to receive support. George Mason and James Madison rejected the idea. They championed Thomas Jefferson's bill that called for no taxation to support churches and for religious freedom for everyone, atheists included.

Unsurpassed Classic in Political Science

The Federalist; or, The New Constitution, written in the year 1788..., Washington, D.C., 1831

This collection of eighty-five essays written by Alexander Hamilton, James Madison, and John Jay outlined how the new government would operate and promoted acceptance of the Constitution by the states. The essays first appeared serially in newspapers. John Marshall read them carefully and was sufficiently swayed by the explanations to argue for adoption. John Marshall often consulted *The Federalist* when making his legal opinions. This volume was his personal copy.

The Finest French Porcelain

Plate owned by James Madison, 1786, Sèvres porcelain. Gift of Mrs. R. P. Mercer

While serving in Paris as U.S. minister to France, Thomas Jefferson famously shipped to Madison crates of books about government that enabled the "Father of the Constitution" to conceive an effective system. Jefferson apparently forwarded decorative objects as well, including Sèvres porcelain. This pattern was designed for a French nobleman, the Duc de Duras. Fragments of porcelain wares in this pattern have been excavated at James Madison's Montpelier residence.

A Voice of Reason

James Madison to Archibald Stuart, letter, 30 October 1787. Gift of Alexander Hugh Holmes Stuart

To Madison's thinking, the balance of power between the federal government and the states was a major issue in debates over the ratification of the Constitution. "[I]ntelligent people," he writes here, "[are] equally divided and equally earnest in maintaining on the one side that the General Government will overwhelm the State Government, and on the other that it will be a prey to their encroachments." The Virginia Historical Society holds twenty of Madison's letters.

JOHN MARSHALL

The First Chief Justice

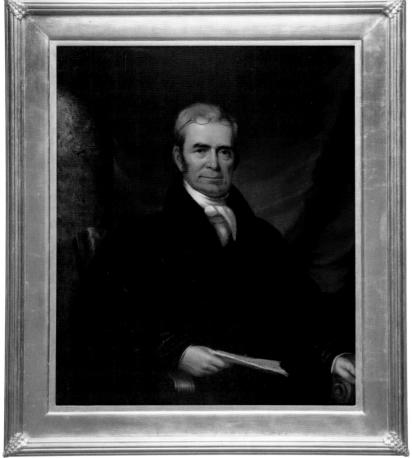

From Valley Forge to Supreme Court
James Reid Lambdin, *John Marshall*, 1832, oil on canvas. Purchased with funds provided by Hunton & Williams in honor of Justice Lewis F. Powell, Jr.

Marshall endured the winter at Valley Forge with Washington while in the Continental Army, he served in the Virginia House of Delegates, and—in support of a strong national government—he led the fight in Virginia for ratification of the Constitution. The longest-serving chief justice, Marshall made the Supreme Court coequal with the legislative and executive branches of government.

First President of the Virginia Historical Society
Unidentified maker in eastern Virginia, desk, about 1780–1805, walnut with yellow pine and white oak secondary. Gift of Edna V. Moffet

By family tradition, this Chippendale slant-front desk, probably made in Richmond, was initially owned by John Marshall. He would have used it while serving as the first president of the Virginia Historical Society.

EARLY AMERICAN SILVER

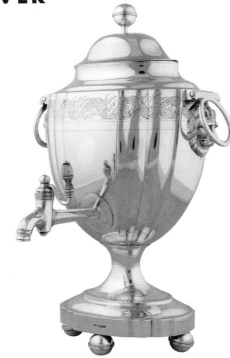

John David, Philadelphia, teapot, about 1785, silver.
Gift of the estate of Crenshaw Chamberlayne

This handsome piece, crafted by a leading
Philadelphia silversmith, was purchased by Edward
Pye Chamberlayne and his wife, Agnes (Dandridge)
Chamberlayne of King William County, Virginia.
Chamberlayne was a grandson of William Byrd II
of "Westover"; Agnes Dandridge was a cousin of
Martha Washington.

Attributed to Christian Wiltberger,
Philadelphia, coffee urn,
about 1800, silver. Gift of
Jonathan Edwards Woodbridge

Typical of the large-scale work of
Wiltberger, this elaborate piece
belonged to Andrew Nicolson,
who was successful in the
development of the Midlothian
coal mines in Chesterfield County,
Virginia. He married in 1798 Judith
Wormeley Digges of Williamsburg.
With wealth and social
prominence, Nicolson reached
beyond Richmond to patronize
leading artisans and artists.

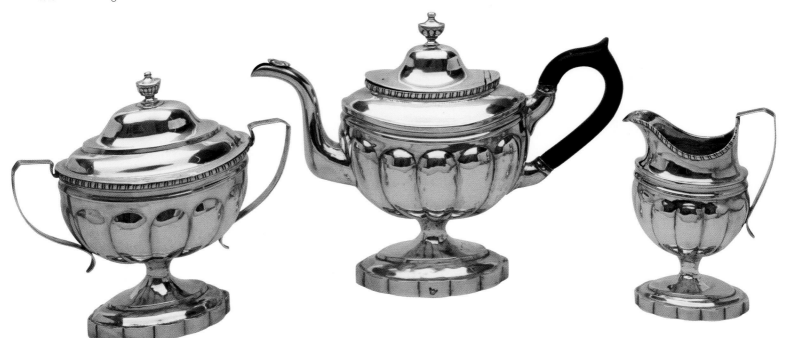

Johnson & Reat, Richmond, three-piece tea service, about 1804–5, silver.
Purchased with funds provided by Nicholas F. Taubman, Alan M. Voorhees,
Anne R. Worrell, and an anonymous donor

The growth of Richmond attracted artisans and craftspeople. Johnson & Reat
was established there by Reuben Johnson (1782–1820) and James Reat
(1782–1815). They advertised as jewelers, silversmiths, and gilders. The
partnership was dissolved with Reat's death in 1815. This service consists of
a coffee/tea pot, a sugar bowl with lid, and a creamer.

EMANCIPATION

"My Duty to Do unto Others"

Richard Rowell, emancipation document, Surry County, 26 August 1782. Anonymous gift through the Virginia Genealogical Society

Rowell was one of a number of slaveholders who freed their slaves after the leaders of the American Revolution promised liberty for all. "I Richard Rowell of Surry County in Virginia being fully persuaded that freedom is the Natural Right of all Mankind and that it is my duty to do unto others as I wou'd desire to be done by in the like situation and having under my care one Negro whom I have heretofore held as a Slave.... I hereby Emancipate [Sarah]..."

"Inconsistent with the Precepts of the Gospel"

"Constitution of the Virginia Society for Promoting the Abolition of Slavery," published in *The Virginia Gazette and Petersburg Intelligencer*, 8 July 1790

In 1782, the General Assembly allowed slave owners to free their slaves. Some did. Many of their manumission documents are written with the same language of condemnation used in this constitution: "[Slavery] is an outrageous violation, and an odious degradation of human nature," "[It] is inconsistent with the precepts of the Gospel, of doing to others as we would they should do unto us."

"All Men Are Created Equal"

St. George Tucker, *A Dissertation on Slavery: With a Proposal of the Gradual Abolition of It, in the State of Virginia,* Philadelphia, 1796

Tucker, a law professor at the College of William and Mary and a judge, discusses the "incompatibility" of slavery with the philosophy of the American Revolution that "all men are created equal," and he proposes a plan for ending it. However—frightened by the slave revolt of 1791 in Haiti—he suggests denying freed slaves their basic civil liberties, and he outlines a slow, decades-long pace for emancipation. Tucker gave this *Dissertation* to Virginia's General Assembly, but it was never considered.

Emancipated by George Washington

Bartholomew Dandridge, certificate, 1824. Anonymous gift through the Virginia Genealogical Society

This certificate issued by the Clerk of the Court of New Kent County states that Arrena Pickett "is one of the negroes emancipated by the last Will ... of Genl. Geo. Washington" and for that reason she is free. This note served her as a freedom paper to prove to anyone who challenged her status or suspected that she was an escaped slave.

WEAPONS FOR THE NEW NATION

Riflemaking's "Golden Age"

Jacob Sheetz, Shepardstown, Berkeley County, "Kentucky" long rifle, about 1810-15, signed "J. Sheetz". Purchased through the Carrie Wheeler Buck Fund and with funds provided by C. Coleman McGehee and Martin Kirwan King

This Upper Valley "flintlock" (it has a flint-striking ignition mechanism) is more correctly labeled a "Pennsylvania-style long rifle." It is a product of riflemaking's "Golden Age." The type evolved from a blending of features of the German jaeger (a military rifle) and the English fowler (a hunting rifle). Jacob Sheetz's talents included those of a furniture maker and a silversmith. The rococo-style patchbox head derives from the riflemaking tradition of York, Pennsylvania, where Jacob Sheetz's father, Philip, once lived.

An Armory in Virginia

"First Model" Virginia Manufactory of Arms pistol, 1805. Purchased with funds provided by Mr. and Mrs. Bruce C. Gottwald and Mr. and Mrs. Floyd D. Gottwald, Jr.

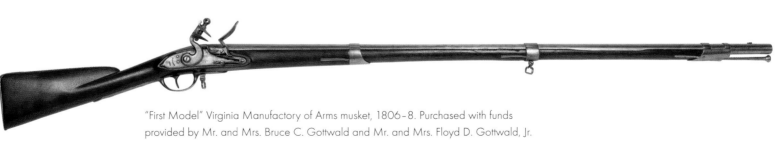

"First Model" Virginia Manufactory of Arms musket, 1806-8. Purchased with funds provided by Mr. and Mrs. Bruce C. Gottwald and Mr. and Mrs. Floyd D. Gottwald, Jr.

Mindful of the need to defend the new nation, President George Washington in 1794 selected Springfield, Massachusetts, and Harpers Ferry, Virginia (now West Virginia), as sites for federal armories that would produce muskets and other armaments. In 1798, Virginia established its own armory, in Richmond, to supply the state's militias. Both decisions proved to be prudent when war was declared in 1812.

THE WAR OF 1812

Development of a Professional Army

U.S. Army infantry coat, 1810–12, worn by Martin Kirtland during the War of 1812. Gift of St. Paul's Episcopal Church, Norfolk

This colorful uniform, with edging, turnbacks, and decorative non-functioning buttons and buttonholes, was worn during the War of 1812 by Martin Kirtland (b. 1790), grandson of a Revolutionary War captain of the same name. It passed down through the family in Norfolk until the mid-twentieth century. The British invaded the Tidewater in 1813, attacking Norfolk and Hampton, and later occupying Alexandria, in retaliation for American incursions into the British-held Province of Quebec (now Canada).

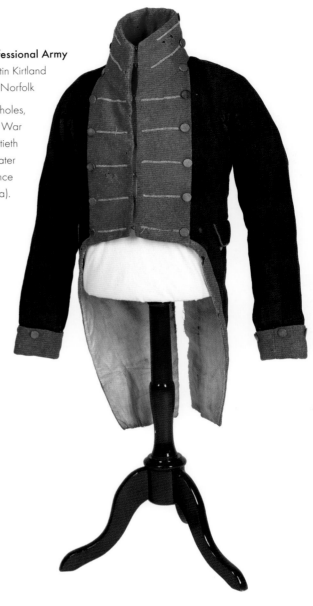

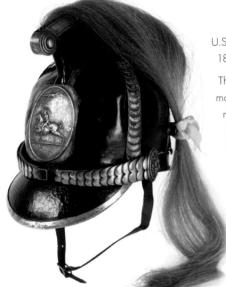

U.S. Army Light Dragoon helmet, about 1810–30. Gift of Ovid H. Bell

This style of headgear was worn by mounted troops serving in the Virginia militia during the early 1800s. It is fabricated from tanned leather, the tin front plate shows a charging dragoon, and the crest is decorated with an impressive horsehair "fall" or plume. This helmet was worn by Henry Law of Lancaster County, Virginia, who served during the War of 1812.

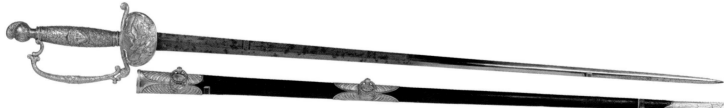

Hero of the New Nation

Ceremonial sword and scabbard awarded posthumously to Captain John Ritchie by the Commonwealth of Virginia, about 1814. Gift of Virginia Ritchie

Ritchie was killed during the War of 1812 at the Battle of Niagara Falls (also known as the Battle of Lundy's Lane), 1814, in present-day Niagara Falls, Ontario. It was one of the bloodiest battles ever fought in Canada. It proved to be a tactical draw but a British strategic victory because the Americans suffered so many casualties (171 dead, 1,500 wounded) that they were forced to withdraw.

JAMES MONROE

Fifth President, a New Focus

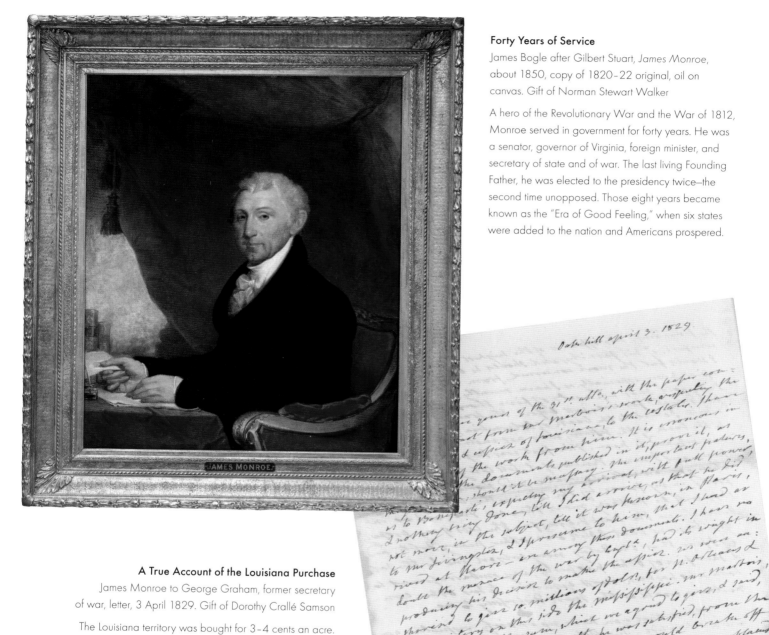

Forty Years of Service

James Bogle after Gilbert Stuart, *James Monroe*, about 1850, copy of 1820–22 original, oil on canvas. Gift of Norman Stewart Walker

A hero of the Revolutionary War and the War of 1812, Monroe served in government for forty years. He was a senator, governor of Virginia, foreign minister, and secretary of state and of war. The last living Founding Father, he was elected to the presidency twice—the second time unopposed. Those eight years became known as the "Era of Good Feeling," when six states were added to the nation and Americans prospered.

A True Account of the Louisiana Purchase

James Monroe to George Graham, former secretary of war, letter, 3 April 1829. Gift of Dorothy Crallé Samson

The Louisiana territory was bought for 3–4 cents an acre. Monroe, who negotiated this purchase while serving President Thomas Jefferson as an ambassador to France, recalled: "We were authorized to give 10 millions of dol[la]rs for N. Orleans & the territory on this side the Mississippi.... We thought therefore that we obtained a very advantageous bargain in giving for the whole province on both sides, the sum which we agreed to."

Washington May 27.th 1821

Dear Sir

I was very much gratified by your letter from Richmond, as it appeard me that the vote which you had just given, was not only in accord with a conscientious discharge of a public duty, but with your personal feelings towards me. Having become acquainted in early life, & connected by strong friend: ship, & acted together, in different, & sometimes trying situations, & my whole course being known to you, with the motives which have governd me, in every cir: cumstance, & in every situation, in which I have been placed, it affords me singular satisfaction, to have obtaind the approbation, & preserv'd the friend: ship, through such a long series of years, of one, who had so good an opportunity, of judging corectly, of my principles & conduct. It has been my undeviating object, to support our free govern: ment, and all my efforts have been devoted to that end. Having been much abroad, and seing by the opportunities thereby afforded me, many of the dan gers to which it is exposed, I have endeavourd, to turn the knowledge thus acquired, to the benefit of my country, and to fortify ourselves in those

Formulating the Monroe Doctrine

James Monroe to Archibald Stuart, letter, 27 May 1821. Gift of Alexander Hugh Holmes Stuart

Eight years of foreign service led Monroe to distrust European nations. Here he worries about the "hereditary monarchs." "Should they smash the [revolutionary] spirit in Europe, may they not then look to America?" Anticipating his "Monroe Doctrine" of 1823 that warned European nations not to interfere in the Americas, Monroe was sure "to see the coast fortified, the navy augmented..., the military academy prepared." The Virginia Historical Society holds seventy-five of Monroe's letters.

1825–1861

CHALLENGES OF A NEW CENTURY

Following the presidency of Virginian James Monroe (1817–1825), the new nation was shaped by sectional conflict, territorial growth, and economic expansion. Virginia planters sought to perpetuate traditions of the colonial era, promoting their agrarian society as one of gentility, wealth, abundance, and good and easy living on the land. Agriculture in the western part of the state actually flourished. Planters spoke of "Old Virginia"—but the term became equally synonymous with the exploitation and cruelty of slavery, which imprisoned a third of the state's population. Slaves were increasingly sold and exported to the Deep South, and slaveholders—who had previously offered self-criticism and had looked to end slavery—instead defended it in response to attacks by abolitionists. Virginia's populations shifted. Thousands continued to abandon soil-depleted Tidewater farms and migrate westward. German and Scots-Irish settlers continued to pour into the Valley. Politicians blamed the westward exodus for a "decline" in the state's "political rank and eminence in the Union." The beginnings of the Industrial Revolution spurred "internal improvements" in road, rail, and canal transportation that better linked the state's isolated western residents to markets. The improvements fueled the development of tobacco, flour, and iron industries and growth of the state's urban centers.

SHAPING VIRGINIA'S IDENTITY

"Old Virginia"

Romanticized Indians

Jean-Julien Deltil, for Jean Zuber et Cie, Mulhouse, France, *Virginia*, 1833,
hand-printed wallpaper panel. Purchased with funds provided by Lora M. Robins

This French idealization of "Old Virginia" pictures an arcadia that has a resident aristocracy, Indian and African American populations, and great natural wonders, the most famous being Natural Bridge. The Indians, wearing Roman-like togas, evoke the romanticized notion articulated by French philosopher Jean-Jacques Rousseau of the "natural man" uncorrupted by civilization. The African Americans are not slaves, but instead are shown to be free, well dressed, and cosmopolitan. (Panels of this wallpaper pattern were installed in the White House by Jackie Kennedy.)

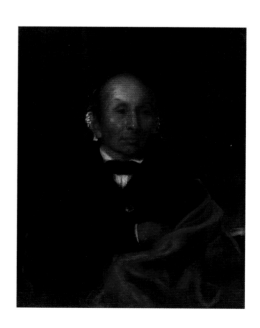

An Actual Indian

Robert Matthew Sully, *Black Hawk (Ma-ka-tai-me-she-kia-kiak)*,
1833, oil on canvas. Gift of Robert Matthew Sully

In 1828, the push of American settlement forcefully removed the Sauk and Fox tribes from their homelands to the west of the Mississippi River. From Iowa, Black Hawk, a Sauk war chief, led incursions into the Illinois region in an effort to regain lost territory. In 1832 one incursion grew into a revolt, the unsuccessful "Black Hawk War." Defeated, Black Hawk was carried east, where he met President Andrew Jackson, became something of a curiosity, and was briefly incarcerated at Fort Monroe in Virginia, where this portrait was painted.

Eccentric and Feared

Arthur J. Stansbury, *John Randolph of Roanoke*, 1829, watercolor. Gift of Thomas G. Peyton

A slight man made high-voiced by illness, Randolph was eccentric and feared in Congress. There—wearing riding boots with whip in hand—he would browbeat opponents with his brilliant wit. Randolph carried to an extreme the ideals of "Old Virginia," including Thomas Jefferson's initiatives to restrict the role of the federal government and promote the agrarian lifestyle which Randolph pursued, at "Roanoke," his slave-sustained plantation in Southside Virginia.

"Corrupt" and "Rotten"

Wogdon & Barton, London, dueling pistols owned by John Randolph of Roanoke, about 1820. Gift of Stewart Bryan, Jr.

Randolph ridiculed the political alliance between the northerner John Quincy Adams and southern Senator Henry Clay that gave Adams the presidency. He called Clay "corrupt ... like a rotten mackerel ... that shined and stunk." Valuing honor more than life, Clay summoned Randolph to a duel. Both men survived. Randolph may have used these pistols in the famous duel with Clay.

Famous Minstrel Song

Daniel D. Emmett, "Dixie's Land," 1859. Gift of Allen Waller Morton

This self-described "Plantation Negro Song" looks admiringly at the antebellum South. Ohio composer Daniel Emmett composed it in New York City as a "hooray" song for a minstrel show. It took the South by storm. (The term "Dixie" probably was derived from ten-dollar notes issued by Louisiana banks that were labeled "Dix"—French for ten.)

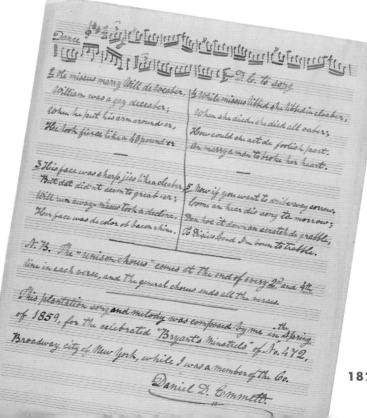

Progress and Paradoxes

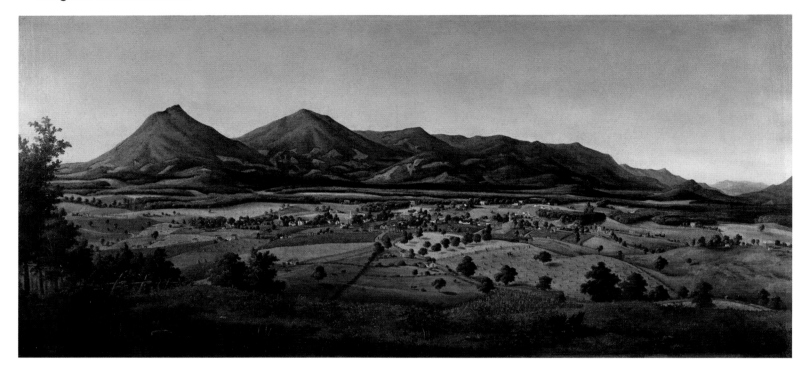

Virginia's Productivity

Edward Beyer, *View of Liberty, Bedford County, Virginia*, 1855, oil on canvas. Purchased with funds provided by Lora M. Robins; Partial gift of Mildred Edmunds Long

Thomas Jefferson endorsed the development of market towns to serve surrounding plantations. These communities would be small and close to nature—free from the perceived evils of large urban centers. Left unanswered was the paradox that slavery was at the heart of this Arcadian vision. The arrangement was productive. Farmers in the Piedmont and Valley produced so much corn and wheat that—despite the recession in the soil-depleted eastern counties—Virginia remained the leading agricultural state in the South.

Racial Stereotypes

Edwin Pearce Christy, "Carry Me Back to Old Virginia," New York, 1847, sheet music

Composed for the popular minstrel shows of the era, this song was a staple of Christy's Minstrels. Full of racist stereotypes, it was performed by a white singer in blackface playing the character of an elderly black man who longs to return to the Virginia of his youth. "Old Virginia" is imagined to be a romantic, pastoral world of moonlight, magnolias, and mint juleps, of gentlemen and belles, of benevolent masters and contented slaves.

The Canal Moves Westward

Edward Beyer, *Lynchburg*, 1854, oil on canvas. Purchased with funds provided by Lora M. Robins

Lynchburg was established in the late 1700s when John Lynch placed a ferry there and later a bridge across the James River. In 1810, Thomas Jefferson judged Lynchburg to be a "rising place." Commerce increased when canal traffic reached there in 1840 and a railroad began construction in 1850. In 1853, a new courthouse was dramatically positioned above the river and completed in 1855. Evidence suggests that Beyer, in this depiction believed to be Lynchburg, painted the scene when the courthouse was under construction (details are wrong). This landscape today is covered by hundreds of buildings.

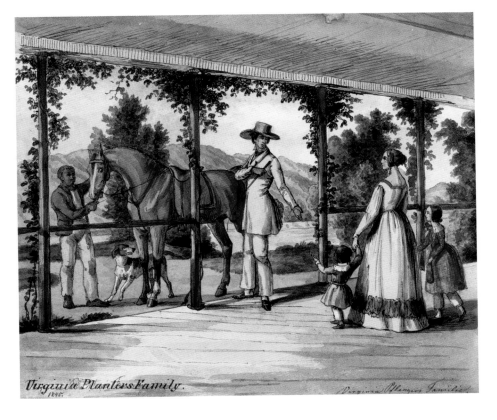

Virginia Planters Family.
1845.

Exporting Virginia Culture to the Western Counties

Augustus Köllner, *Virginia Planter's Family*, 1845, watercolor. Gift of Ballard Hartwell Cabell

Drawn by the availability and economic promise of fertile land, many families from "Old Virginia" moved into the western counties of the state. This migration fueled development there. In some cases, the new settlers attempted to recreate the way of life of the colonial gentry—what many perceived to be the good old days. In this painting, slavery is unabashedly projected as integral to the image of the ideal (white) gentry family.

History and the Land

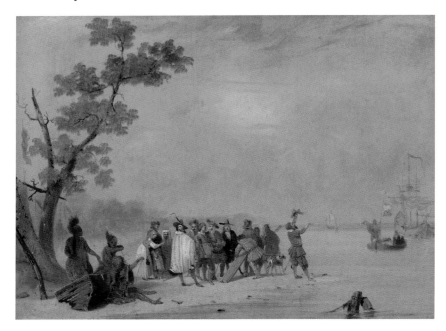

Birthplace of America

John Gadsby Chapman, *The Relief of Jamestown: Old Time in the New World*, about 1837, oil on canvas. Bequest of Lora M. Robins

The term "Old Virginia" celebrates in part the region's "old" and important history, which was a source of pride for Virginians. That history starts with Jamestown, the first permanent British colony in the New World. Chapman, a Virginian, depicts here the arrival in June 1610 of a relief ship from London following the "starving time" of the preceding winter when all but sixty of the fledgling colony's 500 settlers perished.

"The Father of Our Country"

Russell Smith, *The Original Tomb of Washington*, 1836, oil on canvas. Purchased with funds provided by Nicholas F. Taubman, Alan M. Voorhees, L. Dudley Walker, and Anne R. Worrell

The greatest son of "Old Virginia" was George Washington. His tomb became a popular site for both pilgrims and artists. Painters represented it as if it was sanctified, the holiest of holy places. In this work, nature itself seems to know that it holds the earthly remains of a national hero whose memory at least has survived the grave.

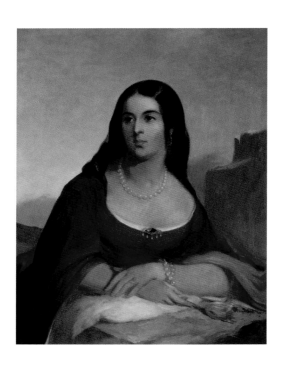

"The Mother of Our Country"

Thomas Sully, *Pocahontas*, 1852, oil on canvas. Gift of Thomas Sully

The early history of "Old Virginia" includes the establishment of Jamestown and the story of Pocahontas, both of which—Virginians would point out—predate the Pilgrims' settlement in Massachusetts. Sully presents what his patrons might have thought her best moment—after her assimilation of their culture. She is portrayed as a person of remarkable refinement and grace, the "Mother of our Country." Sully's image has slight resemblance to the portrait of her taken from life 236 years earlier (p. 21).

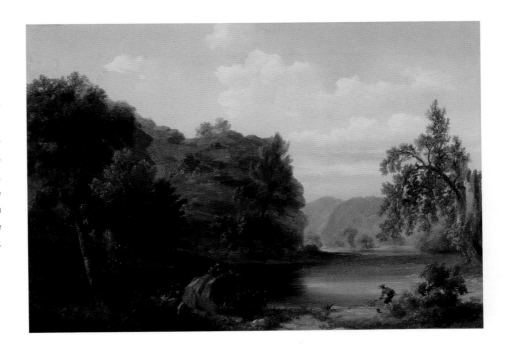

Looking Closely at the Landscape

Russell Smith, *South Fork of South Branch of the Potomac River*, 1846, oil on canvas. Bequest of Lora M. Robins

Virginians increasingly focused attention westward. Smith accompanied a geological expedition to the far reaches of the Valley, jotting down notes with sketches he made there. In this finished painting, he altered the types, positions, and heights of trees, and he shifted landscape features in order to construct what he considered to be a proper finished painting in the Old World tradition of the Picturesque ("looking like a picture").

A New "Eden"

William Louis Sonntag, *Shenandoah Valley*, about 1859–60, oil on canvas. Purchased with funds provided by Lora M. Robins

Many Americans believed in a providential vision for the United States, that God favored them with a continental expanse in which America could become a new Eden or a new Kingdom of Judah. Sonntag searched the Allegheny Mountains for wilderness features that would suggest an American destiny and promised future. In 1852 he was commissioned by the Baltimore and Ohio Railroad to paint scenery along its routes. In the late 1850s he worked near Luray and along the Cheat River.

The Animals of Virginia

John James Audubon, "Common or Virginian Deer, Old Male & Female," hand-colored lithograph, from *The Viviparous Quadrupeds of North America*, New York, 1845–48. Bequest of Paul Mellon

As Americans paid increasing attention to the lands stretching westward, they also took an interest in the animals and birds of the wilderness. Audubon's journeys across the nation included travel in Virginia.

JOHN TYLER

Tenth President, Looking Westward

Emulating Jefferson

Alonzo Chappel, *John Tyler*, about 1841–45, oil on paper

Tyler epitomized the ideals of "Old Virginia." He managed a slave-supported plantation in the Tidewater (Charles City County) and he helped restore Virginia's political eminence by attaining the presidency. His father had been a personal friend (college roommate) of Thomas Jefferson, whom the son emulated. Tyler faithfully endorsed Jefferson's concepts of states' rights, limited federal government, and the virtue of agrarian life.

Accoutrement of a President

Cane of John Tyler, about 1841–45. Gift of the Honorable Madison E. Marye

The cane is inscribed "To his Excellency John Tyler President." In Tyler's long political career before he became president, he served as a Virginia legislator and governor, a U.S. representative and senator, and as vice president, the first to accede to the presidency on the death of his predecessor.

End of an Era

Death mask of John Tyler, 1862. Gift of the Honorable Madison E. Marye

This death mask of the president (1790–1862) was reputedly broken by Union soldiers during the Civil War.

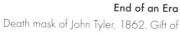

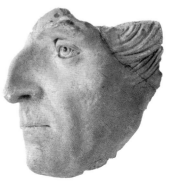

The First Threat of Secession

John Tyler to John Floyd, letter, 13 December 1832

South Carolina's threat in 1832 to secede from the Union shocked Tyler to the core. Unable to sleep, he rose to write the Virginia governor, "I tremble for the Union—and equally as much for our constitution.... Not only the Union is in danger, but all the rights—nay the very existence of the States..... I am humbled, mortified, chagrined."

The Last Threat of Secession

John Tyler to Mrs. Tyler, letter, 17 April 1861

When Virginia seceded from the Union, Tyler recognized that "trying times are before us." He reported to his wife, Julia Gardner Tyler: "Virginia has sever[e]d her connexions with the Northern hive of abolitionists and taken her stand as a sovereign and independent state.... The die is thus cast and her fortune is in the hands of the God of Battle."

American Expansionism

John Tyler to John Young Mason, letter, 11 December 1848, with enclosure. On loan from Mrs. Van Wyck W. Loomis

As the tenth president (1841–45), Tyler provoked a war with Mexico that resulted in the acquisition of land encompassing modern-day Texas, New Mexico, Arizona, and California— territorial expansion on the scale of Jefferson's Louisiana Purchase. Here Tyler defends his annexation of Texas from Mexico—the event that spurred war—in the last days of his presidency: "[T]he whole cabinet ... concurred in the necessity of action."

DEVELOPMENT IN THE VALLEY

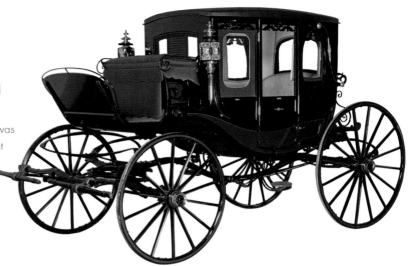

Early Transportation

Unidentified maker, reconditioned in 1860 by J. M. Hardy & Son, Staunton, horse-drawn carriage, about 1830. Purchased with funds provided by Mr. and Mrs. Nicholas F. Taubman

The Virginia & Tennessee Railroad reached into the Valley at mid-century and was at Wytheville by December 1854. Carriages, however, remained the dominant means of local transportation, as is recorded in Beyer's paintings of such towns as Christiansburg and Wytheville. This carriage was owned farther north in the Valley in Rockbridge County by John Glasgow, whose family prospered from the sale of lumber and the production of iron.

Hauling Freight in the 1830s

John B. Kiger of Sperryville, Virginia, Conestoga wagon, about 1830

The Conestoga wagon was a heavy, sturdy vehicle that was developed near Conestoga, Pennsylvania, to navigate rugged terrain. German immigrants brought it into Virginia's Shenandoah Valley. This wagon is stenciled by its maker on its back door. It is the only surviving Conestoga wagon that is signed by its maker. By the 1850s, railroads began to supplement the Conestoga wagon.

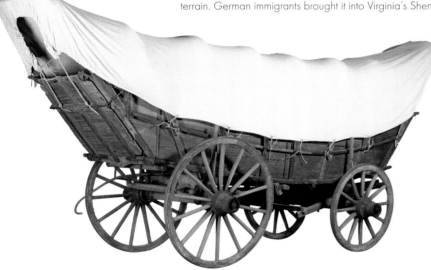

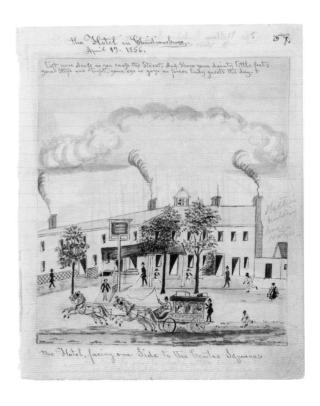

A Diverse Population in the Valley

Lewis Miller, *The Hotel in Christiansburg*, about 1856, from his drawing book of 1856–71, watercolor

The watercolor drawings of Miller emphasize the juxtaposition of English, German, and Scots-Irish people in the upper Valley. He was careful to include depictions of slaves in some of his drawings made in the Christiansburg and Wytheville regions, to give evidence of the African American population there. Miller, who migrated southward along the Great Wagon Road, was of German descent and fluent in German. He spent his last thirty years in Wytheville.

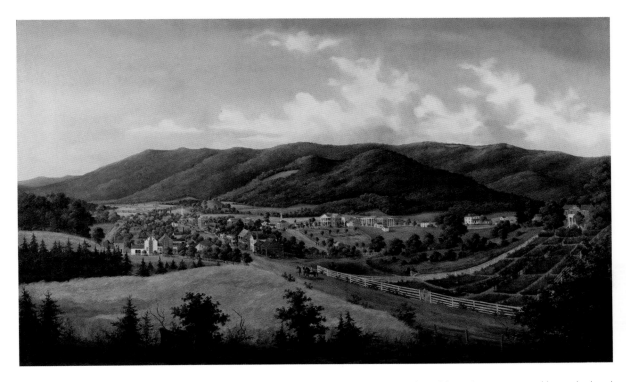

Snapshot of 1850

Edward Beyer, *Churches, Blacksmith Shop, and College: A View of Salem in Virginia*, 1855, oil on canvas. Purchased with funds provided by D. Tennant Bryan, Bruce C. Gottwald, Paul Mellon, Lora M. Robins, E. Claiborne Robins, Jr., Mrs. E. Schneider, Henry F. Stern, and Thomas Towers

The agricultural decline of the Tidewater—caused by its depleted soil—bypassed the fertile Shenandoah Valley. Some twenty residents of the western market town of Salem commissioned Beyer to paint this panorama. He records the buildings of the town and how people dressed, worked, and traveled. Like the foreground couple on horseback, we enter Salem on Main Street and then proceed to tour the town. At the distant right is Roanoke College, founded in 1842.

A Detailed Depiction

Edward Beyer, *Wytheville*, 1855, oil on canvas. Purchased with funds provided by Lora M. Robins

Typically, Beyer positioned himself at a vantage point from which he could take in the breadth of a town and most of the key buildings, which he then plotted on his canvas and lovingly painted with accuracy. The microscopic detail was relished by his patrons, who were both proud of their relatively new communities and sensitive to the beauty of their agrarian settings.

FINE SILVER AND DECORATIVE POTTERY

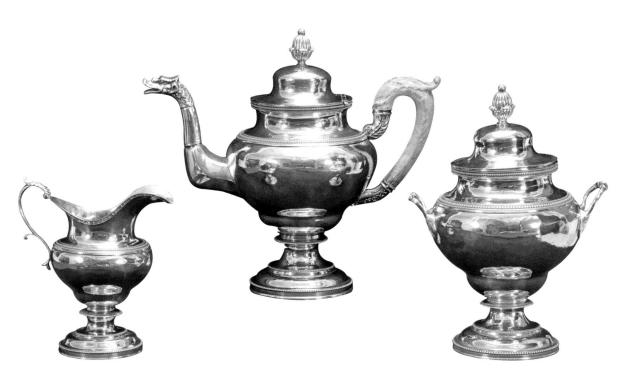

Beyond Flatware to Hollowware

Cooke & White (William Cooke and Andrew White), Petersburg or Norfolk, tea service, about 1830–33, silver. Purchased with funds provided by Lora M. Robins

Silver production increased dramatically in the early nineteenth century. Patrons in "Old Virginia" had easy access to hollowware pieces like these examples that were much grander than the flatware (primarily spoons) produced in the colony. William Cooke, in Petersburg, went into partnership with Andrew White as early as 1829; the firm of Cooke & White was active in Norfolk several years later.

Mastery of the Craft

William A. Williams, Alexandria, ewer, about 1830, silver. Gift of Betsy Gilmer Tremain

This magnificent ewer is one of the grandest pieces of silver ever produced in Virginia. It descended in the Gilmer family of Albemarle County. William Williams established himself in Alexandria in 1809 and worked there until 1835, when he moved to Washington.

Hollowware from England

John Payne (London), covered cup, 1752–53, silver. Gift of Sally Colston Mitchell

Andrew Stevenson of Albemarle County purchased this spectacular piece in London about 1836, when he served there as U.S. minister to England. It was crafted a century earlier—a time when no silversmith in Virginia was able to produce work of this quality.

Pride of Place

Attributed to Philip Byers of Rockingham County, crock, 1837, salt- and cobalt-glazed stoneware. Gift of J. F. Wine, M.D.

While many German immigrants became successful farmers in Virginia, they also developed a reputation for creating utilitarian ironwork and pottery marked by its artistry. The pottery making flourished throughout the 1800s. By the middle of the century, artistic embellishments increasingly appeared on the pieces. The town of Timberville is southwest of New Market.

Storage crock, 1843, glazed earthenware. Gift of J. F. Wine, M.D.

Pottery making in the Valley evolved from the production of purely utilitarian earthenware storage containers to more varied artistic forms and expressions.

Alexandria, D.C.

Benedict Milburn, for H. C. Smith (Hugh Charles Smith, merchant), Alexandria, D.C., crock, glazed earthenware, about 1830–50. On loan from The Lyceum, City of Alexandria

The Residence Act of 1790 moved the national capital to its third and final location on land ceded by Maryland and Virginia. Alexandria became part of the District of Columbia—a fact illustrated by such artifacts as this crock that are labeled "Alexandria, D.C." In 1846, Virginia's land was returned. This retrocession had been lobbied for and was welcomed by Alexandria residents who had lost representation in Congress, whose port needed infrastructure improvements, and whose massive slave-trading business was threatened by an anticipated ban of the slave trade in the District (as happened in 1850).

THE WESTWARD MOVEMENT

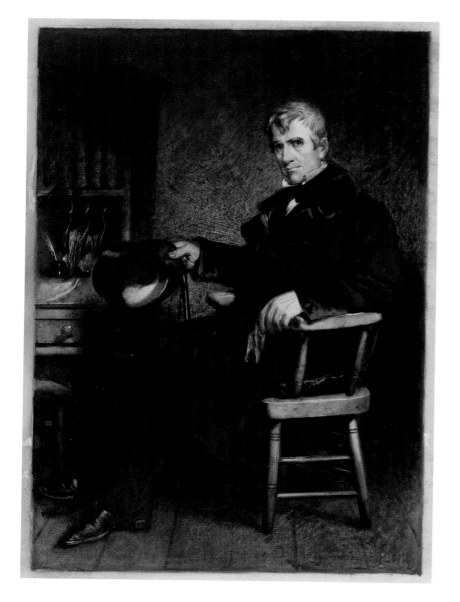

Born in Virginia

Alonzo Chappel after James Reid Lambdin, *William Henry Harrison*, 1861, copy of 1835 original, oil on board

Among the Virginians who moved west and won renown (including Henry Clay, Stephen Austin, and Sam Houston), were two future presidents—William Henry Harrison and Zachary Taylor. Born in Charles City County, Harrison served in the army in the Northwest Territory and became governor of the Indiana Territory. He defeated the Shawnee chief Tecumseh in 1811 at Tippecanoe and recaptured Detroit during the War of 1812. His military fame earned him the presidency.

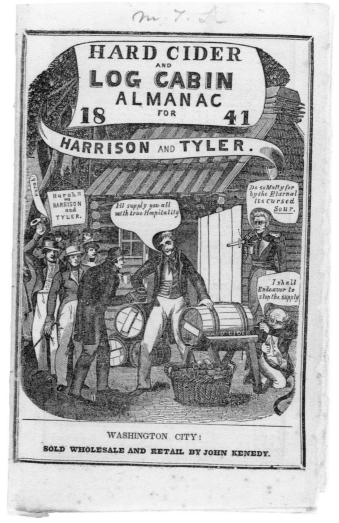

Campaign Rhetoric

John Kennedy, *Hard Cider and Log Cabin Almanac for 1841: Harrison and Tyler*, Washington City, 1840. Purchased through the William Anderson Hagey Fund

In the presidential election of 1840, the Whigs inundated the public with the slogan "Tippecanoe and Tyler Too," which references William Henry Harrison's defeat of Indians in 1811 and his running mate John Tyler. When Harrison's opponents derided him as content to live in a log cabin with a barrel of hard cider, Whigs welcomed the homespun image and anointed him the "Log Cabin and Hard Cider" candidate.

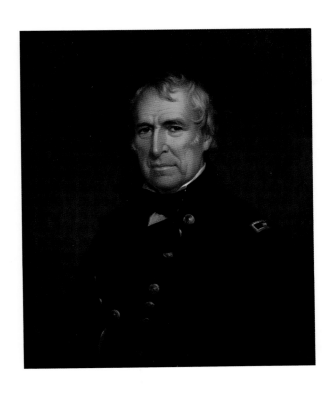

"Rough and Ready"

James Reid Lambdin, *Zachary Taylor*, 1848, oil on canvas.
On loan from The Honorable Helen Marie Taylor Collection

Born in Orange County, Virginia, Taylor was the son of a Revolutionary War officer granted land in present-day Kentucky, where the family moved. "Old Rough and Ready's" distinguished forty-year military career propelled him both to high command in the Mexican War and to the presidency. Taylor, a slaveholder who opposed the expansion of slavery, might have been effective in opposing the secession movement of the 1850s, but he died only sixteen months into his presidency, possibly from gastroenteritis (stomach virus).

Well Traveled

Unidentified maker, Westerwald, Germany, tavern mug, about 1720–50, gray salt-glazed stoneware. Gift of Delbert D. Cayce III

Around 1830, Garritt Quarles carried with him to Kentucky this mug—presumably a family heirloom. Mugs labeled "GR" (George Rex) for the king of England have been excavated at eighteenth-century Virginia sites.

"Rue the Day"

Diary of Elizabeth Ann Cooley McClure, 1842–48. Gift of Love Worrell Cox, Harriet Hawks James, and Faith Worrell Stahl through the courtesy of Dr. Ellen Stahl Carpenter

Unable to find desirable land in Carroll County, Virginia, Elizabeth and her husband, James, set out for Texas in 1846. Mosquitoes, heat, and unfriendly people drove her to write, "I rue the day we ever thought of Texas." They next tried Missouri, where both found part-time jobs teaching. Elizabeth contracted typhoid fever and died there at age twenty-two.

SLAVERY

Power of the Slaveholders

George Catlin, *The Convention of 1829–1830*, 1829–30, oil on canvas

The 1829 state constitutional convention met to address demands by western Virginians for equal representation in the state legislature. It accomplished little. Slaveholding easterners refused to relinquish political control out of fear that a new political order would threaten their perpetuation of slavery, or at the least cause slave owners to be heavily taxed to pay for roads and education badly needed in the western counties. James Monroe presided; John Marshall and James Madison were present.

Widespread Fear

Horrid Massacre in Virginia ... in Southampton County, New York, 1831

Nat Turner, enslaved since birth, learned to read and write at an early age, became deeply religious, and preached to his fellow slaves. In 1831 in the Tidewater county of Southampton, he led some sixty slaves and free blacks in a forty-eight-hour rampage of brutality that left dead fifty-seven white men, women, and children. This rebellion provoked retaliatory violence against blacks as well as widespread fear about slave insurrection throughout Virginia and other southern states. In addition, the Virginia assembly passed harsher laws restricting the lives of enslaved and free blacks.

"You Shall Be Hung"

Dr. Richard Eppes, "Code of [Slave] Laws for [Eppes] Island Plantation," Charles City County, 1850s. Gift of Elise Eppes Cutchin

This book specifies offenses committed by slaves that incurred whipping. Stealing warranted ten lashes, twenty-five for the second offence, thirty-nine for the third offense. Insolence to the master or his overseer, or disobedience, could lead to a fatality. "[S]trik[ing] or injur[ing] your master" brought 500 lashes over a period of five days. "If the act is a bad one you shall be ... hung [hanged]."

Evidence of Cruelty

Whipping post, mid-19th century. Gift of the Yates County Historical Society

Union soldiers at the close of the Civil War found this wooden whipping post in the jail yard in Portsmouth and carried it home to upstate New York as evidence of the cruelty of slavery, which their efforts had ended. Two sets of iron shackles served to hold its victims in place. Slaves could be whipped for offenses as minor as failing to work with the efficiency demanded by their overseers or for disobeying orders. Physical violence against whites could lead to a death penalty for a slave.

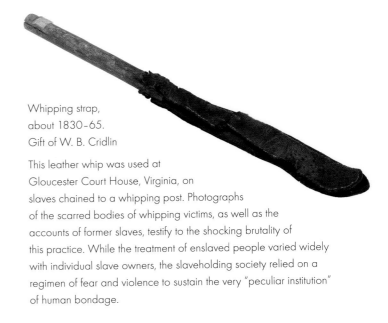

Whipping strap, about 1830–65. Gift of W. B. Cridlin

This leather whip was used at Gloucester Court House, Virginia, on slaves chained to a whipping post. Photographs of the scarred bodies of whipping victims, as well as the accounts of former slaves, testify to the shocking brutality of this practice. While the treatment of enslaved people varied widely with individual slave owners, the slaveholding society relied on a regimen of fear and violence to sustain the very "peculiar institution" of human bondage.

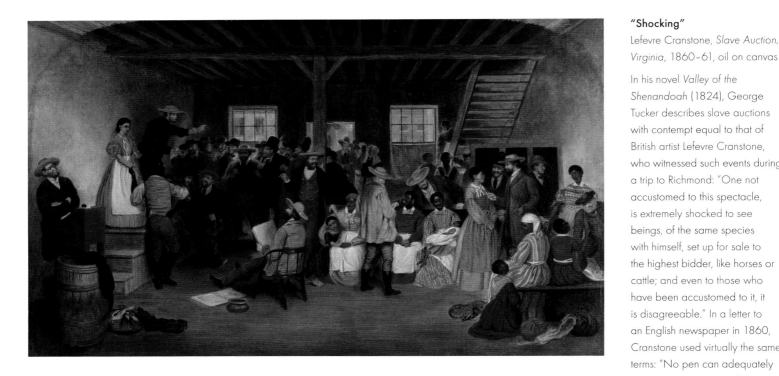

"Shocking"

Lefevre Cranstone, Slave Auction, Virginia, 1860-61, oil on canvas

In his novel *Valley of the Shenandoah* (1824), George Tucker describes slave auctions with contempt equal to that of British artist Lefevre Cranstone, who witnessed such events during a trip to Richmond: "One not accustomed to this spectacle, is extremely shocked to see beings, of the same species with himself, set up for sale to the highest bidder, like horses or cattle; and even to those who have been accustomed to it, it is disagreeable." In a letter to an English newspaper in 1860, Cranstone used virtually the same terms: "No pen can adequately describe scenes so revolting."

The Status of Property

Commissioner's Sale of Negroes ... in the Town of Upperville, in the County of Fauquier, 1845

Most travelers to antebellum Virginia expressed shock and dismay at the numerous signs of slavery they encountered—from posted notices about runaway slaves, to poor housing conditions for blacks and an idle white population. Of all such sights, the one that most distressed them was the slave auction. Broadsides and newspaper ads, which reduced black people to the status of property, publicized such sales.

Grueling Labor

Roster [of Workers] for the Richmond, Fredericksburg, and Potomac Railroad Company, 1839. Gift of CSX Corporation

Slaves were "hired out" to perform labor for others and in that way earn money for their owners. Industrial labor and, later, impressment by the Confederate States of America to dig trenches and fortifications, were the most demanding assignments. In working for railroad companies, not only did slaves perform grueling labor, but they also were paid the lowest wages.

Hellish "Eden"

Thomas Moran, *The Slave Hunt (Dismal Swamp, Virginia)*, 1864, oil on canvas. Purchased with funds provided by Lora M. Robins

The inhospitable terrain of the Dismal Swamp (in southeast Virginia) ironically allowed fugitive slaves to find refuge and develop hidden communities there. Henry Wadsworth Longfellow wrote a poem entitled "The Slave in the Dismal Swamp," and Harriet Beecher Stowe produced the novel *Dred: A Tale of the Dismal Swamp*. Both tell of runaways who remain deprived of freedom because the swamp entraps them. In Moran's nightmarish vision of a hellish Eden, figures that call to mind Adam and Eve are chased by bloodhounds.

No Remorse

Walking stick, about 1823. Purchased through the William Anderson Hagey Fund, Douglas H. Gordon Fund, Betty Sams Christian Fund, and Lucy G. Crockin Fund. Partial gift of Gary S. Johnson, Sr., and Kristina E. Johnson

Made for Brooke & Hubbard, slave auctioneers in Richmond, this cane is carved with the image of an enslaved African American man. It suggests that practitioners of the slave trade in Virginia felt no remorse for their practice but instead took pride in their despicable profession—an attitude fostered by widespread period beliefs in the racial inferiority of blacks.

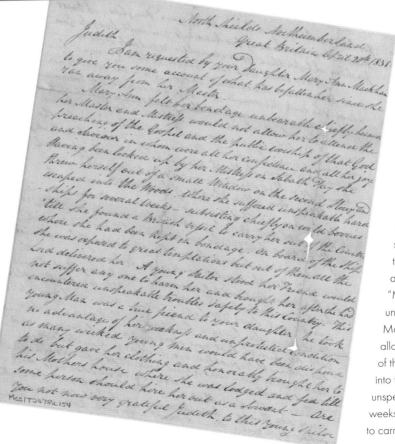

Freedom

Reverend Charles Thompson, Northumberland, England, to Judith, slave to Mrs. George Garrett, Urbanna, Virginia, letter, 20 April 1831. Gift of Mr. and Mrs. Alexander Wilbourne Weddell

Mary Ann Markham escaped slavery. Her minister reported to her mother that she was well and employed as a servant. "Mary Ann felt her bondage unbearable chiefly because her Master and Mistress would not allow her to attend the preaching of the Gospel." She "escaped into the Woods where she suffered unspeakable hardships for several weeks ... till she found a British vessel to carry her out of the Country."

License to Travel

Slave passport, after about 1830, pewter. Purchased with funds provided by Nicholas F. Taubman, Alan M. Voorhees, L. Dudley Walker, and Anne R. Worrell

The intolerable conditions of slavery had induced enough enslaved African Americans to attempt escape that free travel for blacks was restricted. Slaves who were permitted to travel off their master's plantation, or were sent on assignments by their owners, gained passage by carrying either a metal or paper passport. This pass is inscribed "Aunt Jemima Johnston, Born 1799, Nicholas Plantation, Warrenton, Virginia."

Christian Integration

Minutes of the Buck Marsh Corresponding Meeting of Baptist Brethren of Colour, Held at Winchester Meeting House, Frederick County, Va., Whitsunday and Monday 1829, Winchester, 1829. Bequest of Paul Mellon

A few Baptist churches were composed entirely of African Americans, both free and enslaved. The majority of black Baptists, however, were members of the same churches as their owners. Most black churches were linked to similar parishes, both black and white, and their representatives occasionally met together, as is recorded in these minutes.

Religious Faith

Hannah Keeble, slave baptism authorization, 14 January 1828. Bequest of Paul Mellon

At Upper Goose Creek Church in Fauquier County, Virginia, a letter of permission from a slave's owner was required for baptism. Here, the owner writes that her slave Ben had "a Noshan of joinin your Church.... We have owned Ben Ever sense A small Boy and have found him to Be [an] honest truthfull and obidient servant."

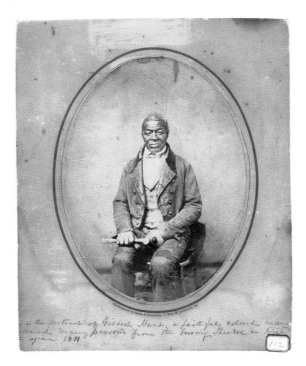

Heroic Figure

Smith & Vannerson, *Gilbert Hunt*, 1860, salt print.
Gift of Mrs. Boykin, Mrs. Crouch, Miss Colquist

Hunt, a former slave, had his photograph taken in 1860 when he was still famous and beloved for his heroic action taken a half-century earlier. He had "[res]cued many persons from the burning theatre in Rich[mond] ... year 1811." After working for the army as a blacksmith during the War of 1812, Hunt purchased his own freedom, for $800, and then opened his own blacksmith shop. (By 1860, the cost in Richmond for his freedom would have doubled to $1,600.)

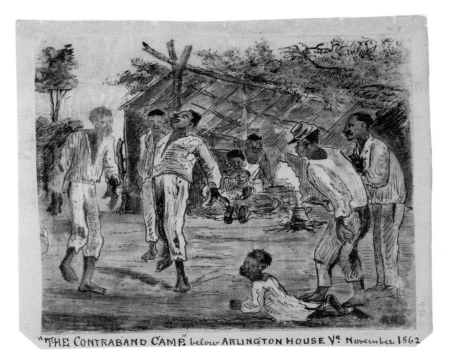

"THE CONTRABAND CAMP" below ARLINGTON HOUSE Va November 1862

Taste of Freedom

Robert K. Sneden, *The Contraband Camp, below Arlington House, Va., November 1862*, 1862, watercolor. Purchased with funds provided by Mr. and Mrs. Floyd D. Gottwald, Jr.

Arlington plantation (now Arlington National Cemetery) was the property that Robert E. Lee and his wife inherited in 1857 at the death of her father, George Washington Parke Custis. The slave population there numbered ninety. Once the Civil War began, that population was enlarged by the addition of slaves whom advancing Union soldiers freed on the premise that their (forced) support for the Confederacy made them "contrabands of war" that could be seized. The Union artist Sneden created this rare image of newly emancipated African Americans and the meager brush arbor that sheltered them.

A Free Black Who Prospered

Daniel Stickley (sheriff of Shenandoah County), announcement of a public sale of the personal estate of Prince Henry in Woodstock, 11 May 1841. Gift of Mr. and Mrs. Thomas Branch Scott

Prince Henry was a free black barber who lived in Woodstock and accumulated an estate. He was one of many former slaves in Virginia who either had earned and paid for their freedom or were emancipated by owners who saw the hypocrisy of ownership in a nation that championed equality. For decades, whites had attempted to force freedmen to leave the state. In 1851, a new Virginia Constitution required "slaves hereafter emancipated" to relocate within twelve months or "forfeit their freedom."

INTERNAL IMPROVEMENTS

The Canal Reaches the Mountains

Edward Beyer, "The James River Canal Near the Mouth of the North River," lithograph, in *Album of Virginia*, Richmond, 1858. Bequest of Paul Mellon

By 1858, the James River and Kanawha Canal had reached its unanticipated stopping point of Buchanan in Botetourt County, Virginia, just west of the mountains shown here. Despite the positive image projected in this lithograph, the undertaking proved to be disastrous for the state financially, in terms of both enormous construction costs and lost income from trade that never materialized.

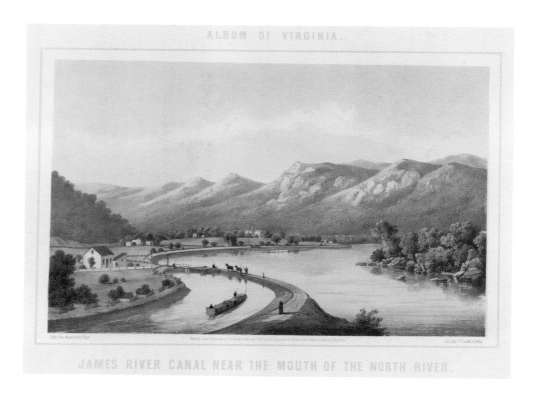

Infrastructure

Claudius Crozet, *A Map of the Internal Improvements of Virginia*, Philadelphia, 1848, lithograph

"Internal improvements" (the nineteenth-century term for the creation of a transportation infrastructure) were an objective of the Whig party during the 1830s and '40s. Maps published by Crozet, principal engineer of the Virginia state Board of Public Works, record local efforts at building lines of transportation. Pictured on his maps are various railroad projects, the Dismal Swamp Canal, and the James River and Kanawha Canal. The latter project would tie up the capital, manpower, and imaginations of Virginians for decades.

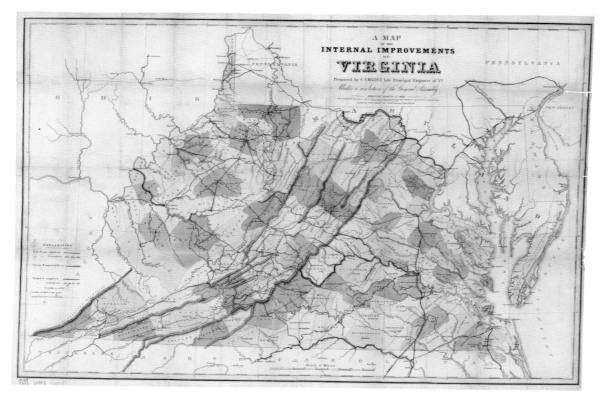

Progress with the Railroad

Edward Beyer, "Viaduct on Cheat River, B. & O. Railroad," lithograph, in *Album of Virginia*, Richmond, 1858. Bequest of Paul Mellon

Beginning in the 1830s, cities along Virginia's geologically formed fall line—where river navigation ended because of rapids or waterfalls—were stimulated to build railroad connections to the interior, across difficult terrain. The new technology of wood-burning locomotives and iron rails made the projects feasible. These lines transported farm products and coal to ports along the fall line. Local stockholders financed competing rail lines. After the Civil War these small companies were united into profitable long-distance networks.

Building a Railroad

Surveyor's transit used by William Mahone, inscribed "Norfolk and Petersburg Railroad," about 1853. Purchased through the Elis Olsson Memorial Foundation Fund

Mahone was an accomplished civil engineer and railroad executive. In 1853, he was chief engineer of the Norfolk and Petersburg Railroad, which he built using this transit. Its roadbed through the Dismal Swamp still functions, as does its track that runs from Suffolk to Petersburg in a straight line. In 1870, Mahone merged three lines to form the 428-mile Atlantic, Mississippi and Ohio Railroad, headquartered in Lynchburg.

Big Business

Roanoke Navigation Company, brass seal, 1830

In 1776 Virginia's trade was four times New York's. Canals were planned to make it even greater. The backcountry beyond the mountains was to be linked to the James and Potomac Rivers. The Roanoke Navigation Company, chartered in 1804, was to connect farms of the Virginia Piedmont to North Carolina markets, as far away as Albemarle Sound. It is believed that this seal was used to emboss business transactions of the company.

THE GROWTH OF RICHMOND

Center of Government

William James Bennett after George Cooke, *Richmond from the Hill above the Waterworks*, 1834, aquatint. Purchased in part through the Frank F. Byram Memorial Fund

In "Old Virginia," Richmond was appreciated as a governmental rather than a mercantile and industrial center. As depicted here, its capitol building perched above the city stands as a symbol of Virginia's political importance. Other buildings that are prominently pictured are civic. Although a half-century earlier the state's trade had greatly exceeded that of New York, Virginia's internal improvements had not kept pace. By 1834, Richmond's commerce lagged behind that of northern ports.

Prosperity

Lefevre Cranstone, *Richmond Looking West from Libby Hill*, about 1860, watercolor

Richmond's prosperity on the eve of the Civil War is evident in this view. Canals and railroads had impacted commerce. New industries were emerging in Virginia's cities. Richmond, Norfolk, Petersburg, Fredericksburg, Lynchburg, and Wheeling all seemed poised for further growth. Virginia now could claim 4,841 manufacturing establishments, making it fifth among the states in this category—though far behind the more industrialized northern states.

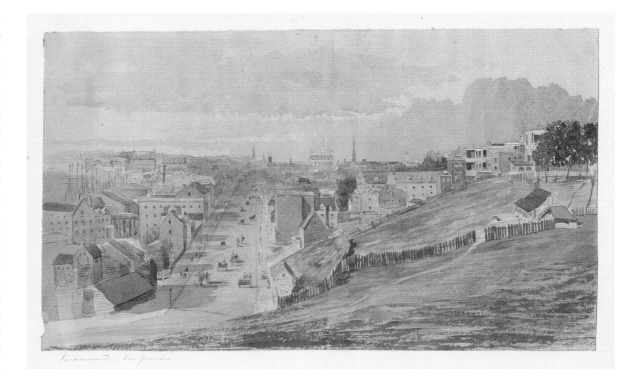

INDUSTRY ON THE RISE

Highest Price Ever

Buckner & Jones, Lynchburg, tobacco box, 1852. Purchased through the Paul Mellon Fund

A period newspaper clipping adhered to the lid of this box states that tobacco bought by Buckner & Jones was grown in Bedford County and in 1852 had brought the highest price ever. The article concludes, "China furnishes the world with its finest teas—Lynchburg with its finest Chewing Tobacco." Canals and railroads allowed for the processed tobacco product to be distributed, mainly through Richmond.

World's Largest Tobacco Center

Stacy & Co., Richmond, Virginia Dare smoking tobacco, about 1864. Gift of Norman Wesley Janitin

Richmond became the world's largest tobacco production center. It had been a center of tobacco trade since 1730. More than a century later, tobacco remained the staple crop of Virginia, and the reach of canals and railroads encouraged its production in the Piedmont and its export beyond to England, Europe, and Australia. By the 1840s, fifty tobacco factories were active in Richmond.

Locomotives and Railroad Cars

Philip Rahm, Eagle Foundry, Richmond, Virginia, 1855. Gift of Catherine Cox Chambers

This broadside advertised that the Eagle Foundry manufactured locomotive engines, tenders, railroad cars, and all descriptions of railroad machinery, stationary engines, and portable engines adapted to farming purposes. Also mentioned is mining machinery, grist and saw mill machinery, forgings and tobacco factory fixtures of every kind. The company boasts of having sixteen letters of endorsement from all over Virginia, as well as from North Carolina and Louisiana.

Third Largest Iron Manufacturer

Mitchell & Tyler (Samuel P. Mitchell and John H. Tyler), pitcher, 1851, silver. Gift of Mr. and Mrs. Frank D. Williams, Jr.

This presentation piece was awarded to Charles Campbell by the artisans who worked for him at the Tredegar Iron Works. Established in 1837, Tredegar was initially manned by experienced workers brought from Tredegar, Wales. By 1860 it was the third largest iron manufacturer in the country; its operation consumed twenty-two acres. Mitchell & Tyler was the largest retailer of silver in Virginia during the 1840s and 1850s.

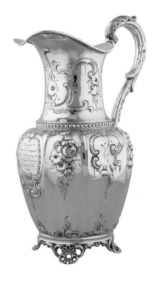

A GROWING DIVIDE

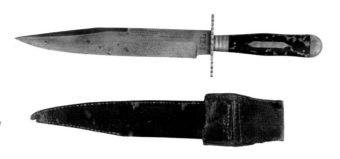

"Old Ossawottomie Brown"

John Brown's Bowie knife, taken by J. E. B. Stuart at Harpers Ferry in 1859. Gift of Virginia Stuart Waller Davis

Before Col. Robert E. Lee ordered U.S. marines to storm the building in which abolitionist John Brown and his conspirators were holding a group of hostages, he sent Lt. J. E. B. Stuart forward under a flag of truce in an attempt to negotiate a surrender. Stuart took as a souvenir this Bowie knife.

"Possuming"

J. E. B. Stuart, Fort Riley, Kansas, to Elizabeth Letcher Stuart, Richmond, letter, 31 January 1860. Gift of Stuart Bland Campbell, Jr.

Lt. Stuart boasted to his mother that he "immediately recognized Old Ossawottomie Brown, who had given us so much trouble ... in Kansas." "I got [John Brown's] bowie knife from his person while he was 'possuming,' and I have it yet," adding that capturing Brown was "the greatest service I rendered the State." Brown's purpose with his raid at Harpers Ferry was to start a slave revolt.

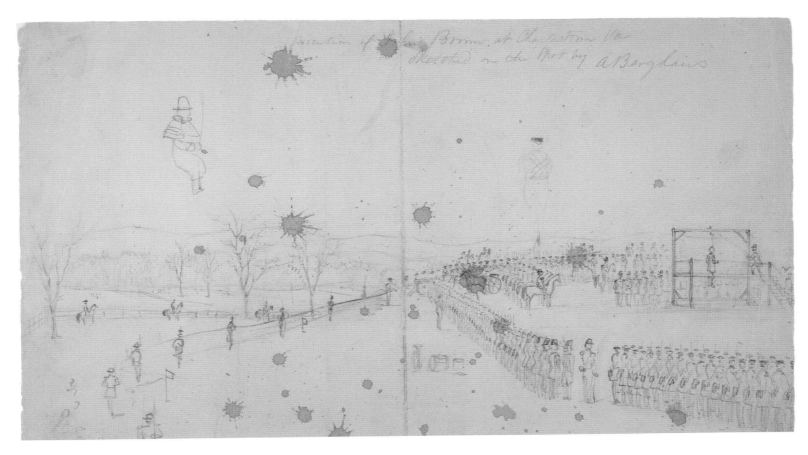

"This Guilty Land"

Albert Berghaus, *Execution of John Brown at Charlestown, VA*, 1859, pencil. Gift of Edith Rodman Swanell

The *New York Times* reported that John Brown "appeared perfectly calm and collected" as he approached the gallows for execution. He handed a prophetic note to one of his guards: "I John Brown am now quite certain that the crimes of this guilty land: will never be purged away; but with Blood." Berghaus was employed by *Frank Leslie's Illustrated Newspaper*.

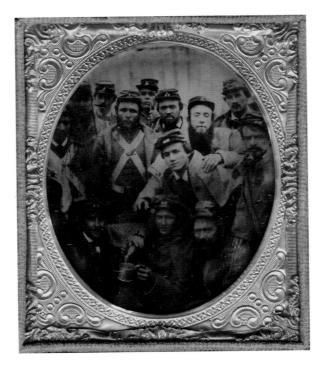

"Death Watch"

Unidentified photographer, *Richmond Grays at John Brown's Execution*, 1859, ambrotype. Gift of Mrs. Wallace C. Saunders

By family tradition of the donor, this photograph depicts militiamen assigned to "the Death-watch" prior to John Brown's execution. Troops were sent to deter attempts by abolitionists to free Brown.

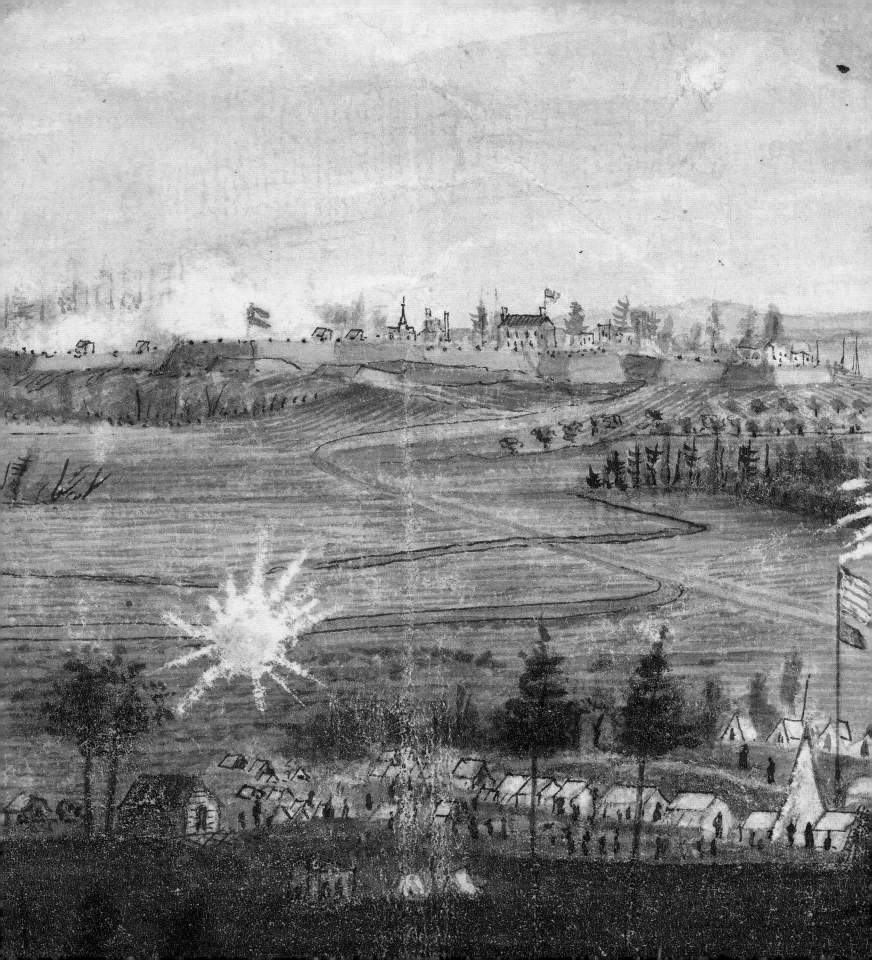

1861–1876

CIVIL WAR AND RECONSTRUCTION

Virginians were instrumental in both creating the Union in 1776 and breaking it apart eighty-five years later. The war began when the Confederate States of America attempted to secede as an independent nation that would perpetuate slavery. Southern wealth was mostly invested in slaves and slave-worked land, and, with the election of President Abraham Lincoln who pledged to ban slavery in new states, the slaveholding South feared becoming too weak in Congress to prevent the abolition of slavery. Most Virginians rejected secession until they were called upon to provide troops to invade the seceded states, where some Virginians held property and where a number of kinsmen had emigrated. The Virginia legislature rejected participation in the invasion. The state's far northwestern counties voted differently: they refused to be a part of secession and instead formed West Virginia in 1863. Richmond became the capital of the Confederacy, and Virginia became the bloodiest battleground of the war. Three out of four white southern men of military age became soldiers, and they died—many of them in Virginia—at a rate that was proportionately three times that of their northern counterparts. In all, at least 258,000 southern soldiers died—one in five white men and one in three soldiers. At the conclusion of the Civil War—which ended in Virginia at Appomattox—slavery was ended and in 1867 black males voted, but the workload and standard of living of African Americans changed little. During Reconstruction, Virginia was placed under federal military rule for five years.

OPTING FOR THE UNION

The Longest Serving General
Miner Kellogg, *Winfield Scott*, about 1851, oil on canvas.
Purchased with funds provided by Mr. and Mrs. Woodbury S. Ober

Scott served as a general in the U.S. Army longer than any other person
in American history. His fifty-three-year career started with the War of
1812, peaked when he was victorious in the Mexican War, and ended
at the start of the Civil War. Though born in Dinwiddie County, Virginia,
he did not join the Confederacy and instead devised the Union strategy—
called the Anaconda Plan—that blocked, separated, squeezed, and
ultimately defeated the Confederacy.

Virginia Pride
Gold medal presented by the
Commonwealth of Virginia to
Winfield Scott for victories in the
Mexican War, 1847. Gift of the
estate of Virginia Scott Hoyt

Scott's many accomplishments—
most notably his victories in the
Mexican War—brought such
pride to Virginians that the state
awarded him this medal.

Virginia Pride
Sword awarded to George H. Thomas for distinguished service in the
Seminole and Mexican Wars, 1847. Gift of Judith E. and Fanny C. Thomas

To honor his gallantry in two wars, proud residents of rural Southampton County, Virginia, presented this
engraved silver sword to their native son. He wore it only once, at his 1852 wedding to Frances Kellogg of
Troy, New York. He left the sword in the care of his sisters in Virginia. In April 1861, Thomas chose to remain
in the U.S. Army. When he asked to have the sword sent to him, his sisters, Judith and Fanny, refused—a
dramatic example of how the Civil War split families.

EMBLEMS OF THE ERA

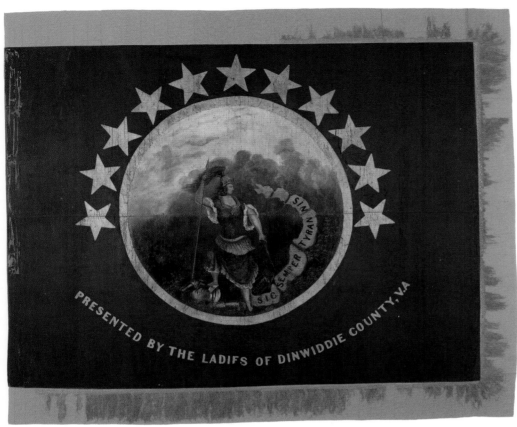

The Ladies Participate

Virginia state flag, presented by the ladies of Dinwiddie County, 1861. Maryland Steuart Collection, gift of Richard D. Steuart

The obverse side depicts the Virginia state seal and motto, "Sic Semper Tyrannis" ("Thus Always to Tyrants"). This female symbol of virtue had been chosen in 1776 to demonstrate that Virginians were no longer willing to be dominated by a "masculine" power, England. The reverse (not shown) depicts a figure of Liberty holding the First National Confederate flag in her left hand and a Confederate shield in her right hand, standing over a U.S. flag and broken staff on the ground. This imagery states that, once again, domination by outsiders was being rejected. The flag was presented to a military unit.

Similar to the "Stars and Stripes"

First national flag of the Confederacy, 1861. Gift of Mrs. Ruth Southgate Bush

The Confederate First National pattern flag, also known as the "Stars and Bars," was adopted in March 1861. Stars were added to the flag as states seceded from the Union. This flag would have been made after 20 May 1861, when the eleventh state to secede (North Carolina) joined the Confederacy. This large flag (twelve feet long) was most likely flown over a building and not used on the battlefield, where its design would—and did—cause confusion with the similar "Stars and Stripes" flag of the Union forces.

Claiming George Washington

Impression of the Great Seal of the Confederacy, 1862. Gift of Mrs. James Moore

The Confederate seal depicts the equestrian statue of George Washington that was erected in 1857 at the Virginia Capitol in Richmond. Both the Confederacy and the United States claimed Washington as a father of their nation.

SECESSION

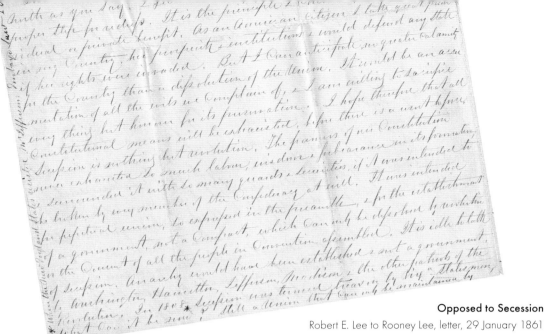

The Act of Secession

Pen used by Valentine Southall to sign the Virginia Ordinance of Secession, inserted into a holder made from the carriage of a gun that fired on Fort Sumter. Gift of Polly Venable Dulaney

After seven Deep South states seceded and Confederate troops in Charleston fired on federal Fort Sumter in 1861, President Abraham Lincoln called for 75,000 troops to put down the rebellion. Officials in Richmond faced a decision: send militia units to fight fellow southerners or join the southern states in secession. Their choice to secede determined the magnitude, campaigns, and duration of the Civil War.

Opposed to Secession

Robert E. Lee to Rooney Lee, letter, 29 January 1861

Lee vehemently opposed secession and said so in multiple letters to family members. Here he tells his son that no greater calamity could befall the country than dissolution, that he would sacrifice everything but honor for its preservation, that secession is nothing but revolution, that a nation should not be maintained by violence, and that only in defense of Virginia would he again draw his sword. On 18 April 1861 Lee was offered field command of the U.S. Army. He declined, putting aside a highly promising career in favor of his allegiance to Virginia. He would not bear arms against his native state.

The Cost of Secession

Alfred Wordsworth Thompson, *A Family of Virginians Leaving their Home and Going South on the Advance of Genl. Patterson's Army from Martinsburg*, 1861, pencil, ink, and watercolor. Bequest of Paul Mellon

The artist explained: "Many Wealthy families ... deserted their farms and plantations taking their Servants and such articles of Comfort as could be conveniently carried ... the Master of the House riding in advance with fowling piece or rifle ... the [enslaved] Males marching beside the Carriage each armed with a gun, as they say, 'to keep de d— Yankees and abunlishioners from harmin de Ladies.'"

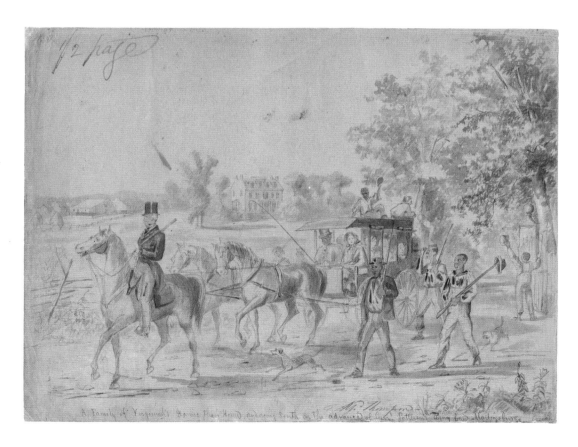

ROBERT E. LEE

Commander of the Confederate States Army

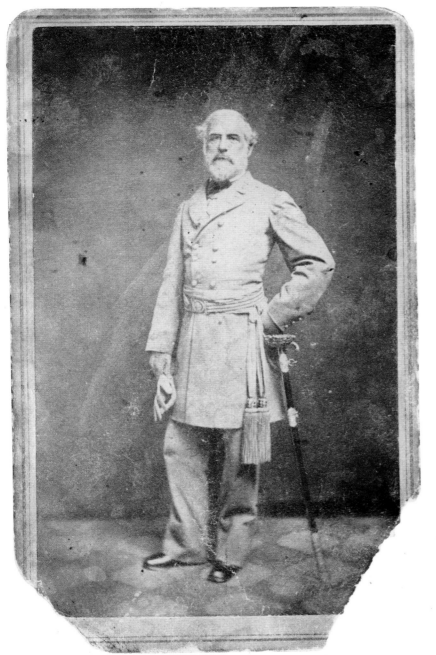

All That Was Noble and Much That Was Troubling

Julian Vannerson, *Robert E. Lee*, 1864, carte de visite by Selden & Co., Richmond

Lee was a handsome, charismatic officer whose deportment spoke as much of his character as of his attainments. He came to symbolize all that was noble and much that was troubling about the Virginia society from which he had emerged, and which the Confederacy itself destroyed in trying to preserve it. His distinguished career in the U.S. Army was ended by the Civil War. Lee's extreme reluctance to end that career and his vehement opposition to secession were eclipsed by an even stronger feeling of allegiance to the state that generations of the Lee family had served.

Support in Maryland

Confederate uniform of Robert E. Lee, about 1861. Maryland Steuart Collection, gift of Richard D. Steuart

Many in Maryland were sympathetic to the South. Women of Carroll and Frederick Counties presented this uniform to Lee as an expression of admiration. It was sent through the lines by Thomas N. Webb of Baltimore who had met the general years earlier when Lee worked there as a U.S. Army engineer. Webb sent Lee many hats that he wore during and after the war.

Uniform stars of Robert E. Lee, about 1861. Gift of Robert E. Lee, IV, and Mrs. A. Smith Bowman, Jr., and gift/purchase from Anne Carter Zimmer

Lee removed these stars from the uniform that he wore at the end of the war and sent them to a friend, Belle Harrison, in May 1865. Unlike most other Confederate full generals, Lee did not encircle the three stars of his rank within a wreath, but instead wore them simply in a line.

IMAGES OF THE CIVIL WAR

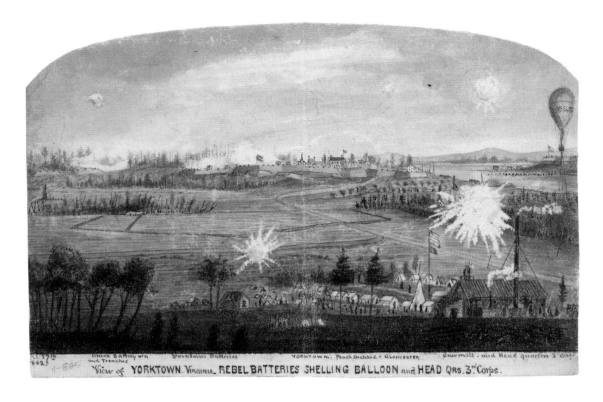

Introduction of Air Power

Robert K. Sneden, *View of Yorktown, Virginia. Rebel Batteries Shelling Balloon and Head Qrs. 3d Corps*, April 1862, watercolor. Purchased with funds provided by Mr. and Mrs. Floyd D. Gottwald, Jr.

Sneden wrote, "[Professor Lowe's reconnaissance] balloon went up for the first time this forenoon.... Lowe and two officers were in it.... They could see, of course, the inside of the enemy's works, sketch the outlines of parapets, and count the guns already mounted, and note their bearings. From this, the draughtsman can make ... maps and plans...."

Destruction of Railroads

Alfred Wordsworth Thompson, *Locomotive and Tender Thrown from the Rail Road Bridge at Harpers Ferry by the Secessionists*, 1861, pencil and watercolor. Bequest of Paul Mellon

Throughout the war, Confederate forces in Virginia slowed Union troop movements by destroying railroads. On the reverse, the artist wrote, "The destruction of Locomotives on the Baltimore & Ohio R Road has been terrible; no less than 50 of the finest kind having been burnt or broken up, at Martinsburg & other points on the Road."

Invasion of Virginia

Alfred Wordsworth Thompson, *Drainesville [Dranesville], Fairfax County*, 1861, pencil and chalk. Bequest of Paul Mellon

An artist for the popular illustrated magazine *Harper's Weekly*, Thompson sketched episodes of the war in Virginia during its opening months. Nineteen of Thompson's drawings in this group were bequeathed to the Virginia Historical Society by Paul Mellon.

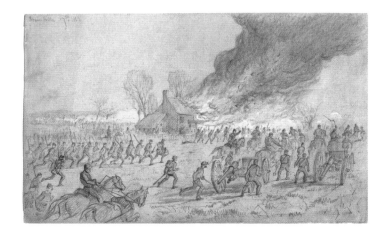

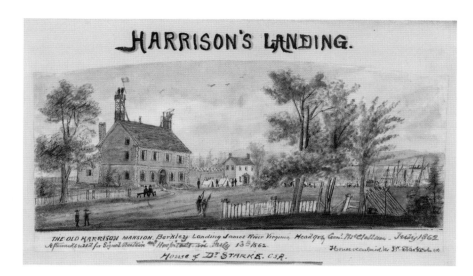

The Creation of "Taps"

Robert K. Sneden, *Old Harrison Mansion, Berkeley Landing, James River, Virginia. July 1862 - Headquarters Gen. McClellan,* watercolor. Purchased with funds provided by Mr. and Mrs. Floyd D. Gottwald, Jr.

It was here at Harrison's Landing (Berkeley Plantation) in 1862 that Union general Daniel Butterfield composed "Taps" to serve as the bugle call that would alert troops to prepare for the evening roll call. It was soon used as well at military funerals.

Importance of Maps

Robert K. Sneden, *Map of Harrison's Landing, James River, Va.,* 8 July 1862. Purchased with funds provided by Mr. and Mrs. Floyd D. Gottwald, Jr.

Private Sneden, a soldier-artist and map maker for the Union army (40th New York Infantry), served during the Peninsula Campaign and in northern Virginia prior to his capture in 1863 and imprisonment, in both Richmond and in Georgia at Andersonville Prison. His maps were valuable to his commanding officers, as they are to us today as records that illuminate the progress of the Civil War. Sneden produced more than 900 watercolors and maps, along with a text of some 5,000 pages.

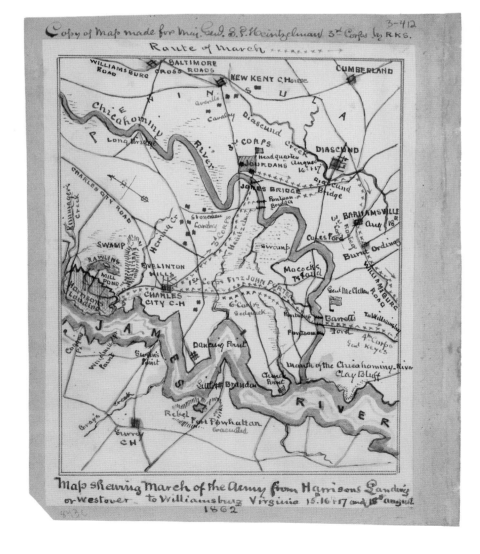

Sketching in the Field

Robert K. Sneden's dispatch case, about 1861, japanned tin. Purchased with funds provided by Bruce & Nancy Gottwald in honor of E. Lee Shepard

The question of how the artist Robert Sneden managed to make hundreds of watercolor images of events and places is partially answered by the discovery of this dispatch case. There the artist could preserve small sketches that he later developed into more finished works. Inside the lid is a note: Sneden's commanding officers offer a reward to any finder of this case "should I [Sneden] be found killed."

War Brought to a Bucolic Landscape

Timothy O'Sullivan, *Union Tents near the Town of Culpeper*, November 1863, albumen print

This beautifully composed image records the presence of a Union encampment of forty or fifty tents in a bucolic landscape surrounding a prospering market town.

Recording the War

Edwin Forbes, *A Wintry March*, early 1860s, pen and ink. Gift of the William R. Berkley Family

From 1861 to 1864, Forbes, who was trained by the animal and landscape painter A. F. Tait, supplied *Frank Leslie's Illustrated Newspaper* with lively imagery. That training accounts for his accomplishment here with the difficult imagery of men hauling artillery in the midst of snow and wind.

Brady's Most Popular Photographs

Mathew Brady, *Capt. Robertson's Battery of Horse Artillery*, 20 June 1862, carte de visite

This mounted Union battery stands in formation near Richmond during the Peninsula Campaign. Views of officers and units issued in small formats of carte de visite and stereograph were among Mathew Brady's most popular photographs.

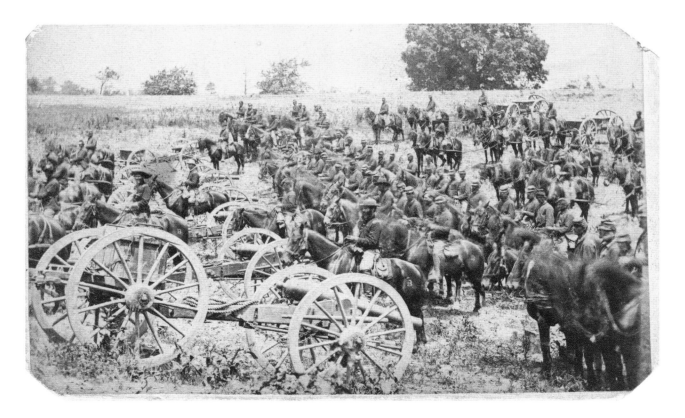

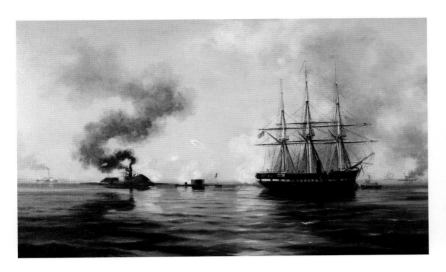

The First Battle between Ironclads

Xanthus Smith, *Battle between the Monitor and the Merrimack*, about 1880,
oil on canvas. Purchased with funds provided by Lora M. Robins

In March 1862, the ironclad ship the CSS *Virginia*, made from remnants of the USS
Merrimack, destroyed two wooden-hulled U.S. warships at Hampton Roads. That battle
revolutionized naval warfare by proving that wooden vessels were obsolete against
ironclads. The next day the Union's first ironclad, the USS *Monitor*, arrived and fought
the *Virginia* to a draw—in the world's first battle between ironclads—ensuring the safety
of the Union blockade fleet. Within weeks, Great Britain—the world's leading naval
power—canceled construction of wooden ships.

Returning to Virginia's Battlefields

C.R. Rees & Company, Petersburg, *Petersburg, Va.*, about 1887,
albumen print

This stark, but peaceful view shows "the Crater" more than two
decades after it had become one of the bloodiest and most famous
battle settings of the war. On the outskirts of Petersburg, on 30
July 1864, Union forces exploded a mine that blew a gap in the
Confederate defenses. Confederate forces quickly recovered, with
both sides suffering severe casualties. The sound of the nighttime
explosion awakened every resident of Petersburg and the memory of it
was passed down through families there for a hundred years.

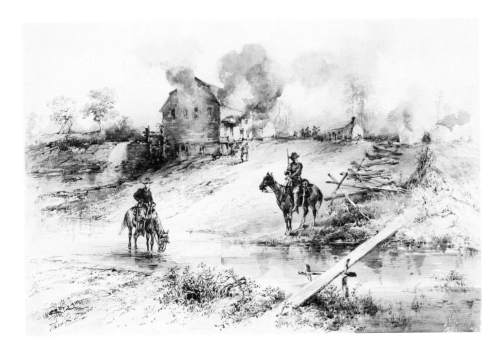

"Eat Out Virginia Clean"

Theodore R. Davis, *Union Troops Burning Out the
Shenandoah Valley*, 1864, pen and ink

Lt. Gen. Ulysses Grant ordered Maj. Gen. Philip
Sheridan to destroy the Valley: "Eat out Virginia clean ...
so that crows flying over it ... will have to carry their own
provender with them.... Do all the damage to railroads
and crops you can.... Carry off stock of all descriptions,
and Negroes, so as to prevent further planting. If the war
is to last another year, we want the Shenandoah Valley
to remain a barren waste."

STONEWALL JACKSON

Confederate General

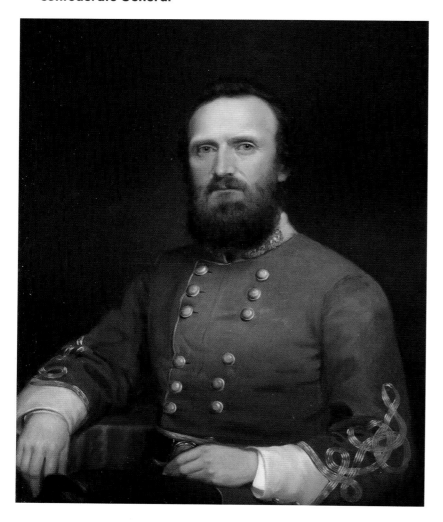

Hero of Manassas

William Garl Brown, *Thomas Jonathan Jackson*, about 1866, oil on canvas. On loan from the Virginia Division, United Daughters of the Confederacy

Brown painted this portrait from a Nathaniel Routzahn photograph of 1862. Virginia Military Institute professor Thomas Jonathan "Stonewall" Jackson of Clarksburg, Virginia (now West Virginia) became one of the most successful of the Confederate generals. He earned his nickname during the first battle of Manassas on 21 July 1861, when Confederate troops rallied around Jackson's troops where he was said to be "standing like a stone wall." The men under his command became known as the "Stonewall Brigade."

Scholar and Soldier

Bookcase of Thomas Jonathan Jackson, mid-19th century. Acquired from the Confederate Memorial Association

Stonewall Jackson's personal library was preserved in its original bookcase by the Confederate Memorial Association, which was subsumed by the Virginia Historical Society in 1946. Because Jackson was both a devout Presbyterian and a professional soldier, religious and military texts were common in his library.

Rapid Movement of Troops

Pocket watch of Thomas Jonathan Jackson, about 1850 (face and mechanics date to after 1863). Acquired from the Confederate Memorial Association

Stonewall Jackson famously stared at this watch while observing the progress of his troops. Much of his military success resulted from his rapid repositioning of his army. Careful not to exhaust his soldiers during forced marches, he ordered ten minutes rest each hour. (The face of this watch has been replaced.)

RENOWNED COMMANDERS

J. E. B. Stuart and John Singleton Mosby

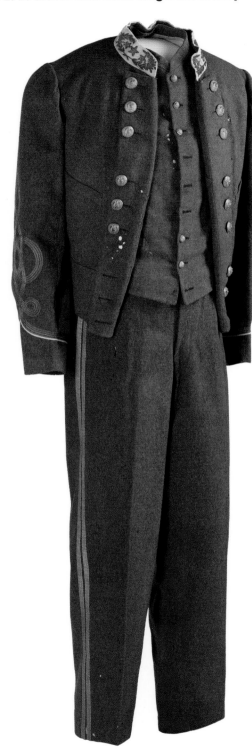

"The Last Cavalier"
Uniform of J. E. B. Stuart, about 1861–62. Gift of Virginia Stuart Waller Davis

The reconnaissance skills and cavalier persona of Confederate cavalry commander Maj. Gen. J. E. B. (James Ewell Brown) Stuart of Patrick County, Virginia—"the Last Cavalier"—boosted southern morale and earned him renown as the "eyes and ears" of Robert E. Lee's army. A general's insignia is prominent here in the gold braid on the sleeves and the three stars on the collar. On each side of the jacket, large brass buttons present the Confederate General Staff eagle insignia. Stuart wore this uniform when he was mortally wounded at Yellow Tavern, near Richmond, in May 1864, at age thirty-one.

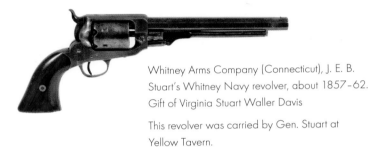

Whitney Arms Company (Connecticut), J. E. B. Stuart's Whitney Navy revolver, about 1857–62. Gift of Virginia Stuart Waller Davis

This revolver was carried by Gen. Stuart at Yellow Tavern.

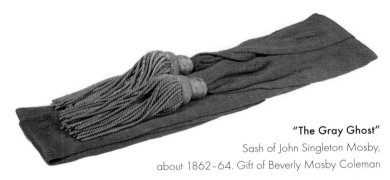

"The Gray Ghost"
Sash of John Singleton Mosby, about 1862–64. Gift of Beverly Mosby Coleman

A Confederate cavalry battalion commander who was born in Powhatan County, Virginia, Mosby later lived in Warrenton. He had been a scout for J. E. B. Stuart before passage of the Partisan Rangers Act allowed the formation of Mosby's Command, a regimental-sized unit of rangers (1,900). They operated in northern Virginia, conducting lightning-quick raids before disappearing into the civilian population. Mosby's gallantry earned him the nickname "Gray Ghost." He projected flamboyance to enhance his reputation. This sash was reputedly worn by Mosby when he was wounded on 21 December 1864.

CASUALTIES OF THE WAR

From Wedding to Funeral
Unidentified photographer,
Gen. John Pegram,
1861–65, tintype.
Gift of J. Rieman McIntosh

After eighteen days of marriage, Pegram was killed in 1865 leading a charge at the battle of Hatcher's Run in Virginia. His widow returned to Richmond with her husband's body, and, exactly three weeks after their wedding, Pegram's funeral took place in the church where the couple had been married.

"Prepare to Follow"
Robert E. Lee to Hetty Cary Pegram, letter,
11 February 1865. Gift of Mrs. Henry Coleman Baskerville

In his condolence letter to Hetty Pegram, Robert E. Lee wrote, "I cannot find words to express my deep sympathy in your affliction.... As dear as your husband was to you, as necessary apparently to his Country and as important to his friends, I feel assured it was best for him to go at the moment he did.... We are left to grieve at his departure, cherish his memory and prepare to follow."

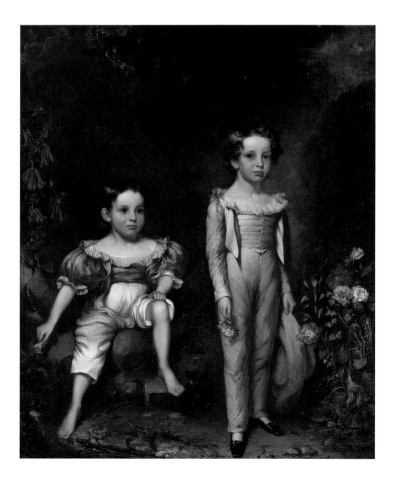

A War for Rich and Poor
William James Hubard, *Randolph and Benjamin Harrison,*
1833, oil on canvas. On loan from Mary Bradshaw

The war altered the lives of Virginians rich and poor. Benjamin Harrison, pictured here (to the right) at age five at the family plantation of Upper Brandon in Prince George County, with his younger brother Randolph, age three, were raised by their father William Byrd Harrison amidst wealth. Both would serve in the Confederate army. Randolph lost his right leg at Hatcher's Run. Benjamin was killed at the battle of Malvern Hill, both in Virginia.

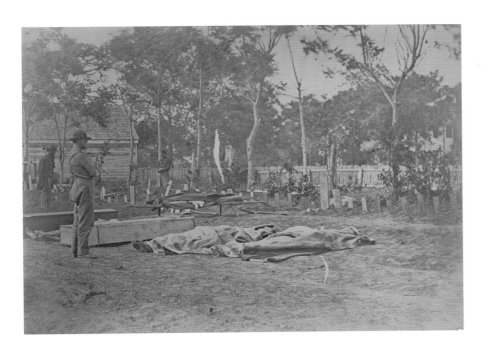

One-Sided Battle

Unidentified photographer, *Burial of Confederate Dead after the Battle of Fredericksburg*, December 1862. From the Collections of The Confederate Memorial Literary Society managed by the Virginia Historical Society

A frontal attack against entrenched Confederate forces at Fredericksburg, Virginia, was described to President Abraham Lincoln as "butchery." In one of the most one-sided encounters of the war, Union Maj. Gen. Ambrose Burnside lost 12,000 soldiers. A northern photographer accompanying Burnside recorded this image as evidence that Confederate Gen. Robert E. Lee suffered losses as well; those totaled 4,000.

The Horror of War

Mathew Brady, *In the Trenches, Fredericksburg, Virginia*, 3 May 1863. From the Collections of The Confederate Memorial Literary Society managed by the Virginia Historical Society

Confederate Maj. Gen. Jubal Early attempted to hold Fredericksburg when Robert E. Lee's army moved west to counter Union Maj. Gen. Joseph Hooker at Chancellorsville. In what was the Second Battle of Fredericksburg, Union divisions under Maj. Gen. John Sedgwick—at the cost of 1,100 men—pushed Confederate forces off their defenses at Marye's Heights, leaving 700 dead "in the trenches." With images such as this example, Mathew Brady introduced northern audiences on the home front to the horror of war.

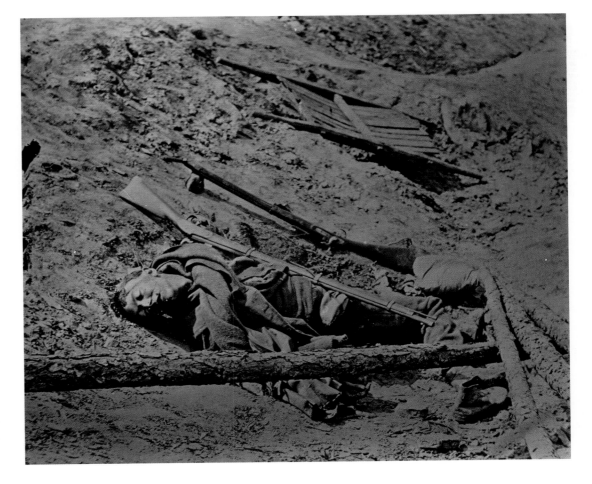

CONFEDERATE AND UNION SOLDIERS

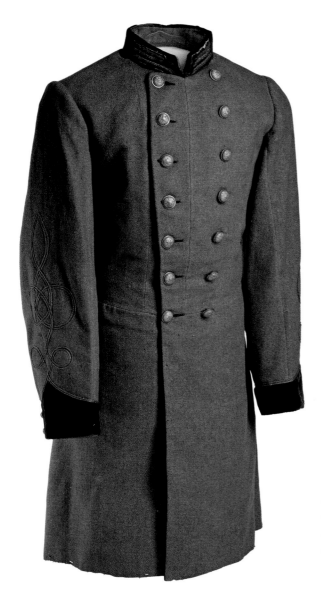

Uniform of Capt. Richard H. Parker, assistant surgeon, 32nd North Carolina Infantry, about 1863–65. Maryland Steuart Collection, gift of Richard D. Steuart

Initially the adjutant of his regiment, Parker relinquished his duties of record keeping in answer to the overwhelming medical challenges faced by an ill-prepared army. He was commissioned an assistant surgeon in 1863. Parker's regiment served in Lee's Army of Northern Virginia and was present at the surrender at Appomattox. By 1865, 3,200 Confederate and 12,000 Union surgeons developed knowledge and skills that reduced death from disease and wounds.

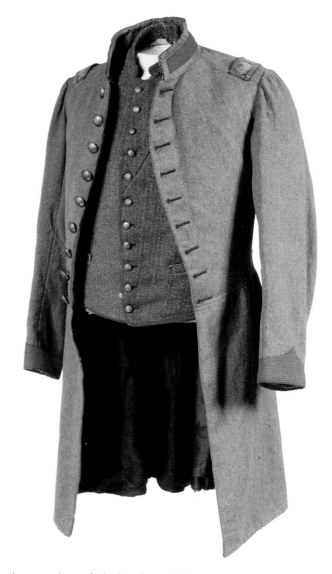

Frock coat and vest of Charles Ellis Munford, Letcher Artillery, 1861–62. Gift of A. Churchill Young III

Lt. Munford was killed on 1 July 1862, at the battle of Malvern Hill. A wagon carried his body and belongings—including his full uniform—seventeen miles to his parents' Richmond home. Awakened, the father suffered a "dreadful attack," was placed "in a hot bath" and given "laudnum and other things." He attempted to console himself with the thought that his son died "standing up to his duty like a true born Virginian defending his home & his Country."

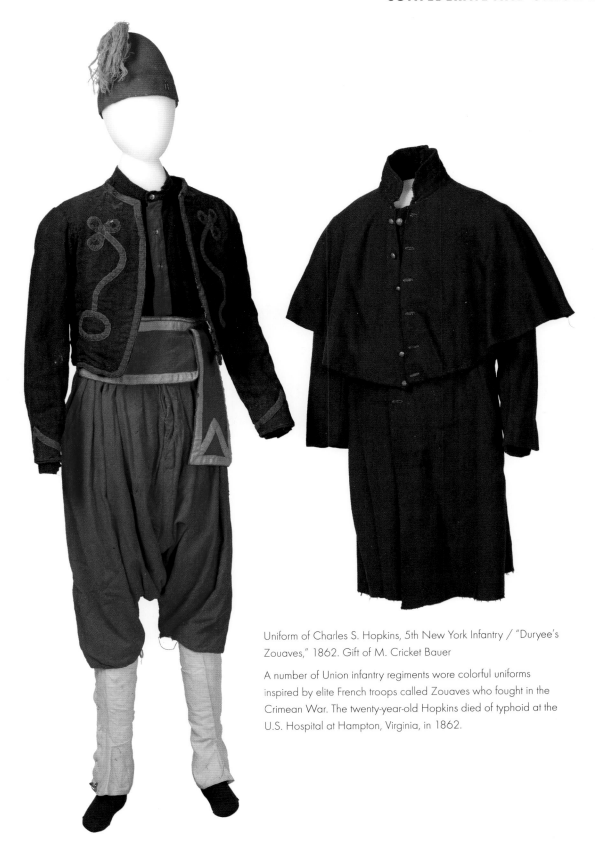

Uniform of Charles S. Hopkins, 5th New York Infantry / "Duryee's Zouaves," 1862. Gift of M. Cricket Bauer

A number of Union infantry regiments wore colorful uniforms inspired by elite French troops called Zouaves who fought in the Crimean War. The twenty-year-old Hopkins died of typhoid at the U.S. Hospital at Hampton, Virginia, in 1862.

WEAPONS OF THE CIVIL WAR

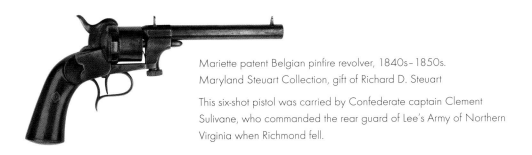

Mariette patent Belgian pinfire revolver, 1840s–1850s.
Maryland Steuart Collection, gift of Richard D. Steuart

This six-shot pistol was carried by Confederate captain Clement
Sulivane, who commanded the rear guard of Lee's Army of Northern
Virginia when Richmond fell.

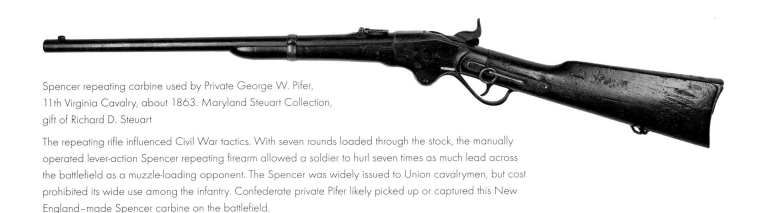

Spencer repeating carbine used by Private George W. Pifer,
11th Virginia Cavalry, about 1863. Maryland Steuart Collection,
gift of Richard D. Steuart

The repeating rifle influenced Civil War tactics. With seven rounds loaded through the stock, the manually
operated lever-action Spencer repeating firearm allowed a soldier to hurl seven times as much lead across
the battlefield as a muzzle-loading opponent. The Spencer was widely issued to Union cavalrymen, but cost
prohibited its wide use among the infantry. Confederate private Pifer likely picked up or captured this New
England–made Spencer carbine on the battlefield.

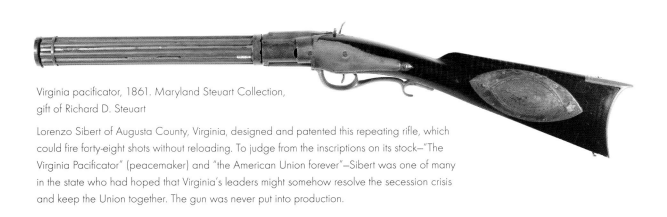

Virginia pacificator, 1861. Maryland Steuart Collection,
gift of Richard D. Steuart

Lorenzo Sibert of Augusta County, Virginia, designed and patented this repeating rifle, which
could fire forty-eight shots without reloading. To judge from the inscriptions on its stock—"The
Virginia Pacificator" (peacemaker) and "the American Union forever"—Sibert was one of many
in the state who had hoped that Virginia's leaders might somehow resolve the secession crisis
and keep the Union together. The gun was never put into production.

S. C. Robinson Arms Manufactory, Richmond, Sharps carbine, about 1862.
Maryland Steuart Collection, gift of Richard D. Steuart

The Sharps carbine was a manually operated breech-loading firearm that was popular with the cavalry of both armies. Using the lever, which served as a trigger guard, the soldier could open the rear of the barrel—the breech—and insert a cartridge containing gunpowder and projectile. He could reload easily—on horseback, kneeling, or even lying down—and fire twice as fast as his muzzle-loading opponent.

Richmond Armory, Springfield-style rifled musket, 1863.
Maryland Steuart Collection, gift of Richard D. Steuart

Inexpensive and reliable, the rifled musket was the most common infantry weapon used by both sides. Spiral grooves (rifling) in its barrel increased accuracy up to 300 yards, making infantry bayonet charges costly and forcing cavalry to dismount. Its soft lead minie ball inflicted dangerous wounds that caused an unprecedented number of combat deaths. This is one of 31,000 rifled muskets manufactured by the Richmond Armory on machinery captured from the federal armory at Harpers Ferry in 1861.

Leech & Rigdon (Thomas Leech and Charles Rigdon), revolver, 1863.
Gift in memory of Dr. Alexander G. Brown III, by Mrs. Alexander G. Brown III, and Mr. and Mrs. Thomas L. Disharoon

Used primarily by officers and cavalrymen on both sides, revolvers allowed high fire rates at close range. Most Civil War revolvers fired six shots before each cylinder needed to be individually reloaded with gunpowder, projectile, and detonator (percussion cap). Leech & Rigdon produced about 1,500 pistols for the Confederacy at its factories in Mississippi and Georgia.

AN ARMY PHOTOGRAPHER'S RECORD

Supply and Devastation

Andrew J. Russell album, about 1865; 1994.121.1-107. Gift of James J. Moore

Photography was two decades old at the outbreak of the war. Most photographs that record its progress were made on the Union side by entrepreneurs. The exception was Captain Andrew J. Russell, attached to the U.S. Military Railroad and the Quartermaster Corps. His images capture the technology, infrastructure, and transportation systems used to move and supply Union armies, and the devastation left by the war. This album of 132 of his photographs is one of only several that survive.

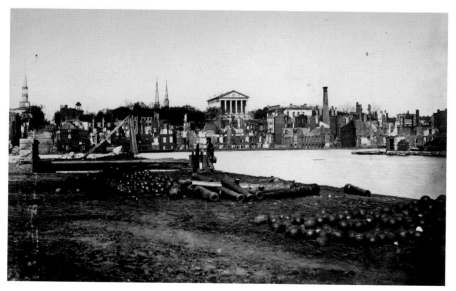

Richmond in Ruins

Andrew J. Russell, *Richmond across the Canal Basin Showing Ruined Buildings, Capitol in Distance, April, 1865*, 1865, albumen print. Gift of James J. Moore

Russell included in his album twenty-two extraordinary views of the city of Richmond in ruins following the evacuation fire. Set by Confederates to deprive the Union army of supplies, the fire raged out of control and consumed most of the city's commercial district. The photographs not only record the extent of the destruction but also offer clues to its appearance prior to the fire.

LIBBY PRISON

Made Infamous by Postwar Recollections

Andrew J. Russell, *Libby Prison*, April 1865, albumen print. Gift of James J. Moore

In 1854, Luther Libby rented a three-building complex in Richmond along the James River to sell shipping supplies and groceries. In 1861 the Confederate government appropriated the buildings for use as a hospital and prison; a year later the warehouses became a prison for Union officers and a processing center for all prisoners. More than 125,000 Union soldiers passed through Libby Prison by March 1864, when food shortages and concerns about security in the city led to the transfer of most prisoners to Georgia. In 1889, the complex was moved to Chicago to serve as a war museum.

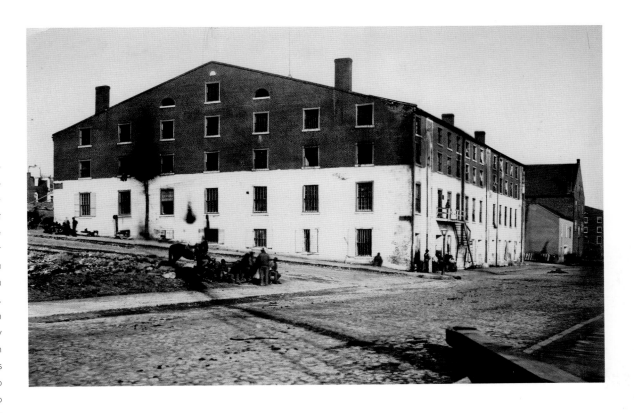

Key from Libby Prison, 1861. Gift of the estate of Douglas Southall Freeman

Though far from the worst of the war prisons, Libby Prison was made infamous by the letters home and published recollections of many of the Union prisoners who were housed there and described horrific conditions, including overcrowding and food shortages. This key that unlocked one of its doors was saved as a reminder of that history.

Window frame from Libby Prison, about 1845–52. Gift of Rochester Museum and Science Center

Private E. L. W. Baker of the 21st Michigan Regiment carved his name and unit into this window frame. He was wounded and captured in Tennessee and was shipped to Richmond. Unlike most of the building, this window was taken to Rochester, New York, when the notorious prison was disassembled following the war.

END OF THE CIVIL WAR

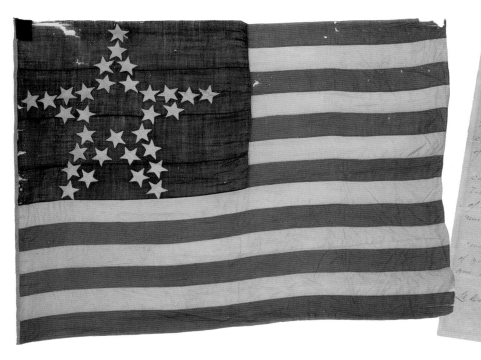

The Fall of Richmond

Thirty-one star United States flag, about 1858.
Gift of the Westfield Historical Society

This U.S. flag was one of the first to fly over defeated Richmond in April 1865, the time of President Abraham Lincoln's visit to Richmond. It was taken to New Jersey as a wartime souvenir by Major Frederick Martin. His granddaughter gave it to the Westfield Historical Society, which gave it to the Virginia Historical Society "as a symbol of friendship between two historical societies, one in the South, and one in the North."

"Overwhelming Numbers and Resources"

Robert E. Lee, "General Order No. 9," 9–12 April 1865. Copy made by Charles Scott Venable and signed by Lee. Gift of Frederick M. Warburg

At the surrender, Lee's men had time to reflect. One wrote, "To belong to General Lee's defeated Army is now the proudest boast of a Confederate soldier." Lee had his aide Charles Marshall draft a statement to address their feelings. The "farewell order" gave the southern explanation for its defeat: "the Army of Northern Virginia has been compelled to yield to overwhelming numbers and resources."

Bad Investment

Confederate bond certificate sheet, 1862

In November 1862, the executive committee of the thirty-year-old Virginia Historical Society transferred the institution's monetary assets from stocks to Confederate States certificates. At the same time, the society was evicted from its Richmond offices by the War Department—which proved to be fortuitous as the building was later burned. Books, manuscripts, and artifacts were stored in various locations including its members' homes. Like many Virginians, the society lost much during the war, including all of its investments.

"The Duty of All Citizens"

Robert E. Lee, Lexington, to General Dabney H. Maury, New Orleans, letter, 23 May 1867 (letterbook copy). Gift of Mary Custis Lee deButts and Anne Ely Zimmer

Southerners looked to Lee for guidance. He urged participation in state conventions assembled to write new constitutions. He instructed all to vote. He tells Maury, "the question then is shall the members of the convention be selected from the best available men in the state, or from the worst.... I think it is the duty of all citizens not disfranchised to qualify themselves to vote, attend the poles, and select the best men in their power."

"Letters to Answer"

Toulmin & Cale, London, lap desk owned by Robert E. Lee at Washington College, after 1850. Gift of descendants of Robert E. Lee

"I have about a bushel of letters to answer," Lee noted in 1866. Many were from correspondents whom he had never met. His opinions advocating "the reestablishment of peace and harmony" contributed significantly to the process of national reconciliation. This lap desk was used by Lee after the war at Washington College (later renamed Washington and Lee University). As president of the college, Lee revived its curriculum and attracted a sizable student body from throughout the South.

The Family Papers

Steamer trunk owned by Mary Custis Lee, about 1900. Gift of Robert E. Lee, IV, and Mrs. A. Smith Bowman, Jr., and gift/purchase from Anne Carter Zimmer

Mary Lee, the last survivor of Lee's children, preserved family papers (along with mementos of her world travels) in this trunk. Included were revealing notes that Robert E. Lee prepared for a history of the Civil War in Virginia. Confederate veterans and publishers pleaded for such a volume. Lee never finished it. Many of his wartime papers were lost, and he was more interested in the present and the future than in the past. The Virginia Historical Society holds one of the largest Lee family archives.

The New Political Landscape

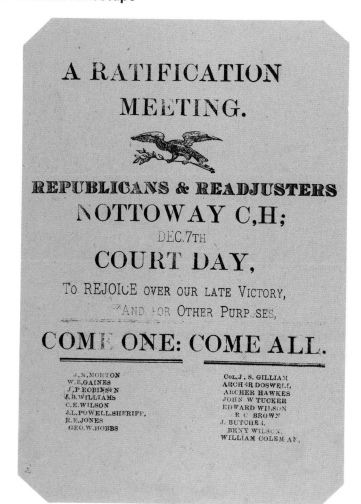

Readjusting to Debt and Emancipation

A Ratification Meeting, Republicans and Readjusters, Nottoway Courthouse, about 1870. On loan from Frank B. Allen and George E. Allen on behalf of the descendants of Robert Henderson Allen

This broadside announced a meeting of Republicans and Readjusters to ratify the new state constitution of 1870, which both prohibited slavery (even though the 13th Amendment to the U.S. Constitution had already done this at the federal level) and established free public schools. The Readjuster Party had been formed by William Mahone, a former Confederate general; it campaigned to readjust (lower) the state's large pre–Civil War debt. Mahone brought together an unlikely coalition of former slaves and poor whites to win control of the state legislature. In 1881 they held the governorship and elected him to the U.S. Senate. In 1885, voters rejected the Readjusters for a Democratic Party that initiated a century of racial discrimination.

A Former Slaveholder Reverses Course

Receipt for the purchase of a slave named Celey by William Mahone, 24 May 1857

This receipt for $925 documents William Mahone's ownership of slaves prior to the Civil War. Two other manuscripts in the collection document his ownership of four additional slaves. Mahone's past as a slaveholder makes all the more remarkable his postwar leadership in quickly moving the Readjuster Party beyond the Confederate defeat to accept emancipation and acknowledge the status of African Americans as free people.

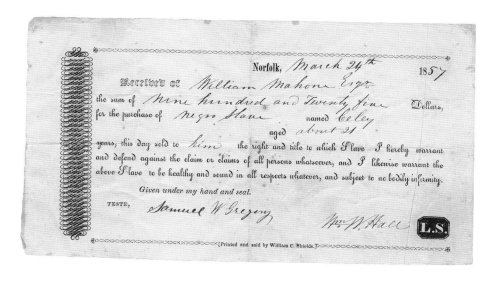

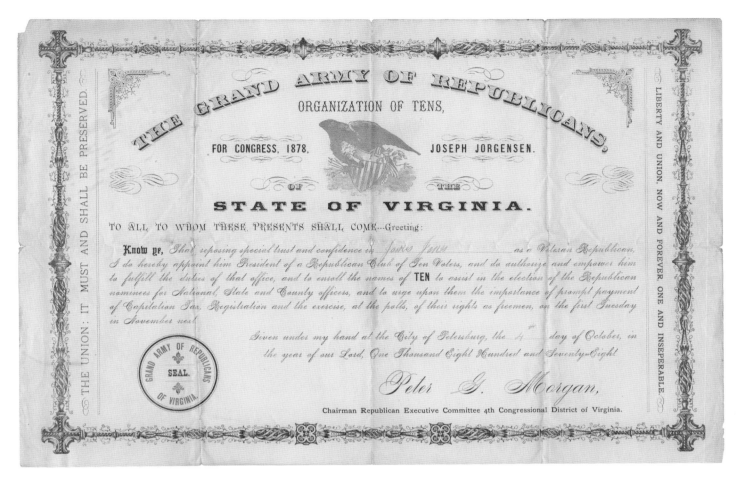

Free to Vote

The Grand Army of Republicans, certificate issued to James Jones, 1878. Gift of Chris Hicks

James Jones of Prince Edward County, Virginia, was a freedman who was active in the Republican Party in the years following the Civil War. He was a local organizer of black voters and a local official. Here, the Republican chairman for Virginia's 4th Congressional District appoints Jones to be "President of a Republican Club of Ten Voters" to assist in the selection of nominees for office. Three generations of the Jones family were active politically in Southside Virginia, where opportunity dramatically appeared and then disappeared.

Popularity of the Black Spiritual

Thomas P. Fenner, *Cabin and Plantation Songs as Sung by the Hampton Students*, New York, 1876. Bequest of Paul Mellon

In 1872 General Samuel Armstrong, the founder of Hampton Institute, and Thomas Fenner, the musical director, created a choral group named the Hampton Singers. The group toured major northeastern cities to raise funds. Many pieces in this publication are work songs. Many of the spirituals are still sung in black Baptist churches today. One of the most popular is "Nobody Knows de Trouble I've Seen."

1876–1924

VIRGINIA IN THE NEW SOUTH

Following the Civil War, Virginia remained largely rural, but Virginians embraced economic development and the new technologies that were revolutionizing everyday life. Defeated Virginia reinvented itself as a part of "the New South." Through industrialization and urbanization—which increased dramatically during an unexpected war in 1917—the state regained its former national stature. The tobacco industry was boosted by the introduction in Richmond of the cigarette; more than a hundred million were soon produced there annually. New railroad lines made widespread industrial growth feasible. A coal mining industry developed to reach new export markets. Northerners and Europeans invested in Virginia. Living standards improved, and Virginians enjoyed the highest income level in the South. World War I brought military bases and shipyards. But while a "New Virginia" allowed economic renewal, it brought little reform. Despite the emergence nationally of a "Progressive" impulse to confront the social problems and corruption caused by the onslaught of urban industry, and despite the efforts of local progressive women, Virginians resisted political and social change, especially racial and gender equality. Some rejected the prohibition of alcohol consumption and in parts of the state perpetuated traditions of "moonshining." The political system became less democratic and society was rigidly segregated by race. The Virginia legislature opposed the 19th Amendment that gave women the vote, and it passed a regressive Racial Integrity Act in 1924.

THE BEAUTY OF THE LAND

"Placid and Delightful"
Andrew Melrose, *Near Harpers Ferry*, 1870s or 1880s, oil on canvas. Bequest of Lora M. Robins

The broken cannon pictured here reminds viewers of the region's Civil War history: Harpers Ferry was the site of an arsenal that produced weapons of war, it controlled routes of transportation, it changed hands multiple times during the war, and the town became part of West Virginia in 1863. The surrounding landscape, however, is the artist's focus. A century earlier, Thomas Jefferson described the scenery near Harpers Ferry as "placid and delightful"— what we see here. The war is over, the rivers are calm, the air is fresh and clean. The landscape has renewed itself.

One of the Wonders of the World
Flavius Fisher, *Natural Bridge*, 1882, oil on canvas. Purchased with funds provided by Lora M. Robins

Natural Bridge had been made famous by Thomas Jefferson, who once owned it and who described it as one of the wonders of the world. Following the Civil War, new railroads made it accessible to tourists. Scientists had explained its creation: slow erosion was the cause, not an unfathomable cataclysmic event. Though the bridge was no longer a mysterious site, it remained a spectacular one that could invigorate the human spirit. To maximize the sense of the bridge's height, Fisher gave the viewer an extremely low perspective and rendered figures on a tiny scale.

Impetus for Preservation

John Ross Key, *Afternoon, Hawks Bill River, Blue Ridge Mountains*, about 1908, oil on canvas. Purchased with funds provided by Lora M. Robins

Key used landscape to call to mind a simpler time, before the industrialization and rapid growth of the post-Civil War period. In 1908, however, even the tranquil landscape pictured here was threatened by settlement. Key pictures part of the region of 190,000 acres that in 1935 would become the Shenandoah National Park. By focusing attention on this remarkable landscape, Key actually provided an impetus for its preservation.

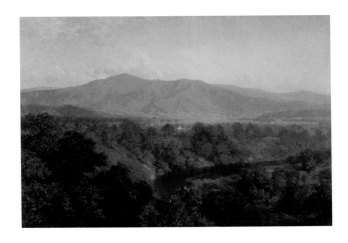

A Return to Innocence

Richard Norris Brooke, *Virginia Scene*, about 1900, oil on canvas. Purchased with funds provided by Lora M. Robins

Following the carnage of war and the political and ideological chaos that followed, the land—ever renewing itself—provided for tenants of the Tidewater and Piedmont a setting for a new beginning. Here, the northern Virginia landscape is pictured as returning to its primeval innocence.

A Dutch Viewpoint

Hubert Vos, *Mossy Creek*, about 1900, oil on canvas. Purchased with funds provided by Lora M. Robins

Vos, a Dutch artist, prompts the viewer to appreciate peaceful and simple rusticity. It was in Holland in the 1600s that the telescope and the microscope were developed, and scientists and artists found delight in the perception of fact and in the rightness of nature. Their pastoral vision was easily applied in the Shenandoah Valley at Mossy Creek, near Mount Solon and Harrisonburg.

AFRICAN AMERICAN VOICES

Plight of the Newly Freed

A. B. Frost, *Negro Funeral Procession*, 1880, pen and ink. Purchased with funds provided by Lora M. Robins

Arthur Burdett Frost, an illustrator from Philadelphia, recorded this aspect of African American culture for *Harper's Weekly*, where it was published as a woodcut. It was drawn in response to northern interest in the plight of the newly freed black population.

Parallel Economies

A. D. Price Funeral Home, Richmond, horse-drawn hearse, late 19th century

Denied access to decent jobs and commercial services by strict segregation laws, former slaves were compelled to establish parallel economies and offer their own basic services such as grocery stores, banks, hotels—and funeral homes. A. D. Price was the most important African American-owned funeral home in Richmond.

Friendship and Loyalty

Knights of Pythias helmet, about 1890. Gift of Carolyn Brown

The Knights of Pythias was a secret black fraternal order—similar to the Masons—that had branches around the world. It was named for Pythias, an ancient Greek willing to sacrifice his life to save a friend. Members of the order strove to copy his example of friendship and loyalty. They sold insurance that paid funeral expenses and provided death benefits and sick pay.

A Voice for Former Slaves

Scurlock Studio, Washington, *Booker T. Washington*, about 1900

Between 1890 and 1915, Washington was a leader in the African American community. Born a slave in the Shenandoah Valley of Virginia, he became a voice of the former slaves and their descendants. He advocated long-term educational and economic advancement and cooperation with the white hierarchy—rather than confrontation over segregation. His Tuskegee Institute in Alabama became a national center of black education.

Remembering the Slave Era

Paul Laurence Dunbar, *Candle-Lightin' Time*, New York, 1901

This volume of Dunbar's poetry was the third illustrated by the Camera Club of Hampton Institute. Organized in 1893, the Hampton club was possibly the first photography club in Virginia. Its members photographed a wide variety of subject matter. Dunbar, an African American poet from Ohio who earned an international reputation, wrote many poems in Negro dialect associated with the slave era of the Old South. His poems earned a mixed response, mostly positive.

Mutual Aid Society

Jefferson Fine Art Gallery, *Assembled True Reformers*, about 1905

To combat the iniquities of segregation, African Americans supported one another through mutual-aid societies and fraternal organizations like the Grand Fountain of the United Order of True Reformers, the largest black business enterprise in the country between 1881 and 1910. William Washington Browne, a former slave, founded it in Richmond. Members were offered banking, real estate, and retirement services, and a youth business division. This assemblage of 113 photographs is a proud display of images of the organization's officers, employees, and activities.

VALLEY POTTERY

George Washington Adapted to the Potter's Vision

Attributed to the Bell Family Pottery, Strasburg, *George Washington*, about 1860–80, redware. Gift of J. F. Wine, M.D.

The Bell Family Pottery was innovative for both glazes and imagery that melded German and American traditions. Their pottery became the center of an industry that expanded following the Civil War, when improved railroad transportation broadened the market for both their utilitarian wares—of redware and stoneware—and their fanciful pieces. Bell's four sons, John, Samuel, Solomon, and Upton, all practiced the craft.

German Ingenuity

Attributed to the Bell or Eberly Pottery, Strasburg, shaving mug, about 1860–80, lead-manganese-, and copper-glazed earthenware. Gift of J. F. Wine, M.D.

The imagination of the Valley potters fit with national trends in art and architecture during this period, when practitioners searched for new and expressive forms and gave emphasis to the texture of surfaces, variety of materials, and richness of decoration.

German Expressionism

Solomon Bell, jardinière, about 1860–80, glazed earthenware. Gift of J. F. Wine, M.D.

The largely German tradition of pottery making in the Valley evolved in innovative ways, as new forms were created and utilitarian storage containers were enlivened with abstract color. This flower pot holder with classical lion's-head handles and exuberant painted decoration is signed "Solomon Bell, Strasburg."

MICHAEL MILEY—MASTER PHOTOGRAPHER

Capturing Color

Michael Miley, *Still Life with Grapes, Color*, about 1900-16. Purchased with funds provided by the Rockefeller Foundation

Miley created some of the earliest color photographs. He received a patent in 1902 for his inventive technique that involved three successive exposures of a subject through three filters. He then laid down color dyes on the photographic paper, one over another. Miley contributed to the advance of color work, but modern color photography derived from entirely different techniques.

A Natural Wonder

Michael Miley, *Natural Bridge*, about 1880-90, carbon print.
Purchased with funds provided by the Rockefeller Foundation

Miley chose to exaggerate the appearance of the bridge in order to evoke ideas of the sublime—to remind us of those forces of nature that make us aware of the futility of human endeavors. He suggests that the bridge tilts. He manipulated the image of the rock sides of the bridge to suggest that they were shaved away with time. Carbon printing gives the photograph its mood. Small figures establish the massive scale.

JAMES AMBLER—ARCTIC EXPLORER

Tragedy in the Bering Strait

Ernest Grist, *The Jeannette Trapped in the Ice,* 1879–81, watercolor. Purchased in part through the Frank F. Byram Fund

This watercolor recreates the scene of the small steamboat *Jeannette* beset by ice north of the Bering Strait. Aboard was Dr. James M. Ambler, a U.S. Navy surgeon from Fauquier County, Virginia. In 1881, the crew abandoned their ice-bound ship, set out in small boats, and then trekked over the ice pack to reach Siberian settlements. After weeks of hunger and exposure, most of them died, including Ambler.

James Ambler Mementos

Gold medal awarded to Dr. James Markham Ambler, 1890. Gift of James C. Ambler

This medal was awarded posthumously by Congress to Ambler for his services to the crew of the *Jeannette.* For a year—until supplies ran out—Ambler helped to keep others alive. The medal was offered "in commemoration of perils encountered and as an expression of the high esteem in which Congress holds his services."

Diary of James Ambler, 12 June–18 October 1881, p. 95. Gift of James C. Ambler

Eleven of the crew members were rescued. Ambler was among the twenty-one who perished. His remains were found. Among them were his watch, scarf, and a diary he had kept in the summer and fall of 1881.

Auguste Saltzman, watch of James Ambler. Gift of James C. Ambler

Scarf of James Ambler. Gift of James C. Ambler

Ambler's scarf was returned to his mother.

POLITICAL PARTIES

ACCOMACK COUNTY

All on Fire For

HANCOCK AND ENGLISH AND GARRISON!

NEGROES REGISTERING AND
Republican National Committee
Paying Their Poll Tax!

Negro Leaders Coming

TO THE FRONT AND EXHORTING THE WEAK-
KNEED TO STAND BY THEIR FRIENDS.

DEMOCRATS TO THE RESCUE.
REGISTER BEFORE THE 23d OF OCTOBER OR
YOU WILL BE TOO LATE.

PAY YOUR 1879 POLL TAX
TO THE CLERK OF THE COURT!

The Democratic Canvassers will address the people at the
following places and times:—
Muddy Creek, Saturday afternoon, 3 o'clock, P. M., October 16th.
Guilford—Saturday night, October 16th.
Hunting Creek, J. C. Justice & Co's Store, Mon. night, Oct. 18th
Locust Mount—Tuesday night, October 19th.
Cashville—Wednesday night, October 20th.
News Town—Thursday night, October 21st.
Sykes Island—Friday night, October 22nd.
Greenbackville—Saturday night, October 23d.
Heath's Store, Chesconessex Creek, Tuesday night, October 26.
Hoffman's Wharf, Thursday night, October 28th.
Lee Mont, Friday night, October 29th.
Hall's Store, Saturday afternoon, October 30th.
Horntown, Saturday night, October 30th.
Chincoteague Island, Monday night, November 1st.

"VIRGINIAN," Job Printing Office, Onancock, Va.

The Right to Vote

Accomack County:... Negroes Registering and Republican National Committee Paying Their Poll Tax!..., Onancock, Virginia, 1879

Following emancipation, many former slaves became Republicans and elected nearly 100 African Americans to state office. Others joined with poor whites to form the Readjuster Party, which won control of the state legislature and elected a U.S. senator. As a backlash, white voters in 1886 rejected both the Republicans and Readjusters in favor of the Democratic Party and initiated a century of government-sponsored racial discrimination. Black political advancement in Virginia largely ceased.

"FITZ-YOU"

DESIGN OWNED AND REGISTERED, 1901, BY DIXIE TOBACCO CO.

Survival of the Confederacy

Dixie Tobacco Company, tobacco label ("Fitz-You"), about 1886–90. Gift of James C. Kelly

Heroic military leaders for the Confederacy who sought political office after the war often were successful. Most ran as Democrats. Fitzhugh Lee, a former Confederate cavalry general who was Robert E. Lee's nephew and the son of Sydney Smith Lee, a captain in the Confederate navy, became Virginia's fortieth governor in 1886. The marketing of a tobacco product by using the name of Fitzhugh Lee is evidence of the lingering popularity of the defunct Confederacy.

GRIT AND RESILIENCE

Frontier Violence

Baldwin-Felts Detectives, Inc., *$2,800.00 Reward*, Roanoke, 1912

A culture of frontier violence survived into the twentieth century in some remote rural regions of Virginia. An infamous gunfight at Carroll County Courthouse followed the sentencing of Floyd Allen for assault. Members of his clan rejected the court's verdict and immediately initiated his escape in a shootout. The Allen family killed five people and injured seven others. Each family member pictured was captured.

Prohibitable?

Still, about 1890, copper. Purchased with funds from the Betty Sams Christian Business History Fund

Despite efforts to suppress it, "moonshining"—distilling liquor without paying an excise tax—persisted in Virginia into the twentieth century. The attempted prohibition of all alcohol consumption, which was to begin in Virginia in 1916 and nationwide in 1919, would make "moonshining" all the more profitable. In 1935, Franklin County, south of Roanoke, would earn the nickname "The wettest place in the United States." This still was used farther southwest in Washington County by the McConnell family.

Remembrance

Charles Hoffbauer, *Memorial Military Murals*, 1913–20, oil on canvas attached to walls. Acquired from the Confederate Memorial Association

Commissioned as a centerpiece of the now-defunct Confederate Memorial Institute (acquired for a different use by the Virginia Historical Society), the murals of French artist Charles Hoffbauer are a grand expression of remembrance. As the title reveals, their purpose was to memorialize the loss of life. The southern mortality rate was high: one in three soldiers died. Veterans supervised the mural project; they envisioned a series of grand military scenes akin to those in the Battles Gallery at Versailles. Like the many post-Civil War monuments erected throughout the South, the murals are a manifestation of the "Lost Cause" ideology that lingered for more than half a century.

Music and Myth

James A. Bland, *Carry Me Back to Old Virginny*, Boston, 1906, sheet music

For many, Eastman Johnson's painting *Negro Life at the South* invoked nostalgic memories of bygone days. James Bland's "Carry Me Back to Old Virginny" (first issued in 1878) would come to be associated with that image, which is pictured here on this sheet music cover. Such interwoven associations helped lead to the creation of a mythical Old South.

THE TOBACCO INDUSTRY

An Old Stereotype

Cigar store figure, about 1880–90

This tobacco store figure with African American facial features and American Indian dress evokes the history of enslaved African Americans who grew tobacco and the Native Americans who introduced this crop to colonists. It also reveals the stereotypes, held by many whites, that both were inferior. That perception allowed the Virginia General Assembly in 1924 to pass the Racial Integrity Act, which labeled both simply as "colored." As state records were altered, Virginia Indians were stripped of their identity. In 2016, at long last, the federal government recognized one tribe, and six tribes in 2018.

Largest Annual Output

Tobacco label ("The Belle of Virginia"), about 1890

The David Dunlop Company produced "all kinds of Black Twist and Plug Tobacco for export." It advertised that "The celebrated Dunlop's 'Derby' Tobacco was awarded the gold medal … at the Centennial International Exhibition, held at Melbourne, Australia in 1888 and 1889, [and that the] total number of pounds manufactured and exported for year 1891 was 2,394,899, being the largest annual output of any Export Manufacturer in the United States of Twist and Plug Tobacco."

International Acclaim for Petersburg

Gold medal awarded to D. B. Tennant & Co. at the Calcutta International Exhibition, 1883–84. Gift of Mrs. John Dunlop

D. B. Tennant & Co. of Petersburg was the successor to a tobacco company established by James Dunlop in 1791. The Tennant company produced products for an international market. Its principals, David Dunlop and David Brydon Tennant, were awarded this gold medal at an international exposition in India for their sweet blend of tobacco named "Honeydew." The likeness of Queen Victoria appears on the medal.

A Center of Tobacco Manufacturing

Chas. H. Conrad & Co., Danville, Virginia, tobacco box ("Old Virginia Log Cabin Smoking"), about 1871

The mythology about "Old Virginia" was sufficiently well known and revered for that name to be applied to tobacco products. While the manufacture of twist chewing tobacco and snuff continued, a new demand for pipes and cigars revitalized Virginia's postwar economy. By the 1870s, Danville had become a center for tobacco manufacturing. By 1880, Richmond and Petersburg produced a million pounds of smoking tobacco per year.

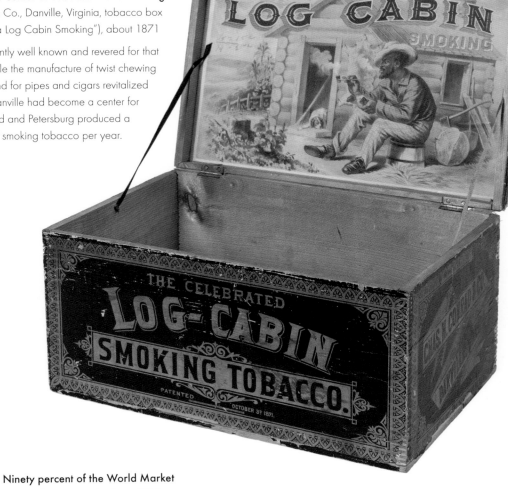

Ninety percent of the World Market

Hyco, tobacco pouch, about 1900

Hyco farm, near South Boston, Virginia, became a major world player in the production of tobacco seed. By 1916 it supplied 90 percent of the world market.

Cigarette Capital of the World

Richmond Gem Cigarettes, cigarette tin, about 1900. Gift of Mr. and Mrs. J. Madison Macon IV

Allen & Ginter, a Richmond firm that produced this product, was acquired by the American Tobacco Company of Durham. By 1900, one-half of the work force of Richmond and Petersburg was producing tobacco for pipes and cigars. By 1910, production totaled 12,000 brands of plug, twist, and fine-cut chewing tobacco; 7,000 brands of smoking tobacco; 3,600 brands of snuff; and 2,000 brands of cigarettes, cigarros, and cheroots. Richmond had become the cigarette capital of the world.

THE RAILROAD

Potential of the Land

Scenes and Places of Interest along the Norfolk & Western Railway, about 1906, photo-lithograph

This image of a modern railroad imbedded in the picturesque western landscape of the state illustrates the transformation of Virginia at this time. The state remained largely rural and defined in part by its diverse geography, but the potential of the land brought economic development and technology. This booklet illustrated scenes along the routes of the N & W and is representative of numerous such publications issued by the newly prospering railroads.

Travel in Style

Stone Printing and Manufacturing Co., Roanoke, *Summer Excursion Tickets to the Mountain and Seashore Resorts of Virginia on the Norfolk and Western Railroad*, early 20th century, lithograph. Purchased through the Betty Sams Christian Business History Fund

This poster advertised access by railroad to Virginia resorts. The stylish young woman pictured here holds a ticket to Virginia Beach. Labels on her trunk record travels to Ocean View, Mapleshade Inn Pulaski, Luray Caverns, and Hotel Roanoke.

Flat and Straight

Cup, mallet, and spike awarded in ceremonies to mark completion in Richmond of the Seaboard Airline Railway, 1900, gold. Gift of Clinton Webb

Railroads were critical to Virginia's postwar economic revival. Factories in both Richmond and Roanoke built locomotives, while improved and new lines carried coal, lumber, and tourists to new markets. John Skelton Williams of Richmond looked beyond the state to link Virginia with Florida by rail and thereby create additional commerce and jobs. The line he built was so flat and straight that it was called an "air line" railway.

Thousands of Locomotives

Urn and goblets presented to C. A. Delaney of Richmond Locomotive Works, 1899, silver plate. Gift of Eleanora Jeffreys Moore in memory of C. A. Delaney's grandchildren, C. Delaney Walthall and Mary Walthall Hensel

The iron industry in Virginia expanded alongside the railroad industry. Richmond Locomotive & Machine Works, which grew out of the Tredegar Iron Works and other companies, employed 5,000 staff in Richmond and produced perhaps several thousand locomotives, 682 of which are documented. One is preserved at Finland Station in St. Petersburg because it carried Lenin in 1917 out of exile and back to Russia. In 1901 Richmond Locomotive merged with what became the American Locomotive Company.

THE MINING INDUSTRY

Italian, Hungarian, and Black Miners
Unidentified photographer, *Toms Creek Mine, Wise County*, about 1910–20

Sixteen photographs in the Virginia Historical Society collection document the mining operations at Toms Creek, a coal town in the mountainous coal country of far southwestern Virginia. This community, built at Thomas Gist Creek, became largely self-sufficient. Italian, Hungarian, and black miners were recruited and segregated into separate housing communities. More than 100 houses were built, all with neatly maintained yards. This group of photographs records aspects of the way of life there that otherwise would be forgotten.

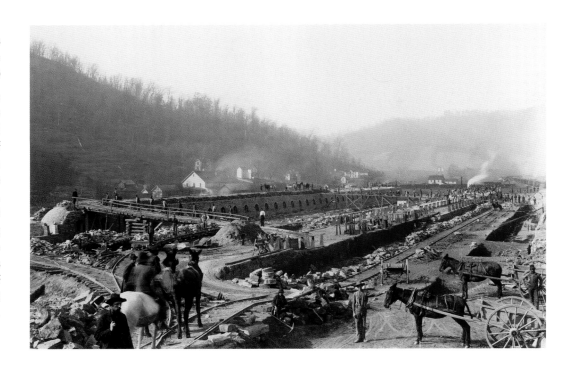

Bringing Coal to the Port
Aubrey Bodine, *Norfolk and Western Railroad Coal Piers at Newport News*, after 1924

The railroads expanded the markets for Virginia's agricultural produce, manufactures, and natural resources. The 1873 discovery of vast high-grade coal fields transformed southwest Virginia into a booming, industrialized area. Coal-powered steam locomotives transported the coal. In 1882 the town of Big Lick blossomed into the city of Roanoke, which became headquarters of the Norfolk & Western Railway, which connected the newly discovered coal fields of southwest Virginia to Norfolk and Newport News, which became two of the world's largest coal ports.

The Canary in the Mine
Handmade bird cage, about 1900, wood

Coal mining is extremely dangerous. Hazards include suffocation, gas poisoning, roof collapse, gas explosions, and such debilitating chronic diseases as black lung. From an early date, birds—particularly canaries—were used in coal mines to detect the presence of carbon monoxide. Their rapid breathing rate, small size, and high metabolism made them more sensitive to dangerous air quality, and their distress or death was an early warning system telling miners to vacate.

NORFOLK AND THE TIDEWATER

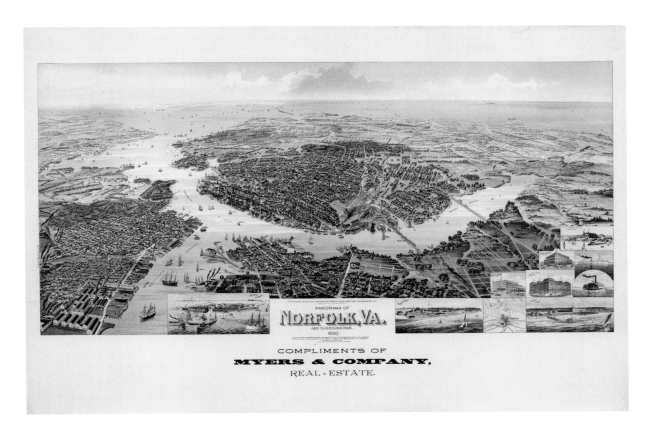

PANORAMA OF
NORFOLK, VA.
AND SURROUNDINGS.
1892.

COMPLIMENTS OF
MYERS & COMPANY,
REAL ESTATE.

Meteoric Growth

American Publishing Company, Milwaukee, *Panorama of Norfolk, Va. and Surroundings, 1892,* 1892, lithograph

Norfolk's urbanization was meteoric following the Civil War. An unexpected boost came in 1893 when Hampton Roads—through the help of Virginians in Congress—was made the site of the first in a chain of celebrations leading to the Columbian Exhibition in Chicago. President Grover Cleveland greeted thirty-eight warships from ten countries that gathered at Norfolk for an International Naval Review, the greatest accumulation of warships since Queen Victoria's Golden Jubilee of 1887.

Poised to Become the Nation's Naval Center

Edward Biedermann, *The 300th Anniversary Celebration of the Founding of Jamestown,* about 1907, gouache, watercolor, and pencil on paper, laid on board. Purchased with funds provided by the Battle Abbey Council

Virginians saw opportunity in staging a Jamestown Tercentennial Exposition that would repeat the naval pageantry of the 1893 international review—at the same site, Norfolk. Here, many of the fifty warships representing eight nations are shown weighing anchor in Hampton Roads and sailing past the exposition grounds, which in a few years would become the site of the present Norfolk Naval Base. The two celebrations in Norfolk returned Virginia to the mainstream of American thought and poised Norfolk to become the nation's naval center.

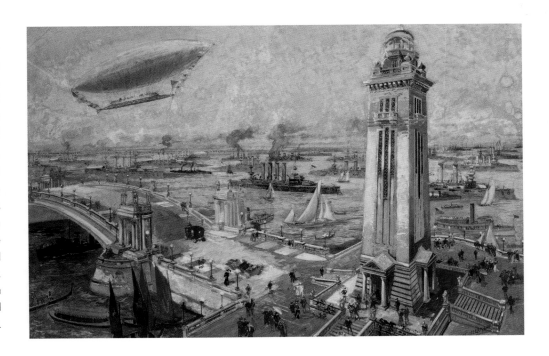

STREETCAR TO MOTOR CAR

First in the World

Richmond streetcar, 1918. Gift of David S. Robinson, Jr., and Deborah H. Robinson in memory of S. Straughan Robinson, Hylah Edwards Robinson, David Straughan Robinson, Sr., and Berniece English Robinson

In 1888 in Richmond, Frank Sprague of New York developed a self-propelled streetcar by creating a central generating station that provided electricity. Long poles, called trolleys, reached to wires that ran overhead. Richmond became the first city in the world to introduce a large-scale, fully-operational electric streetcar system. Its twelve-mile network of tracks extended beyond the city limits, facilitating growth and allowing for the development of suburban communities.

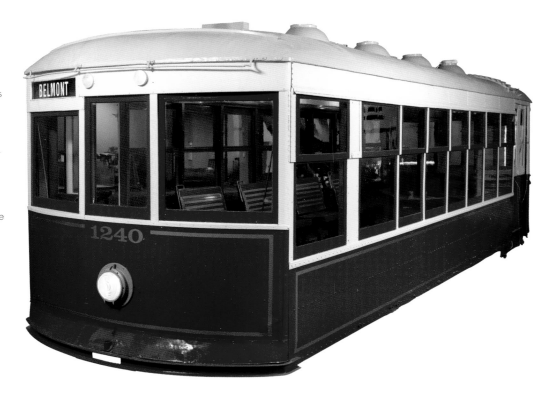

End of the Line

Gustave A. Dentzel, Dentzel Carousel Co. of Philadelphia, carousel horse, 1895

Parks with carousels and other amusements were often located at the end of streetcar lines, providing entertainment at accessible destinations away from the city. This horse is from the carousel once located in Forest Hill Park, Richmond.

Made in Virginia

Kline Motor Car Corporation, Kline Kar seven-passenger touring car, series 6–38, 1918. Partial gift of Debbie and Tim Crowder and purchased through the Paul Mellon Acquisitions Fund

The only automobiles produced by Virginia-owned companies were the "Virginian," made in Richmond, the "Kline Kar," made in Richmond, and the "Piedmont," made in Lynchburg. The only surviving vehicles made in Virginia are this car and a 1912 Kline race car. The Kline company of York, Pennsylvania, relocated to Richmond in 1912. It ceased operations in 1923 after failing to adopt the assembly line method introduced in Detroit.

SOCIAL PROGRESS

Intolerable Conditions for Children

Lewis Hine, *Group of Child Workers from the Alexandria Glass Factory*, 1911. Purchased in part through the Betty Sams Christian Business History Fund

The advent of urban industry brought intolerable conditions for some workers. The most vulnerable were children. In 1908, Lewis Hine became an investigative photographer for the National Child Labor Committee, an organization committed to the abolition of child labor. During the next decade he traveled across the country photographing the working conditions of children, such as those shown here in Alexandria, Virginia. Not until 1938 did the federal Fair Labor Standards Act set the minimum age of employment at fourteen.

The Rights of Workers

Delegate badge of the Virginia Federation of Labor annual convention, Bristol, 1922

The Virginia Federation of Labor was founded in 1895 to advocate for the rights of workers and minimize divisions among labor unions. Through the efforts of organized labor, Virginia workers have seen major improvements in their conditions and pay, and today enjoy the benefits of more than a century of union-led negotiations and struggles.

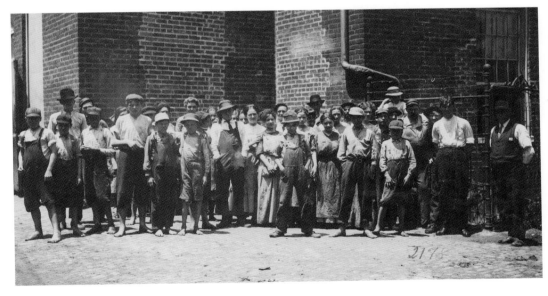

"None Working under Fourteen"

Lewis Hine, *Noon-Hour at Riverside Cotton Mills, Danville, Virginia*, 1911. Purchased in part through the Betty Sams Christian Business History Fund

Danville, Virginia, was long known as a cotton mill town. Started in 1882, Riverside Cotton Mills (also known as Dan River Mills) grew to become the largest textile firm in the South. The mills were a prime target for union leaders looking to organize other textile plants. Children were drawn into the mill industry. The superintendent who posed this group for Hine told him, "Be sure not to get any little dinner-toters in the photograph. We have none working under fourteen." Hine noted, "I did see some but not many."

WOMEN'S VOICES

Best-Selling Author

Paul Troubetzkoy, *Amélie Louise (Rives) Troubetzkoy*, 1895, bronze. Gift of Sarah Landon Rives

The academic Neoclassical tradition of idealized forms and stoic expression was revolutionized at the end of the nineteenth century. Amélie Troubetzkoy of Albemarle County, Virginia, was herself revolutionary, as a writer. Her first novel, *The Quick or the Dead?*, explored the erotic passions of a newly widowed woman; it sold 300,000 copies. Troubetzkoy continued to write until 1930, producing a dozen additional novels and plays. Her second husband sculpted this piece.

Well-Trained Photographer

Sarah Landon Rives, *Amélie Louise (Rives) Troubetzkoy*, about 1905–15, photograph. Gift of Allen R. Potts

Landon Rives was the younger sister of Amélie Rives. Both, remarkably talented, lived at Castle Hill, the family estate in Albemarle County, Virginia. In 1905 Landon studied under the famed New York photographer Alfred Stieglitz, whose evocative style is recognizable here.

First Woman Member of Parliament

Jo Davidson, *Nancy Witcher (Langhorne) Shaw Astor, Viscountess Astor*, about 1920, bronze. Gift of the Honorable Michael Astor

Nancy Langhorne of the Mirador estate in Albemarle County, Virginia, married Waldorf Astor of Cliveden, England. With Waldorf Astor's succession to a title and consequent ineligibility to sit in the House of Commons, Nancy became in 1919 the first woman member of Parliament. She served for twenty-five years, championing temperance, women's and children's welfare, and capitalism. Davidson, born in New York City and trained in Paris, sculpted numerous world figures.

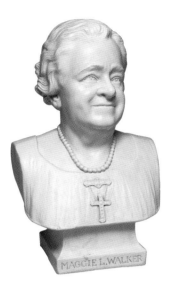

First African American Female Bank President

P. Beneduce, *Maggie Walker*, 1931, plaster

Initially a school teacher, Maggie Walker soon led the
Independent Order of St. Luke, a black fraternal burial society
that ministered to the sick and aged and promoted self-help and
integrity. She established a newspaper for the organization,
then she chartered its St. Luke Penny Savings Bank and served
as its president—the first African American female bank president
to charter a bank in the United States.

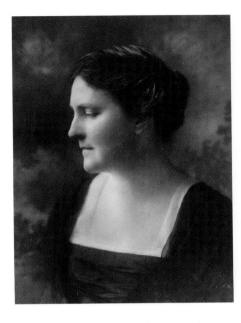

Passionate about Social Justice

Unidentified photographer,
Mary-Cooke Branch Munford, about 1900

Born into a prominent Richmond family that
had owned slaves, Mary Munford became
passionate about social justice and interracial
cooperation. She devoted her career to
education reform, health care, labor rights,
and women's suffrage. She helped establish
the Richmond Education Association, served
on the boards of the National Urban League,
University of Virginia, College of William and
Mary, and the Virginia Industrial School for
Colored Girls, and was a founding member of
the Virginia Inter-Racial League.

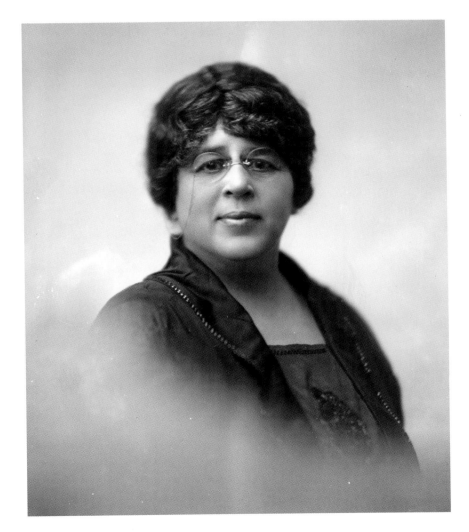

Social Reformer

Walter Washington Foster, *Janie Porter Barrett*,
1921. Gift of W. Foster Orpin

A social reformer, educator, and welfare worker, Barrett
established a school in her home in Hampton, Virginia, that in
1890 grew into the Locust Street Social Settlement, the nation's
first settlement house to assist low-income African Americans.
In 1908 she founded the Virginia State Federation of Colored
Women's Clubs, which helped her establish in 1915 the Virginia
Industrial School for Colored Girls, a pioneering rehabilitation
center for African Americans who had been incarcerated.

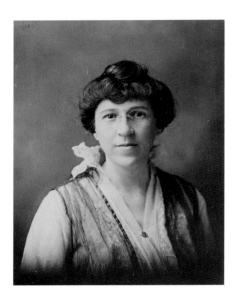

Equal Suffrage

Walter Washington Foster,
Lila Meade Valentine, about 1920.
Gift of Louise Cadot Catterall

President and co-founder of the Equal
Suffrage League of Virginia and active in
the National American Woman Suffrage
Association, Valentine also championed the
causes of health care and public education,
notably in her native Richmond. Her papers
in the Virginia Historical Society collection
include speeches and notes relating to
the Suffrage League and the Richmond
Education Association. Too ill to vote in
1920, when the 19th Amendment gave
women that right, she died the next year.

Commitment to Human Rights

Walter Washington Foster, *Lucy Randolph Mason*,
1923. Gift of W. Foster Orpin

Lucy Mason followed her ancestor George
Mason's commitment to human rights. In Richmond,
she worked for women's suffrage and economic
advancement for African Americans. She then
addressed fair labor standards: she worked for
safer workplaces and campaigned to end child
labor, raise wages, and shorten work hours. In
1937, "Miss Lucy" became a "roving ambassador"
throughout the South for the Congress of Industrial
Organizations (CIO). She contributed to the
passage of the 1938 Fair Labor Standards Act.

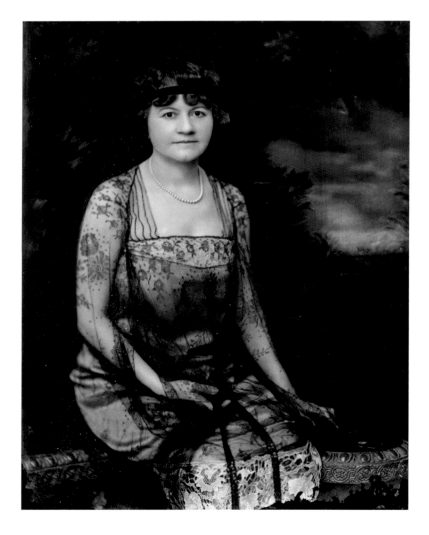

Prolific Author

Attributed to Walter Washington Foster,
Ellen Glasgow, 1920s

From 1897 to 1942, Glasgow produced twenty novels
in which she rebelled against traditional modes of
feminine conduct and thought—those of the Virginia
aristocracy into which she was born and which she saw
as a dying order. With realism and irony she painted
a social history of Virginia entirely different from the
mythology of "Old Virginia." Her Virginia heroines are
confined by their society's rules. Glasgow received a
Pulitzer Prize for *In This Our Life* (1942).

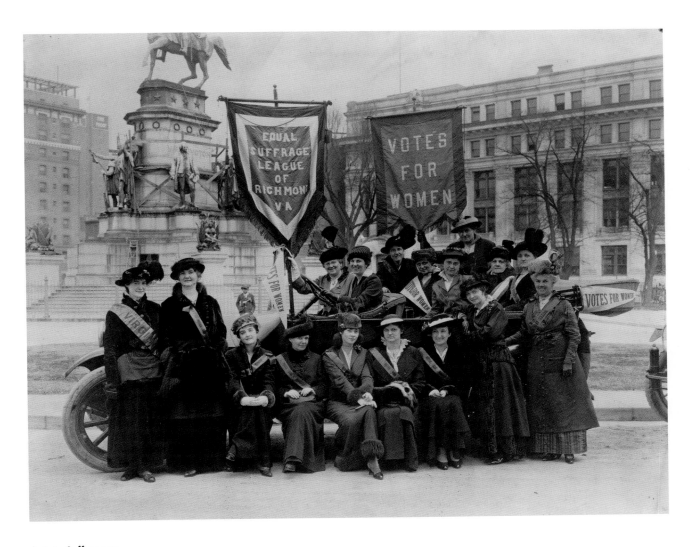

Artistic Suffragette

Walter Washington Foster, *Members of the Equal Suffrage League of Richmond, Capitol Square*, 1915 (Adèle Clark is on the far left). Gift of Adèle Clark

Adèle Clark was a major figure in Richmond's art scene and political life. She studied art in New York, then worked with the Virginia Arts Program of the WPA (Works Progress Administration). She became involved in the women's suffrage movement, first as a founder of the Equal Suffrage League of Virginia. In the 1920s, when the Equal Suffrage League became the Virginia League of Women Voters, Clark served as its president.

Art and Suffrage

Walter Washington Foster, *Nora Houston*, 1917. Gift of W. Foster Orpin

A Richmond native, Houston studied art in New York and abroad. She returned to Richmond in 1911 and became involved in multiple arts organizations, including the Art Club, the Richmond Academy of Arts, and the WPA Virginia Arts Program. In many of these organizations she worked with friend Adèle Clark, and with Clark was involved in the women's suffrage movement and state Democratic politics. Houston served as president of the Catholic Woman's Club.

WOODROW WILSON

Twenty-eighth President and Internationalist

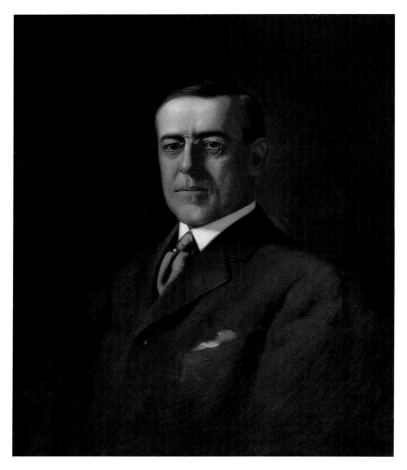

The Fight for Democracy

Charles E. Drake, *Woodrow Wilson*,
about 1913, oil on canvas

The son of a Presbyterian minister in Staunton, Virginia, and deeply religious, the twenty-eighth president conceived an idealistic international philosophy based on morality and now referred to as "Wilsonianism": the United States is obligated to enter the world arena to fight for democracy. A Progressive, President Wilson brought reform to banking, trade, business practices, farm loans, and taxes—yet he refused to advance the rights of African Americans. He first rejected entry into World War I, then found himself leading the nation and its allies in fighting German aggression.

"Americanism"

Woodrow Wilson, "Nations of Nations" speech, Cincinnati, 26 October 1916. Gift of David J. Mays

Wilson outlines here, in shorthand, his idea of a single "international nation" made up of nations that share a vision of freedom. In America, he states, we are "creating freedom among our own people that we would wish to see created among the peoples of the world." "This is Americanism ... nothing human [is] foreign to us.... We demand nothing for our citizens which mankind should not demand for itself." Wilson anticipates his later proposal for a League of Nations.

Leading the War Effort

Red Cross poster, about 1918

As wartime president, Wilson led the national effort to raise billions of dollars in funding for the war effort through the sale of Liberty Bonds. He also led a movement to supervise food production in order to adequately supply America's armies, and one to suppress anti-war activities.

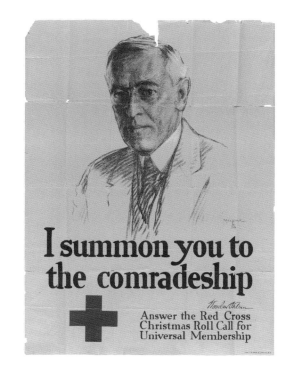

WORLD WAR I

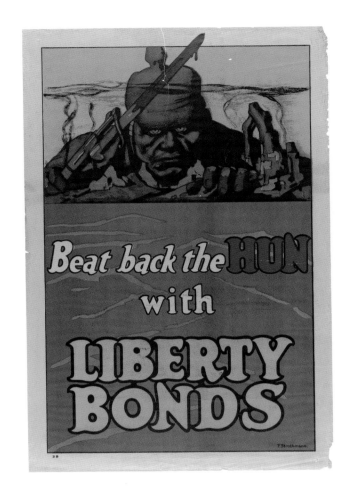

The Propaganda War

Beat Back the Hun with Liberty Bonds,
1917–19, lithograph

A dozen posters in the Virginia Historical Society collection record the use of visual propaganda to stir the patriotic purchase of bonds—appropriately named Liberty Bonds—that funded the war effort. Images range from Joan of Arc and a U.S. soldier with wife and child, to figures and flags of Liberty and derogatory depictions of the German enemy ("the Hun"). Innumerable posters were made in this country and in England and France. Images of German atrocities in Belgium are among the most provocative.

A Brave Life Given for Others

Memorial medallions awarded to John Ralston and Alexander Ralston of Richmond, after 1918. Gift of Matthew Prestone

Prior to U.S. entry into World War I, some Americans served and died with English or Canadian forces. The Ralston brothers, twins, joined the Seaforth Highlanders and the North Staffordshire Regiment. These memorial plaques were presented to the Ralstons' parents, each with a tribute from King George V of England: "I join with my grateful people in sending you this memorial of a brave life given for others in the Great War."

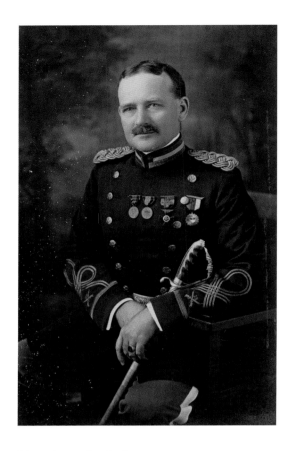

"Conspicuous Service"

Unidentified photographer, *General George Hairston Jamerson*, after 1918

Jamerson, from Martinsville, Virginia, was a West Point graduate who won distinction during the Spanish-American War and Mexican Border Campaign. During World War I, as brigadier general and regimental commander of the 317th Infantry, and brigadier commander of the 159th Infantry Brigade of the 80th Division, Jamerson was awarded the Army Distinguished Service Medal for "conspicuous service" in the organization, training, and command of his units and command of his brigade in the Meuse-Argonne offensive.

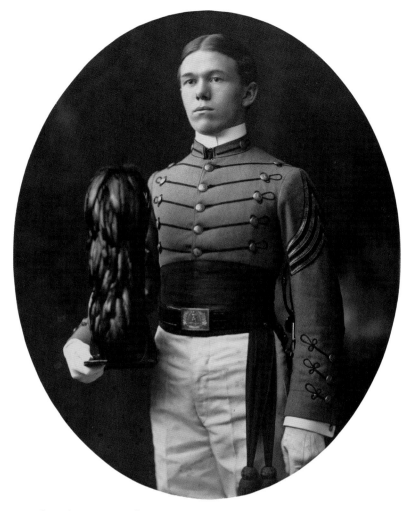

The Finest from the Virginia Military Institute

Michael Miley, *VMI Cadet George Catlett Marshall*, 1901.
Purchased with funds provided by the Rockefeller Foundation

Army chief of staff to President Franklin Roosevelt during the Second World War and renowned for his "Marshall Plan" of economic recovery for post–World War II Europe, Marshall planned important operations during the First World War. A 1901 graduate of the Virginia Military Institute, he directed the movement—without German knowledge—of fifteen divisions of the army after the Battle of Saint-Mihiel, thus initiating the decisive Meuse-Argonne offensive of 1918.

Highest Ranking Virginia National Guard Officer

Pistol of Colonel Edward Everard Goodwyn, 1911. On loan from Clayton R. Watkins, II

Goodwyn, from Emporia, Virginia, who served in the 4th Virginia Regiment, became the chief logistical officer for the "Division Trains" of the 20,000 soldiers of the famed 29th Infantry Division. The infantry of the 29th were active in the combat zone around Verdun and took part in the pivotal Meuse-Argonne offensive of October 1918. Goodwyn was the highest ranking Virginia National Guard officer to serve throughout the war. His pistol is the M1911 45-caliber semi-automatic that was standard issue for the U.S. military from 1911 to 1986.

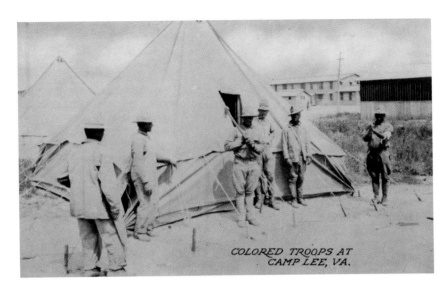

Virginia's Military Complex

Unidentified photographer, *African American Troops at Camp Lee*, 1917–18. Gift of Ben Kastelberg

With the exceptions of Fort Myer (established during the Civil War) and Fort A. P. Hill (established on the eve of the Second World War), Virginia's major bases were built in answer to the needs brought on by World War I. Fort Story was established in 1914, Army-Air Force Base Langley-Eustis in 1916 and 1918, Quantico and Camp Lee in 1917, Camp A. A. Humphreys-Fort Belvoir in 1917 and 1918, and the Naval Operating Base in 1918. Black soldiers assigned to Camp Lee were compelled to work at menial tasks and endure substandard living conditions.

U.S. Army uniform jacket of Captain George Walker Patteson, 1917. Gift of George W. Patteson III

Patteson, from Buckingham County, Virginia, was a 1917 graduate of Virginia Polytechnic Institute (Virginia Tech). He served in the Motor Transport Corps of the 4th U.S. Army Corps that participated in the offensives of Saint-Mihiel and Lorraine. Motor Transport was formed in July 1918 to manage the new fleets of trucks acquired by the army to address its supply needs. Trained at Fort Myer, Virginia, to serve in the cavalry, Patteson adeptly shifted to motor transportation, rising to the rank of captain.

U.S. Army uniform of Private Herbert Guy Farley, 1917. Gift of the Berkebile and Bass Families

Farley, from Rice, Virginia, served as a marksman in the 318th Infantry Regiment of the 80th Division. His army record of service—which is preserved in the Virginia Historical Society collection along with his discharge certificate—lists his participation in the American offensives of Saint-Mihiel and Meuse-Argonne, during which he was injured and hospitalized. His discharge records his "character" as "excellent."

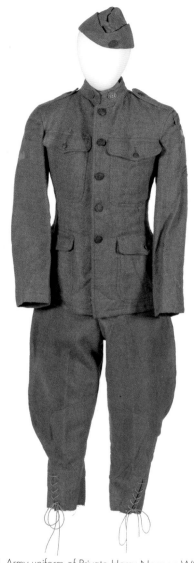

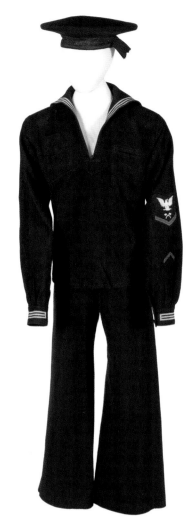

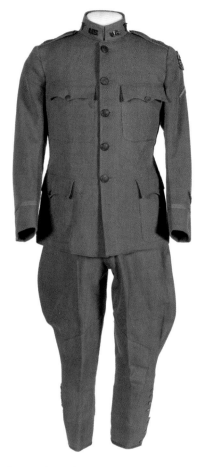

U.S. Army uniform of Private Harry Norman Witt, 1917. Gift in memory of Katherine Allen Witt by Sarah G. Culver

Witt, a barber from Richmond, served as an engineer in the Second U.S. Army, which was activated to hold the line on a portion of the Saint-Mihiel sector along the Lorraine front. His unit advanced toward Metz and launched vigorous and successful attacks. Engineers of the army worked to improve the badly damaged French roads that impeded supply efforts, slowing the progress of pushing the German lines eastward.

U.S. Navy uniform of Walter Alfred Clayton, Jr., 1917. Gift of Carolyn Clayton Morano

Clayton, from Appomattox County, Virginia, entered the navy in 1917 as a seaman and rose to the rank of carpenter's mate. His ship was a merchant marine vessel, the SS *Florence Luckenbach* (built by the Luckenbach Steamship Company). It survived a German submarine attack, only to be sunk in World War II by a Japanese submarine. On Clayton's dress blue uniform is his insignia as Petty Officer Third Class.

U.S. Army uniform of Major Fred Murchison Hodges, M.D., 1917. Gift of the family of Dr. Fred Murchison Hodges

Hodges served in Toul, France, as chief radiologist at Base Hospital 45, a 2,300-bed facility established in a converted infantry barracks eight miles from the front. The hospital treated 17,000 soldiers. Hodges suffered radiation injuries. He was one of twelve doctors and thirty nurses drawn from Richmond's Medical College of Virginia. Fifty enlisted men assisted them. The hospital was assigned to the 80th Division, a Virginia unit engaged in the Saint-Mihiel and Meuse-Argonne offensives.

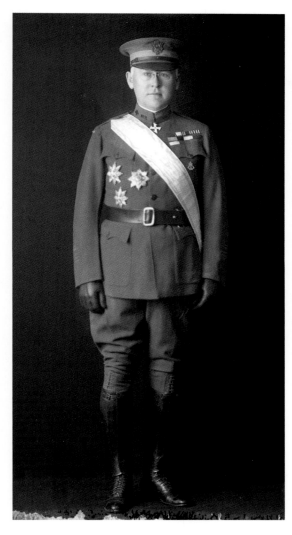

Unidentified photographer, *Queen Marie of Romania*, 1919. Gift of Mrs. James Asa Shield

In Romania, Colonel Anderson became romantically involved with that country's queen, who presented him with a series of photographs of herself that are not state portraits. The photographs are personalized, like this example that is inscribed "To Col. Anderson" from "Marie 1919." Their relationship ended Anderson's engagement to the novelist Ellen Glasgow, who attempted suicide as a result. She later assigned Anderson's personality traits to protagonists in several of her novels.

Walter Washington Foster, *Lieutenant Colonel Henry W. Anderson*, 1917. Gift of W. Foster Orpin

Anderson was a Richmond lawyer who later was a candidate for the governorship of Virginia. During World War I he was made both chief of the American Sanitary Mission and Red Cross commissioner to Romania and the Balkan States. Those countries awarded him numerous citations and medals for his wartime service.

Red Cross uniform of Carrie Triplett Taliaferro (Scott). Gift of the family of Thomas Branch Scott, Jr.

The outbreak of World War I brought phenomenal growth to the Red Cross and $400 million dollars of public contributions for its support. It staffed hospitals at home and in France, recruiting 20,000 registered nurses nationwide to serve the military. Taliaferro, twenty years old in 1917, was a Red Cross volunteer in Richmond at an army canteen. She wore the uniform that is pictured during World War II.

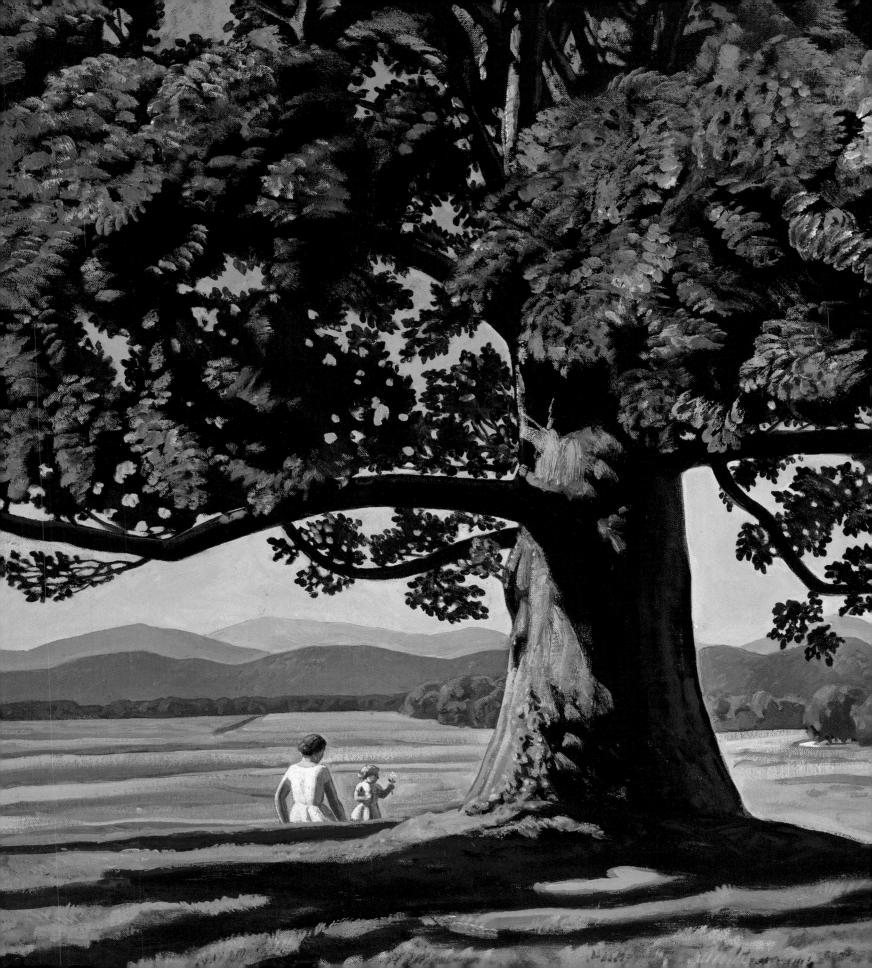

A NEW DOMINION

A century of foreign wars greatly expanded the presence of both the federal government in northern Virginia and the military in the Hampton Roads area. The governmental complex serving Washington became immense. The need for training facilities for all branches of servicemen and a dramatic increase in shipbuilding transformed the state's maritime region. Growth in those areas helped transform the state from a rural to a primarily urban and suburban one, from a poor to a relatively affluent one, and from a state with mainly native-born citizens to one with residents from other regions and countries. Since 1960, the population has doubled. As the state's demographics changed, so did its politics. Only painstakingly, however, have minorities made significant progress toward equality. Not until mid-century did leaders reject the injustices of the Racial Integrity Act of 1924, not until 1952 did legislators endorse the 1920 amendment allowing women to vote, and not until 1970—with the governorship of Linwood Holton—did most white citizens reject a regressive stance regarding race and gender. Black activists in Virginia used the judicial system to move towards fruition the promise of Virginia's Founding Fathers that "all men are ... equal" and should be treated as such. From the Civil Rights movement and from the military and the foreign service, significant historical figures emerged. The largest employer now is the government; next is agriculture, which adds billions of dollars to the state's economy. The economy of Virginia has shifted from traditional staples to new and different industries, including those in technology.

THE BYRD FAMILY IN THE 20TH CENTURY

Richard Byrd and Harry F. Byrd, Sr.

Intrepid Explorer

Dementi Studio, *Tickertape Parade in New York City for Admiral Richard Byrd on His Return from the South Pole*, 1929

Byrd and his brother, U.S. Senator Harry Flood Byrd, Sr., were descended from the colonial William Byrd family of Westover plantation (Charles City County). In 1926 Richard Byrd was reputedly the first man to fly over the North Pole, a claim that was later disputed because he possibly turned back due to an oil leak. In 1929, however, he became unquestionably the first man to fly over the South Pole. His feats of exploration during the 1920s captured America's imagination and he became a national hero. Congress awarded Byrd the Medal of Honor.

The Youngest Admiral

Fur parka worn by Richard Evelyn Byrd, about 1929. Purchased with funds from the Robert G. Cabell, III and Maude Morgan Cabell Foundation in honor of B. Walton Turnbull

Made of reindeer fur, this was one of Byrd's work parkas that he wore on Antarctic (South Pole) explorations, several of which he led as director of U.S. government expeditions. He also served in World War II. As a result of his fame from the first Arctic (North Pole) expedition, Byrd was promoted to the rank of rear admiral. Only forty-one years old at the time, he became the youngest admiral in the history of the United States Navy.

Virginia Pride

Presentation sword given to Richard Evelyn Byrd by the People of the Commonwealth of Virginia, 1930

Byrd was awarded this sterling silver sword by his native state in recognition of his pioneering accomplishments in aviation and polar exploration and for his skills in organizing complex expeditions, funding them, and utilizing the latest technologies in order to bring them success. Among the decorative devices on the sword and scabbard are the Virginia seal, the U.S. Navy seal, the Byrd family arms, and a map of the route to the South Pole.

Unprecedented Political Power

William Washington Foster, *Harry Flood Byrd, Sr.,* 1931. Gift of the Virginia National Guard

Byrd shaped Virginia's history during forty years of public service, a remarkably long period when he held unprecedented political power. He served as governor (1925–29) and U.S. senator (1933–65), and in both positions led the state's Democratic Party political organization—the "Byrd machine"—that controlled political destinies throughout the state, a feat not likely to be duplicated. Byrd streamlined the state's bureaucratic government, reduced taxes, promoted highway development, and established a conservative fiscal policy for the state, while also promoting long-standing segregationist politics.

Aristocratic Roots and Practicality

Unidentified photographer, *Harry F. Byrd, Sr., with His Grandmother Jennie, Father Richard, and Son Harry, Jr., at Byrd's Summer House "The Bungalow,"* 1925

This photograph, taken at Byrd's modest summer house when he was governor-elect, hints at both his aristocratic roots and his practicality. A high school dropout who remained little interested in public education, Byrd took over the failing family newspaper at age fifteen and turned the Winchester *Evening Star* into a profitable operation. He purchased two other newspapers, leased apple orchards, managed a toll road near his native Winchester, and built a multimillion-dollar business. During his political career, he remained a staunch segregationist who would lead the "Massive Resistance" campaign to reject school integration.

THE DEPRESSION

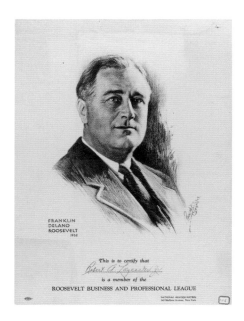

A "Hundred Days" of Legislation
Roosevelt campaign poster, 1932

Following the stock market crash of 1929 and the beginning of the Great Depression, Franklin Delano Roosevelt was elected president and initiated a "Hundred Days" of significant legislation, more than had been produced by any previous American Congress. Roosevelt's "New Deal" was largely rejected by Virginia leaders of his own party, led by Democrat Harry Byrd. One FDR supporter in Virginia was Robert Lancaster, corresponding secretary of the Virginia Historical Society, whose name is inscribed on this image.

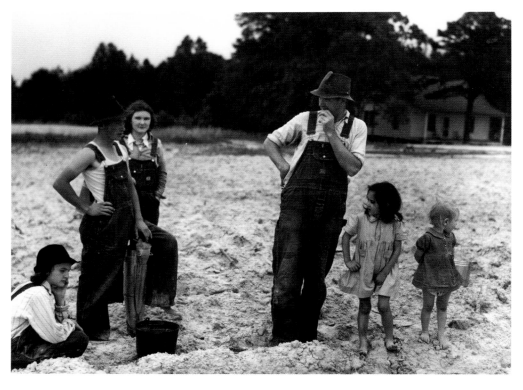

Documenting the People's Needs
Jack Delano, *Tenant Family in Field Ready for Tobacco Planting, Nine Miles North of Danville*, 1940

The Great Depression brought misery to many Virginians, creating poverty and need akin to that of the dark days of the Civil War. Unemployment reached 25 percent, industrial wages and manufacturing output fell by a third, and farm income fell to a half. In an attempt to ameliorate widespread hunger, soup kitchens cropped up in cities and in remote mountain regions. Some farmers stopped growing tobacco. The Farm Security Administration engaged photographers, including Jack Delano, to document the need for extreme corrective measures.

Dire Conditions
John Vachon, *Singing Hymns at the Evening Service of the Helping Hand Mission, Portsmouth*, 1941

The New Deal brought to Virginia a wide range of federal programs that restored confidence and improved conditions for many in need. The Federal Emergency Relief Administration provided food, shelter, clothing, and employment. In Virginia, $26 million in federal spending impacted a half-million people; yet the Byrd administration opposed the relief and refused to authorize matching funds. Rural and urban poverty were combatted by the Farm Security Administration, whose photographers illustrated the dire conditions.

NATURE'S RENEWAL

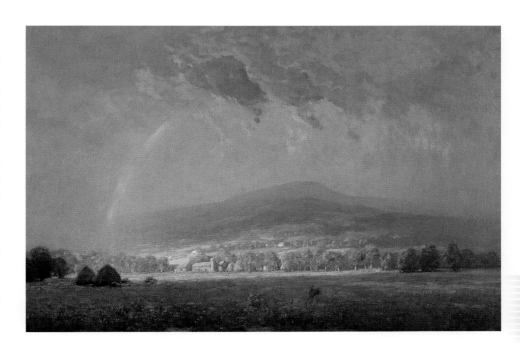

Sunshine Follows Clouds

Alexis Fournier, *The Passing Storm, Shenandoah Valley*, 1924, oil on canvas. Purchased with funds provided by Lora M. Robins

As late as the 1920s, painters still looked to find bucolic scenery in the Valley. Here Alexis Fournier shows that nature is always renewing itself, and in turn the spirit of those who depend upon the land for their well-being. Fournier was a Minnesota painter who in 1893 had traveled to Paris for training. Working on site in the Valley, probably in Rockingham County or farther north, he adapted French impressionism to an idyllic setting.

"Discovering the Beauty of the Land"

Pierre Daura, *Landscape with Cattle*, 1935, watercolor. Gift of Martha Randolph Daura

The Spaniard Pierre Daura traveled at age eighteen to Paris to pursue his career. For two decades he matured in that stimulating environment, associating with such renowned modernists as Wassily Kandinsky, Fernand Léger, and Piet Mondrian. He brought that experience to painting the landscape of the Valley of Virginia, where he and his Richmond-born wife had moved in 1939. He infused into his imagery an enthusiasm for nature. One goal, he wrote, was "to help [the rural residents of Rockbridge County] discover the beauty of the land where they live."

An Emotional Reaction

Ernest Lawson, *Radford Farm*, about 1931–37, oil on canvas. Purchased with funds provided by Lora M. Robins

A member of the famous early modernist group named "The Eight," Lawson painted colorful landscapes with thick impastos and broken brushstrokes. He was best known for his depictions of urban scenes in New York City. "Color affects me like music affects some persons," he said, "emotionally." Critics likened his palette to "crushed jewels." In 1931 he began to visit Florida annually, probably driving through the western counties of Virginia down Route 11, passing by Radford, where he stopped to paint this scene.

THE COLONIAL REVIVAL

Rediscovering Virginia's Early Past

Philip De Laszlo, *Alexander Wilbourne Weddell*, 1937, oil on canvas. Bequest of Mr. and Mrs. Alexander Wilbourne Weddell

A highly visible player in the recovery of Virginia's colonial legacy and a social force in Richmond, Washington, D.C., and international circles, Alexander Weddell was ever conscious of Virginia's heritage. Putting aside his family's strong ties to the Confederacy, he helped Virginians to rediscover the early portions of their past—the seventeenth and even the late sixteenth centuries—that he believed held greater significance than did the Confederate legacy.

Supporter of the Virginia Historical Society

John Christen Johansen, *Virginia Chase Steedman Weddell*, 1923, oil on canvas. Bequest of Mr. and Mrs. Alexander Wilbourne Weddell

Alexander Weddell enjoyed a distinguished diplomatic career. In 1923, while ambassador to India, he married Virginia (Chase) Steedman of St. Louis, the widow of James Harrison Steedman. Weddell's diplomatic service in Beirut (1916), Athens (1917–20), Calcutta (1920–24), Mexico City (1924–28), Argentina (1933–39), and Spain (1939–42) is evidence of America's increased prominence in international affairs in the first half of the twentieth century. Weddell served as president of the Virginia Historical Society from 1943 until 1948, when he and Mrs. Weddell were killed in a train accident.

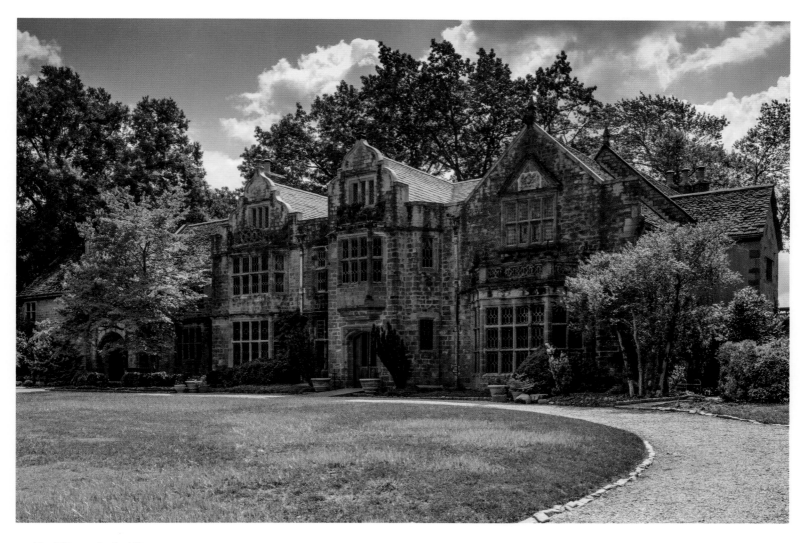

The Ultimate Revival House

Virginia House, built west of Richmond in Henrico County
(now Richmond), 1926–28

The Colonial Revival—a celebration of the colonial past—was a tool that could
be used to mold contemporary society to the model of Anglo-Saxon, colonial
America, which was unmistakably elitist. Alexander Weddell was a leader
in the movement. He and his wife, Virginia, outdid their neighbors when they
purchased an ancient English manor house and had it disassembled, shipped
across the ocean, and reconstructed in Virginia. The architecture of the former
Warwick Priory harkens back to the Elizabethan age when the first voyages
to Virginia were undertaken. A president of the Virginia Historical Society,
Weddell bequeathed this property to the institution.

NEW TRENDS

"Call for Philip Morris"

Uniform of "Bellhop Johnny" Roventini, after 1933

Famous for the "Call for Philip Morris" oration that he repeated more than a million times during a forty-year career as a product spokesman for Philip Morris brand cigarettes, Roventini appeared on radio, on television, and in print advertising media. He was discovered working as a bellboy at the New Yorker Hotel in 1933. He was less than four feet tall and reportedly could vocalize a perfect B-flat tone. The Philip Morris International tobacco company is headquartered in Richmond. (PMI was a company of Altria Group until it was spun off in 2008.)

From Horse-Driven to Gas-Fueled

Progress Manufacturing Company, Arthur, Illinois, gas pump, about 1927

This gravity-flow pump, used near Petersburg, Virginia, is evidence of the state's transition from horse-driven to gas-fueled transportation. In 1923, Virginia farmers, businessmen, and tourists were driving cars and trucks on inadequate, mostly dirt roads. Rather than sell bonds to finance 3,500 miles of new roads and thereby plunge Virginia into debt, state senator Harry F. Byrd insisted on a "pay-as-you-go" approach—a three-cent-a-gallon tax on gasoline to shift the cost to the people who used the roads. Byrd's fiscal conservatism resonated in Virginia, and it survives today.

"Brother Rat"

Jacket worn by Ronald Reagan in the film Brother Rat, Warner Brothers, 1938

President Ronald Reagan's political career was preceded by three decades of stardom as a Hollywood actor. Brother Rat, a story about the memorable Virginia Military Institute experience, was an early film for Reagan, one that brought him, thematically, to Virginia.

First Lady of Song

Richard Frooman,
Ella Fitzgerald, 1962,
oil on canvas

One of the world's most famous entertainers, Fitzgerald was born in Newport News, Virginia, and moved to New York as a child. Her 1938 recording "A-Tisket, A-Tasket" brought national celebrity. By the 1940s her superb pitch, diction, rhythm, and mastery of wordless vocal improvisation (scat-singing) gained her the title "First Lady of Jazz." By the 1950s she was the "First Lady of Song."

Political Revisionism

Rudulph Evans,
Thomas Jefferson,
1941–42, plaster. Gift
of Clark S. Marlor

President Franklin Roosevelt returned Thomas Jefferson to public attention when he initiated the idea of a memorial in Washington, D.C. to counterbalance the Lincoln Memorial that honored the founder of the Republican Party. In an act of political revisionism, he reinvented Jefferson—the champion of minimalist government—as a New Deal Democrat. Ignoring the political intrigue, Rudulph Evans created this bust as a study for the full-length sculpture of Jefferson that stands in the memorial. Evans copied the 1789 bust that was sculpted in Paris by Jean-Antoine Houdon.

The "Bubbler"

Rudolph Wurlitzer Company,
Tonawonda, New York,
jukebox, 1946. Purchased in
part with funds provided by
Sydney and Frances Lewis

The popularity of the jukebox was fueled by a demand for coin-operated music machines in bars and dance halls following the end of Prohibition in 1933. This later model (# 1015) offered twenty-four selections of recorded music. Referred to as the "1015 bubbler," it sold so well that it is considered a pop culture icon. This jukebox was found in Thaxton, Virginia, west of Bedford.

Modern Industrial Design

Chair designed by Florence Knoll,
1958. Gift of the Reynolds Metals Company

Reynolds Metals Company filled the spaces of its acclaimed International Style executive office building in Richmond with furniture—including this chair—that was made with aluminum, the company's product. The furniture repeats the sleek silhouettes and clean lines of the architecture and is of modern industrial design. More than a million pounds of aluminum were incorporated into the building's exterior cladding and throughout the interior. Threads of aluminum were used even in the carpets and draperies.

THE SHIPBUILDING INDUSTRY

The Sound of Work

Newport News Shipbuilding and Dry Dock Company, steam siren, 1912. On loan from The Mariners' Museum, Newport News, Virginia. Gift of Newport News Shipbuilding and Dry Dock Company

This siren was used along with long-bell whistles for blowing signals to stop and start work at the Newport News Shipbuilding and Dry Dock Company. Installed in 1912, it was replaced by an electric siren in 1948. Newport News Shipbuilding and Dry Dock Company was established in 1886 to repair ships. It eventually was building warships, and, in turn, ocean liners. It has produced 70 percent of the U.S. Navy's current fleet, and is now Huntington Ingalls Industries.

Steamboating in the Tidewater

Ship's wheel from *The Virginia*, 1902. On loan from The Mariners' Museum, Newport News, Virginia. Gift of Bethlehem Steel Company

This ship's wheel was used aboard a steamboat that was built by the Trigg Company in Richmond. *The Virginia* was in operation from 1902 to 1951.

An Accomplishment of Newport News Shipbuilding

Newport News Shipbuilding, engine order and revolution transmitter from the USS *Enterprise*, 1936. On loan from Naval History and Heritage Command

This machinery from the USS *Enterprise* was used to communicate speed orders to the engine room. The second carrier of the Yorktown-class to be built, the *Enterprise* was launched in 1936 at Newport News Shipbuilding. In World War II, the *Enterprise* participated in more major actions against Japan than did any other United States ship.

WORLD WAR II

George S. Patton, War Hero

"The Old Man"

Underwood & Underwood, Washington, *George S. Patton*, about 1938. Gift of James H. Whiting

Patton attended the Virginia Military Institute (VMI) in 1903, before his appointment to West Point. Patton identified himself as a Virginian because his father, grandfather, and three great uncles also attended VMI. While serving in the First World War, Patton demonstrated the same bold leadership and daring for which he became famous during World War II. Between the wars he was posted several times at Fort Myer, Virginia, as commander of the 3rd Squadron, 3rd Cavalry. This photograph was taken during his 1938 deployment.

Pipe of George S. Patton, about 1940. Gift of James H. Whiting

Patton used theatrics to promote his objectives. In 1940, and again in 1941, he staged a drive of 1,000 tanks and vehicles from Georgia to Florida and back to emphasize the need for armored forces in the coming conflict. One theatrical prop that he used was this simple corncob pipe that called attention to the "blood and guts" general who throughout the war sought the most critical assignments. "The Old Man," as his troops called him, routinely conversed with them.

Briefcase of George S. Patton, about 1940. Gift of James H. Whiting

James H. Whiting, the donor who gave to the Virginia Historical Society the photograph of Patton and the general's briefcase and pipe, was the brother of Patton's godson, Henry W. Whiting.

Uniforms and Those Who Wore Them

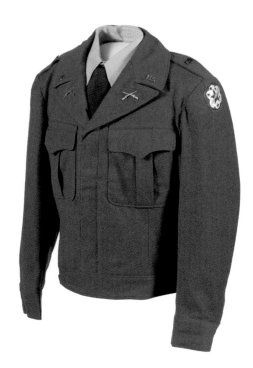

U.S. Army uniform worn by Lieutenant Samuel E. Bonsack, about 1940. Gift of Samuel E. Bonsack III

Bonsack graduated in 1940 from Virginia Polytechnic Institute (Virginia Tech), where he served as class president and regimental commander of the school's corps. He served in the Asiatic-Pacific Theater and with the Army of Occupation in Japan. He gave to the Virginia Historical Society his entire holdings from the war, including his full uniform and accessories and a Japanese bayonet and scabbard, cap, flag, and decal from a plane.

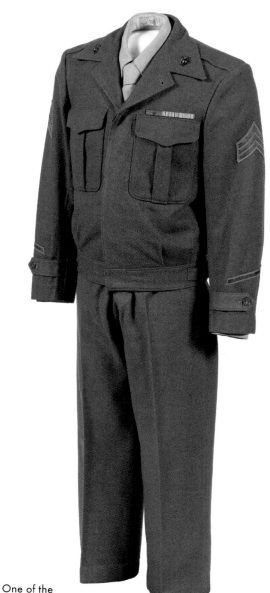

"Bedford Boy"

Winter combat jacket worn by Lieutenant Elisha "Ray" Nance, 1944

Twenty-three of the thirty-four Bedford County soldiers who participated in the D-Day invasion of Normandy were killed. They were part of the 29th Infantry Division's 116th Regiment, Company A, assigned to the first wave of attack on Omaha Beach, where they entered water over their heads. Ray Nance, one of the "Bedford Boys," wore this jacket at Normandy; shrapnel holes are visible. Because the small town of Bedford suffered the greatest loss of men per capita of any U.S. community, Congress established the National D-Day Memorial there.

One of the First Black Marines

Marine Corps uniform worn by Sergeant Dimmiline Booth, Jr., about 1943

Throughout World War I and until 1942, the Marine Corps accepted no African American soldiers. Dimmiline Booth, Jr., of Richmond was one of the first blacks allowed to enlist in the Marine Corps. The military that he joined, however, in all branches, separated black and white servicemen. In 1948, President Harry Truman signed Executive Order 9981 into law, abolishing racial discrimination in the armed forces and paving the way for the end of segregation in the military.

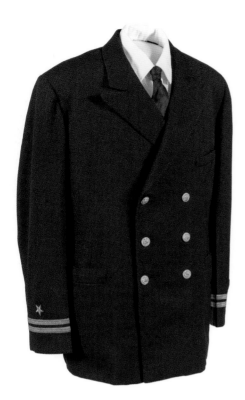

U.S. naval uniform worn by U.S. Navy Reserve Lieutenant John A. Mapp, about 1944. Gift of John A. Mapp

Mapp commanded PT-376, a patrol-torpedo boat deployed in the South Pacific to conduct reconnaissance, rescue, and combat missions. He served on combat status for eighteen straight months prior to March 1945, when Corregidor and the other islands of the Philippines were recaptured. His task at Corregidor was to rescue paratroopers who unintentionally landed on the beach and were exposed to Japanese fire. Following the war, Mapp served as dean of the Virginia Commonwealth University's evening college.

Flight jacket of Bomber Pilot Robert Willis, Jr., about 1941. Gift of Robert Grant Willis, Jr.

This sturdy leather jacket with sheepskin lining and leather straps with black metal hardware was designed to provide both warmth and some protection during high altitude flights over hostile enemy territory. Willis, whose father served in World War I, was from Richmond.

Red Cross uniform worn by Josephine Jackson Miller, about 1940. Gift of Josephine Jackson Miller

As in World War I, the Red Cross was called upon in the Second World War to provide extensive services to the U.S. military, the Allies, and to civilian war victims. More than 104,000 nurses enrolled for military service. They prepared 27 million packages for American and Allied prisoners of war, and shipped more than 300,000 tons of supplies overseas. At the military's request, the Red Cross also initiated a national blood program that collected 13.3 million pints for use by the armed forces.

The Aftermath

"Life without Him"
Claire Weir, letter to the Leazer family,
2 October 1944. Gift of Linda Leazer Kennedy

Lieutenant Harold Leazer of Remington (near Culpeper), Virginia, served in the 15th Air Force 454th Bombardment Group, based in Italy. His B-24 Liberator, part of a 500-plane raid against Axis oil production facilities near Vienna, was shot down in June 1944. Leazer was able to keep the plane aloft long enough for four crew members to parachute to safety. Leazer and five others did not survive. His distraught fiancée, Claire Weir, wrote Harold's family about the loss and the difficulty of continuing life without him.

Killed in Action over Italy
Western Union death telegram,
1944. Gift of Dr. Francis M. Foster, Sr.

Clemenceau Givings graduated from Armstrong High School and Virginia Union University in Richmond. He served with the famed Tuskegee Airmen, the black aviators who completed more than 1,500 missions over Sicily, the Mediterranean, and North Africa, destroying more than 260 enemy aircraft, numerous enemy installations, and a destroyer. Givings was a member of the 100th Fighter Squadron, part of the 332nd Fighter Group. He logged eleven raids and twenty-seven operation hours. This telegram reported to his family that Givings had been killed in action over Italy.

Virginia's Arlington Cemetery
Burial flag of Elmer Charles Clawson, 1968.
On loan from the family of Nancy Clawson Ansell

American soldiers, sailors, marines, and airmen from every state are interred in Virginia's nineteen national cemeteries. The first military burial at Arlington—formerly the home of Robert E. Lee—took place in May 1864. Still active, the 200-acre cemetery is the final resting place for more than 400,000 service members, veterans, and their families. Clawson served in North Africa during World War II. He is buried in Section 8 of Arlington National Cemetery.

Author of the "Marshall Plan"

Samuel J. Woolf, *George C. Marshall*, 1949, charcoal drawing

Commissioned for the *New York Times Magazine*, this sketch was published in December 1949. A 1901 graduate of the Virginia Military Institute, Marshall distinguished himself during World War I by conceiving and directing major military operations. He served as army chief of staff to President Franklin Roosevelt during the Second World War. He won even more renown for his "Marshall Plan" of economic recovery for post-World War II Europe, announced in 1947. The resulting public attention peaked in 1953 when he received the Nobel Peace Prize.

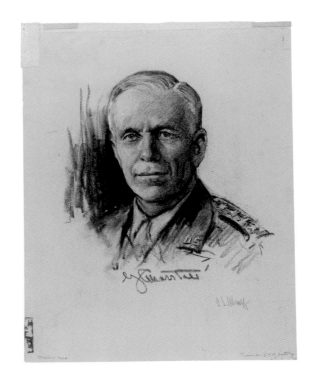

General of the Army

Unidentified photographer, *Douglas MacArthur*, 1950s. Gift of Catherine Robertson Claiborne

Famous for leading troops in the Asiatic-Pacific Theater in World War II and later during the Korean War, MacArthur had graduated first in his class at West Point in 1903. He rose to the rank of general during the First World War following his repeated acts of heroism. His ties to Virginia were through his mother; he is buried in her hometown, Norfolk. This photograph was autographed for and given to Walter Spencer Robertson, who served in the Pacific as a diplomat during most of MacArthur's years there.

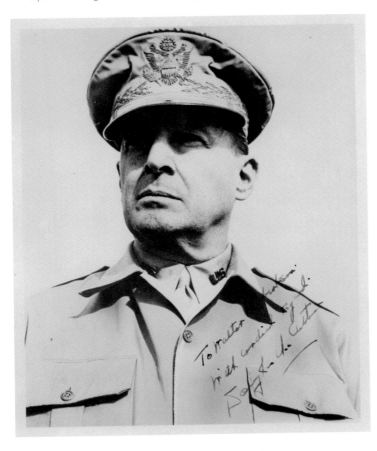

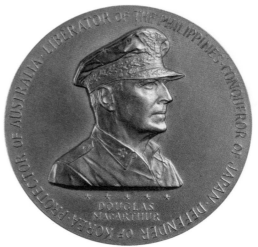

Gold medal awarded to Douglas MacArthur, "Liberator of the Philippines, Conqueror of Japan, Defender of Korea," 1962. Gift of Catherine Robertson Claiborne

A Congressional gold medal was awarded to MacArthur in 1962. It was inscribed on the reverse, "Duty-Honor-Country. In Recognition of the Gallant Service of General of the Army Douglas MacArthur to His Country. The Inescapable Price of Liberty Is an Ability to Preserve It from Destruction." The rank General of the Army has been awarded only eight times; it was created in 1866 for Ulysses Grant. MacArthur gave bronze duplicates of his medal to friends and colleagues. (This duplicate was given to Walter Robertson.)

FAR EASTERN AFFAIRS

Formidable Assistant Secretary under a Formidable Secretary
Foster Studio, *President Dwight Eisenhower, Assistant Secretary of State for Far Eastern Affairs Walter Robertson, and Secretary of State John Foster Dulles*, 1950s. Gift of Catherine Robertson Claiborne

A native of Nottoway County, Virginia, and a Richmond investment banker, Walter Robertson held diplomatic assignments in the Far East during the Franklin Roosevelt, Harry Truman, and Dwight Eisenhower administrations. He was admired by many in that region for his extensive knowledge of Asian affairs. He was a chief architect of the strong anti-Communist line and pro-Nationalist China policy followed by Eisenhower, who had himself become staunchly anti-Communist in the wake of Russian aggression following World War II. Robertson was a formidable assistant secretary serving under a formidable secretary.

U.S. Army Korean War uniform worn by Colonel Elmo Hill Alvis, 1950s. Gift of Elmo Hill Alvis

Elmo Alvis, who was born in Henrico County, Virginia, and who retired in Fredericksburg, served in the army in 1941–46 and in 1948–62. The patches on several of his uniforms—for the IV Corps, 103rd Division, and 86th Army Battalion—primarily document his service during World War II throughout Europe and the African Middle East, as do some of the service pins. Three service pins honor his Korean War tenure.

Champion for the Chinese Nationalists

Unidentified photographer, *Chiang Kai-shek, Madame Chiang, and Walter Robertson*, 1958, probably at Robertson's home in Richmond. Gift of Catherine Robertson Claiborne, Jaquelin T. Robertson, and Walter S. Robertson, Jr.

Robertson in 1945–46 served as American minister in Chungking, China. When the Chinese Communists were victorious in that nation's civil war (1946–49), Robertson became a vigorous supporter of the defeated Chinese Nationalists and a close friend of their leader, Generalissimo Chiang Kai-shek. When Chiang established his rump regime as the true government of China on the island of Taiwan, off the Chinese coast, Robertson backed Chiang and helped gain for him economic and military support.

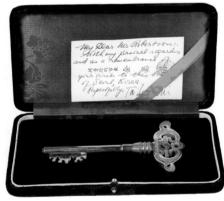

Citations from Korea, China, Thailand, and the Philippines

Key to the city of Seoul, Korea, 1959. Gift of Catherine Robertson Claiborne

As assistant secretary of state from 1953 until 1959, Robertson championed U.S. support for South Korea. He received innumerable gifts and honorary certificates. A card accompanying this key to Seoul reads, "My Dear Mr. Robertson: With my personal regards and as a remembrance of your visit to this City of Seoul Korea. Respectfully, Tai Sun Kim [mayor of Seoul]." A Republic of Korea Medal was presented on behalf of President Syngman Rhee. Robertson received additional decorations and citations for service from China, Thailand, and the Philippines.

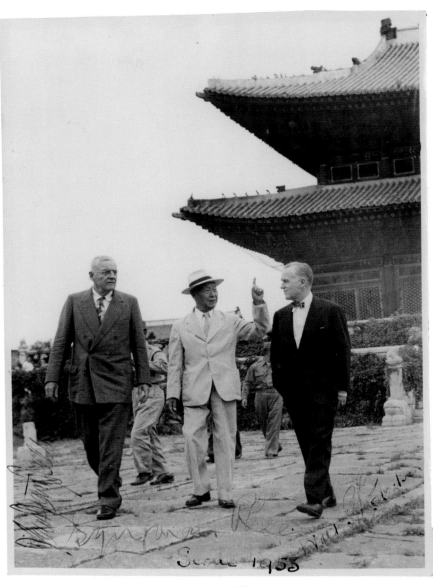

Ending the Korean War

Unidentified photographer, *John Foster Dulles, Syngman Rhee, and Walter Robertson, Seoul, Korea, July 1953*, 1953. Gift of Catherine Robertson Claiborne

Appointed to the State Department by President Eisenhower in 1953, Robertson's first task was to persuade President Syngman Rhee of South Korea to accept armistice terms to end the three-year-old Korean War. Rhee had threatened to march into North Korea. Robertson successfully conveyed the message that the Chinese were determined to prevent a unified Korea, that Eisenhower had no intention of dropping an atomic bomb to halt the Chinese, and that the U.S. would support and defend South Korea.

CIVIL RIGHTS

Dignity and Compassion

Robert Gwathmey, *Tobacco Farmers*, 1947, screenprint

Considered one of the most significant Virginia artists of the century, Gwathmey, a "social realist" painter, was a white, Richmond-born, eighth-generation Virginian who depicted rural African Americans with a socially conscious view that countered prevailing racism. Using a bold, original style, he pointed to the consequences of segregation. Sharecroppers are shown trapped in a cycle of peonage. Serenity, however, prevails. We encounter grave dignity, empathy, biting satire, and compassion, as well as hope rather than despair.

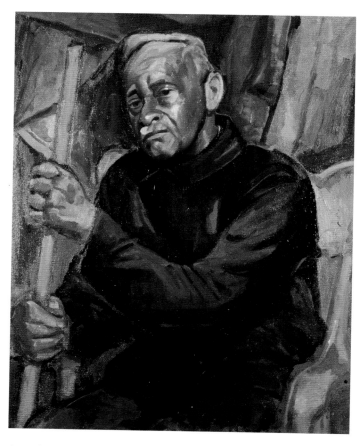

Rejecting "Separate but Equal"

Jacket, shirt, and tie worn by Oliver Hill, 2nd half of 20th century. Gift of Oliver W. Hill, Jr.

Attorney Oliver White Hill, Sr., utilized the legal system to reject the concept of "separate but equal" as contradictory to the philosophy of Virginia's Founding Fathers that "all men are ... equal." Hill and his legal partner Spottswood Robinson, representing the NAACP (National Association for the Advancement of Colored People), assisted students, led by Barbara Johns, at Moton High School in Prince Edward County in their legal suit that led to the Supreme Court decision Brown vs. the Board of Education (1954), which ended segregated schooling. Hill championed numerous civil rights issues. He was awarded the Presidential Medal of Freedom in 1999.

A Fresh Approach

Pierre Daura, *Janitor, Red Broom*, about 1951, oil on canvas. Gift of Martha Randolph Daura

Daura, another highly significant twentieth-century Virginia painter, was a Spaniard who began his career in Paris in 1914 when the futurists and cubists altered the course of art. He brought to Virginia both modernist design and an appreciation for overlooked subject matter. The artist's fresh approach to the land and to the segregated society that he encountered found forceful expression in his energized depictions of Virginia settings and in this image of a dignified manual laborer at one of the Lynchburg colleges where he taught.

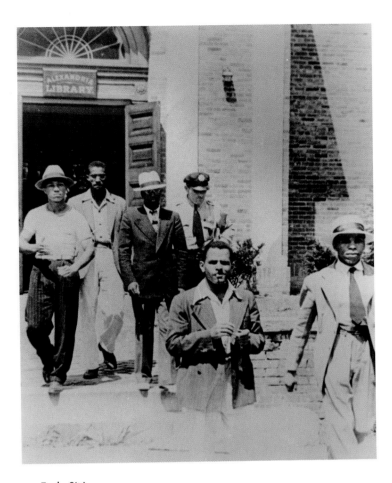

The Sit-Ins Escalate

Congress of Racial Equality (CORE), *Don't Buy at Woolworth*, New York, 1962

In February 1960, four African American college students sat at a "whites only" lunch counter at Woolworth's "five-and-dime" store in Greensboro, North Carolina, and were refused service. Three weeks later, "The Richmond 34"—students from Virginia Union University—duplicated the Greensboro protest at Thalhimer's Department Store in Richmond. The national Congress of Racial Equality launched a boycott campaign that remained active in 1962 when this broadside was printed.

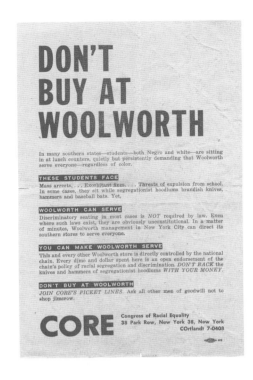

Early Sit-In

Unidentified photographer, *Alexandria Sit-In*, 1939 (copy). Purchased from the Alexandria Library, Local History, Special Collections

One of America's first sit-ins took place at the segregated Alexandria public library in 1939. Samuel Wilbert Tucker, who had passed Virginia's bar exam at age twenty, led African Americans who attempted to register for a library card but instead were arrested. When a library for blacks was constructed the next year, Tucker rejected the overture. White newspapers chose not to cover the episode. Tucker later served as Virginia's lead lawyer for the National Association for the Advancement of Colored People.

Martin Luther King, Jr. in Virginia

Program of the Virginia State Unit of the Southern Christian Leadership Conference meeting, March 1962. Purchased with funds provided by L. Dudley Walker

The Southern Christian Leadership Conference (SCLC) presented Dr. Martin Luther King, Jr., as the keynote speaker for its Eastern Virginia Mass Meeting, held 28 March 1962, at First Baptist Church in Petersburg. This program for the event is signed twice by Dr. King and by leaders of the SCLC, including Ralph Abernathy and Virginia's Curtis W. Harris.

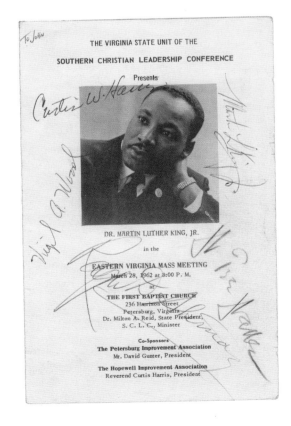

A NEW VIEW OF THE LANDSCAPE

"Expressionist" Landscape

Pierre Daura, *Red Barns and Jump Mountain (Rockbridge Baths)*, 1945–55, watercolor. Gift of Martha Randolph Daura

In 1928 Daura married Richmonder Louise Blair, who was educated at St. Catherine's School and Bryn Mawr College. She traveled to Paris to study art, and there she met Daura. At the outbreak of World War II, the couple settled on her family's property in Rockbridge Baths. This image is impressive evidence of how Daura was able to bring a Virginia landscape to life by utilizing a modern ("expressionist") formula of color, application, and structure.

A Vivid Vision

Rockwell Kent, *Child under Tree, Virginia*, 1956, oil on canvas. Purchased with funds provided by Lora M. Robins

Rockwell Kent found at Oak Ridge in Nelson County an unspoiled portion of the Virginia landscape. This large estate belonged to his patron, the grandson of its builder Thomas Fortune Ryan. Kent's distinctive style is linear and reductive, with attention to basic geometric shapes and relationships that are dynamic because of their simplicity. Clean and vivid color is integral to his vision.

THE VIEW FROM ABOVE

Aerial Photography

Air Photographics, Inc., *Vertical Aerial View of Arlington along the Potomac River*, 1948

This view records the twentieth-century growth in northern Virginia of both the population and the military industrial complex. The Pentagon is prominent, as is Arlington National Cemetery, which has long provided evidence of the modern proliferation of wars. Different from the "aeroplane photographs" of the 1920s that were shot at low altitude, this image is taken from a height made possible by the technological advances developed as early as World War II. Aerial views aid urban planners who today are increasingly confronted with land usage problems.

International Incident

U-2 spy plane pilot suit and helmet, 1960. On loan from Francis Gary Powers, Jr.

This suit and helmet were worn by Francis Gary Powers of Pound, Virginia, a U.S. Air Force pilot who in 1956 joined the U-2 program of the Central Intelligence Agency. The pressurized uniform suit and helmet helped regulate the effects of flight at high altitudes on a pilot's body. On 1 May 1960, Powers's CIA U-2 spy plane was shot down as he flew a reconnaissance mission over Soviet Union airspace. Powers was captured and spent the next two years in Soviet prisons; his exchange in 1962 garnered national attention.

The Langley Research Center

Supersonic transport drop model, 1990s. On loan from NASA Langley Research Center

This model was used at the Langley Research Center in Hampton, Virginia. Unpowered drop models like this one aid in the study of aircraft spin dynamics. More than forty wind tunnels are used there to study improved air and spacecraft safety, performance, and efficiency. Established in 1917, Langley Research Center is the oldest NASA field center. Scientists there engineer materials for aerospace uses, troubleshoot how to build replacement parts for vessels in space, and have designed and built the Orion capsule and Space Launch System, the successor to NASA's Shuttle Program.

NATIONAL FIGURES

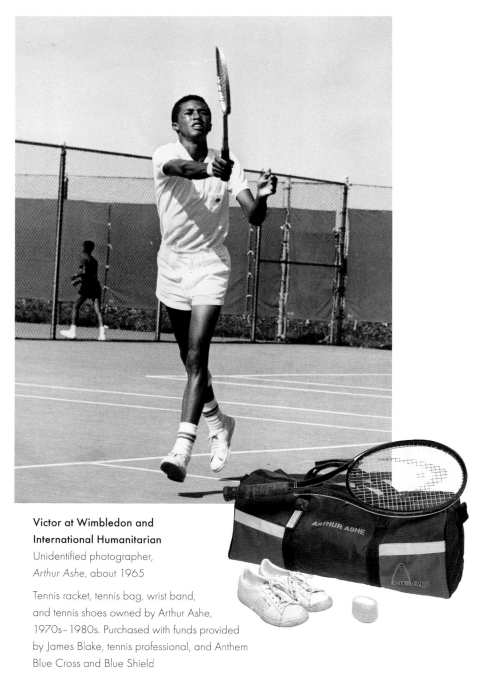

Victor at Wimbledon and International Humanitarian

Unidentified photographer,
Arthur Ashe, about 1965

Tennis racket, tennis bag, wrist band,
and tennis shoes owned by Arthur Ashe,
1970s–1980s. Purchased with funds provided
by James Blake, tennis professional, and Anthem
Blue Cross and Blue Shield

Arthur Ashe began his tennis career on the colored-only courts of segregated Richmond. After a strong amateur career, and after winning the men's singles title at the U.S. Open championship in 1968, Ashe became the first African American to win the World Championship tennis singles title at Wimbledon, England, in 1975. Ashe was a humanitarian who fought for racial justice in the United States and overseas, vocally opposing apartheid in South Africa. He died prematurely at age forty-nine in 1993.

A New Direction in Virginia Politics

Holy Bible used at
Governor Linwood
Holton's inauguration,
17 January 1970

Unidentified
photographer,
*Governor and Mrs. Holton
at His Inauguration*, 1970.
Gift of the Honorable A. Linwood Holton, Jr.

The election of Holton, the first Republican governor of Virginia since Reconstruction (1865–77), ended Democratic control of state politics. Holton's opposition to the Byrd "political machine" and his support of public school integration led to his victory. Six months after his inauguration he made national news when he placed his four children in integrated public schools in Richmond. "It was a great opportunity to set an example of how people ought to behave," he stated, adding, "the era of defiance is behind us."

Conservative on the Court

Dementi Studio, *Justice Lewis F. Powell, Jr.*, after 1971. Gift of Dementi Studio

Born in Suffolk and a graduate of Washington and Lee University, the W&L Law School, and Harvard Law School, Powell worked as a corporate attorney in Richmond before serving as a justice of the U.S. Supreme Court from 1971 to 1987. His "Powell Memorandum" of 1971, commissioned by the U.S. Chamber of Commerce, proposed actions to advance the free enterprise system; it became a foundation of the American conservative movement that followed. Powell's record on the court was as a conservative whose swing vote often brought compromise.

Lucchese (bootmaker), boots given to Governor Douglas Wilder at his commencement address at New Mexico State University, about 1990–92. Gift of the Honorable L. Douglas Wilder

Wilder's boots are embossed and embroidered with the seal of the Commonwealth of Virginia in gold toned leather and black thread.

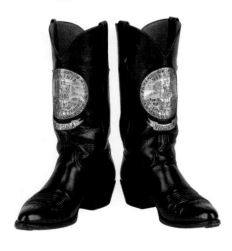

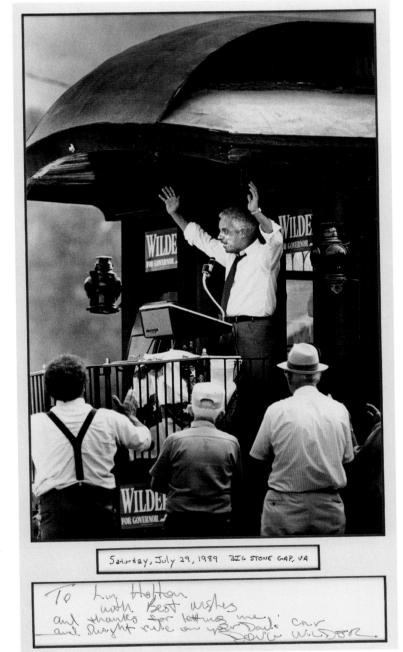

Saturday, July 29, 1989 BIG STONE GAP, VA

The First African American Governor

Unidentified photographer, *L. Douglas Wilder at Big Stone Gap, Virginia*, 29 July 1989. Gift of the Honorable A. Linwood Holton, Jr.

In 1989, Douglas Wilder became the first African American to be elected governor of any state in the nation. He already had served Virginia as a state senator and as lieutenant governor, working diligently as a liberal in a conservative legislature, promoting anti-crime legislation and a balanced budget. Wilder is shown here at the back of a train in the midst of his ambitious "back roads" statewide campaign for governor. This photograph was given to former governor Linwood Holton. Big Stone Gap was Holton's birthplace, where his father had been an executive at a small railroad.

INTERNATIONAL CONFLICTS

A POW in Vietnam

Poster ("Bring Paul Galanti Home To Richmond / Send A Letter To North Vietnam"), 1971. Gift of Phyllis E. Galanti

In June 1966, Lieutenant Commander Paul Galanti was shot down over North Vietnam. In Virginia, his wife Phyllis transformed from a shy navy wife into an activist who brought governmental, national, and international attention to the plight of prisoners of war in Southeast Asia. She rallied massive local participation in a "Write Hanoi" campaign in 1971, and met with numerous world leaders. This poster was displayed in all Reynolds Metals company locations in Richmond.

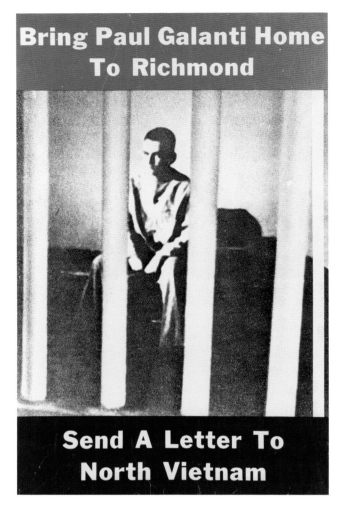

Reunion at Last

Dress and jacket worn by Phyllis Galanti, 1973. Gift of Phyllis E. Galanti

This outfit was worn by POW wife and activist Phyllis Galanti for her 1973 reunion with her husband after his captivity in North Vietnam for six years and eight months. Photographs of their happy reunion—with the lieutenant commander in his navy dress military uniform and his wife in this dress and jacket were published nationally.

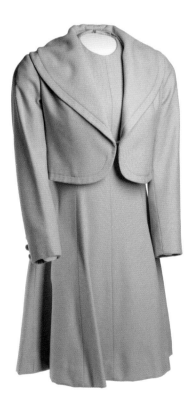

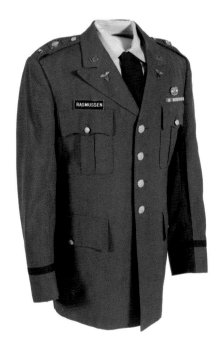

From Vietnam to Washington

U.S. Army uniform worn by First Lieutenant John Curtis Rasmussen, Jr., 1967. Given in honor of John Curtis Rasmussen, Jr., by William M. S. Rasmussen

A 1965 graduate of the Virginia Military Institute, Rasmussen served in South Vietnam in 1967–68. He was assigned to the 25th Infantry Division, one of the most decorated divisions to fight in Vietnam. He was one of few officers awarded the Combat Medical Badge, eligible to those in the medical corps who were "engaged in actual ground combat" and were "personally present and under fire." Following the war, he worked for two congressmen, then served in the Department of Commerce, earning its "Bronze Medal Award for Superior Federal Service."

The Gulf War

U.S. Air Force desert battle uniform worn by Captain James Gregory Eanes, 1990. Gift of Greg and Rose Eanes

Greg Eanes, from Crewe, Nottoway County, Virginia, served in 1990–91 in the first Gulf War (codenamed Operation Desert Shield and Desert Storm) as an intelligence officer and acting "Chief of Targets." The war was waged by a force from thirty-four nations in response to Iraq's invasion of Kuwait. A campaign to defend Saudi Arabia was followed by the liberation of Kuwait. Eanes participated in the determination of targets, then conducted site missions for the collection of war crimes evidence. He was awarded the Bronze Star for Meritorious Wartime Achievement.

The Horror of 9/11

Limestone fragment from the burned section of the Pentagon, Arlington, attacked on 9/11, 2001. Gift of United States Department of Defense

On 11 September 2001, minutes after two planes hit the World Trade Center in New York City, American Airlines Flight 77 departed Dulles International Airport in Dulles and Chantilly, Virginia. It was hijacked and crashed into the Pentagon, penetrating three of the building's five concentric rings. All sixty-four on board died, as did 125 on the ground. The "9/11" attack by Islamist extremists who were enraged by U.S. involvement in the Middle East instigated a massive U.S. response—the "war on terror," which remains the longest war in American history.

Saddam Hussein's Iraq

Iraqi Air Force poster, before 2003. Gift of Greg Eanes

Iraqi leader Saddam Hussein repeatedly incurred the wrath of the Western world. He massacred his own citizens, aligned with the Soviet Union, supported terrorism, and invaded Kuwait. In 1991, when coalition forces liberated Kuwait, they halted their advance and declared a ceasefire, enabling Hussein, though defeated, to remain in power and rebuild his military. This poster was confiscated a decade later, in 2003, at the Iraqi Air Force Headquarters in Baghdad by Lt. Col. Greg Eanes. The image shows the dictator defiant and unrepentant.

Operation Iraqi Freedom

U.S. Air Force desert camouflage uniform worn by Lieutenant Colonel James G. Eanes, 2003. Gift of Greg and Rose Eanes

U.S. forces invaded Iraq in 2003; the war was codenamed Operation Iraqi Freedom. Greg Eanes was assigned to lead part of the Iraq Survey Group, an intelligence task force charged with the search for weapons of mass destruction and with ascertaining the fate of missing Gulf War pilot Navy Captain Michael Scott Speicher. Eanes debriefed captured "high value detainees," personally interrogating, among others, former prime minister Tariq Aziz and intelligence chief Ali Hassan al-Majid—known as "Chemical Ali."

Saddam Hussein Deposed

Iraqi flag, 2003. Gift of Greg Eanes

This flag was taken during the first phase of Operation Iraqi Freedom, when Saddam Hussein was quickly deposed. According to U.S. president George W. Bush, the mission was "to disarm Iraq of weapons of mass destruction [none were found], to end Saddam Hussein's support for terrorism, and to free the Iraqi people." Others argue that the 11 September attacks prompted this second war with Iraq. (The invasion of Iraq had been preceded by an earlier phase of the "war on terror," the 2001 U.S. invasion of Afghanistan, launched to dismantle the terrorist organization al-Qaeda, remove the extremist Islamic Taliban regime, and capture Osama bin Laden, the orchestrator of the 11 September attacks.)

THE HOME FRONT

A Piedmont Landscape

Andrei Kushnir, *Sheep in the West Meadow, Valley View Farm*, 2001–2, oil on canvas. Gift of Andrei Kushnir

The setting is Valley View Farm, in Fauquier County, Virginia, in the hunt country of the northern Piedmont. This bucolic and seemingly timeless image unites elements of the oldest architecture on the property—a barn and sheds of an earlier farm—with the newest livestock, sheep that were reintroduced to the landscape in the 1990s. Kushnir, who works out of Washington, has focused much of his attention on settings in the Shenandoah Valley. This painting captures the remarkable serenity of the landscape of the northern Piedmont.

Philanthropist and Supporter of the Virginia Historical Society

Bernard Hailstone, *Paul Mellon*, 1970, oil on canvas. Purchased through the Paul Mellon Acquisition Fund

Known for his great philanthropy and love of art and horses, Paul Mellon led one of the most fascinating lives of the twentieth century. His father, Andrew, the banker and later secretary of the Treasury, amassed huge fortunes, and Mellons were among America's wealthiest families. Longing for the pleasures of the country life that he had learned in his mother's native England, Paul Mellon purchased a farm in Virginia in 1935. Many of the valuable objects that he bequeathed to the Virginia Historical Society are surveyed in the book *Treasures Revealed: American Rarities from the Paul Mellon Library* (2001).

WOMEN FIGHT ON

A Woman's Rights

Red jeans worn by protester Camille Rudney at a pro-choice rally, Capitol Square, Richmond, 2012. Gift of Camille Rudney

In 2012, the Virginia legislature proposed House Bill 462, a law requiring ultrasounds for abortion patients. In many cases, these scans were only possible through invasive procedures. Lawmakers eventually passed a law that mandated external, rather than internal, scans. Camille Rudney was among a thousand people who gathered in opposition to anti-abortion legislation proposed by state lawmakers. Thirty men and women were arrested by police officers in riot gear.

KARATE MASTER SPLIT OPERAS MAKE AMENDS **DINING LESSONS OF 2012** January 2, 2013

ST LE
WEEKLY

2012
RICHMONDERS
OF THE YEAR
The women's rights demonstrators who took on the ruling party — and won.

BY SCOTT BASS

A New Protest

Ryan Norris, knit hat worn on the Women's March on Washington, 21 January 2017. Gift of Alyssa Murray

Virginian Alyssa Murray wore this hat during the Women's March on Washington, part of a worldwide protest staged to advocate legislation and policies regarding human rights and other issues, including women's rights, immigration reform, healthcare reform, reproductive rights, the natural environment, LGBTQ rights, racial equality, freedom of religion, and workers' rights. The rally targeted Donald Trump immediately following his inauguration as president of the United States. Through the orchestration of social media, it became the largest single-day protest in U.S. history.

LOOKING AHEAD

The Brewer's Craft

Beer tap handles, 2017. Gift of (from left to right) Jamison Davis (1–2), Loveland Distributing Co., Inc. (3), Jamison Davis (4), Ardent Craft Ales (5), Genesis Chapman and Parkway Brewing Company (6–8), Loveland Distributing Co., Inc. (9)

Like the wine industry, the beer industry in Virginia has exploded in the past decade. The Commonwealth now boasts more than 100 craft breweries. Various regions promote their nationally recognized breweries as tourist destinations, encouraging the development of beer-centric trails like the "Brew Ridge Trail." The tap handles pictured here come from across the state, from breweries as diverse as Devil's Backbone, Wolf Hills, Wild Wolf, Smartmouth, Lost Rhino, Heritage, and Parkway.

Virginia is for History Lovers

"Virginia is for Lovers" memorabilia, 2015. Gift of the Virginia Tourism Authority doing business as the Virginia Tourism Corporation (pin). Gift of the estate of Henry Clay Hofheimer II (bumper sticker). Gift of Paulette Schwarting

In 1968, the Richmond advertising group that grew to become The Martin Agency won the Virginia State Travel account and created the state's iconic slogan. The group first came up with the statement "Virginia is for History Lovers," then added "for Beach Lovers" and "for Mountain Lovers," finally changing the message to "Virginia is for Lovers." In 2009 their marketing campaign was voted one of the top ten of all time. In 2016, an LGBT tourism promotion campaign added a rainbow-colored heart to the logo.

As has happened in past decades, Virginia has changed dramatically since 1968 when the "Virginia is for Lovers" slogan was coined. Its population continues to grow, now faster than the nation, and it is becoming increasingly diverse. But, one thing has remained constant—Virginia is for, and is full of, history lovers. This love of history will hopefully translate to a bright future for the Commonwealth and its people.

Afterword

The Virginia Historical Society and its Virginia Museum of History & Culture are the keepers of the Virginia story—this remarkable and far-reaching historical journey. The pages of this book offer a selection of artifacts that all have their own provenance; together they form a unique and impressive history of a place and its people.

This book is a snapshot in time for the museum and for the Commonwealth. While the objects and archives housed at the museum are easily the most encyclopedic collection of Virginia, and likely always will be, there is much still to be added.

The collection, just as this book, is lacking in its focus on all the geographic regions of the state, particularly northern Virginia, Hampton Roads, southwest Virginia, and the mountain and valley region. Just the same, it speaks to earlier institutional and community priorities. It also specifically reflects what previous generations decided to donate, and those who donated. It lacks depth in African American history and American Indian history, among others. Even time periods are necessary to consider, as our strength in documenting the founding era is wholly different from what we have available to tell the story of twentieth-century Virginia and beyond. Today, more than half of Virginians were born somewhere else. More than one-tenth of Virginians prefer a language other than English.

This gives great purpose to the museum's future work, and hopefully Virginians at large. We can labor to fill holes in our collection, and we will. We can also do better about capturing the events of today for future benefit, and we will. But, we will need help and involvement from all reaches of the state and all backgrounds if we are to be successful in telling our shared history.

The objects of this remarkable organization must do what the museum itself works tirelessly every day to do—represent all Virginians, and share the extraordinary story of this Commonwealth with the world.

Join Us.
VirginiaHistory.org

Index

Index